GARDEN WILD

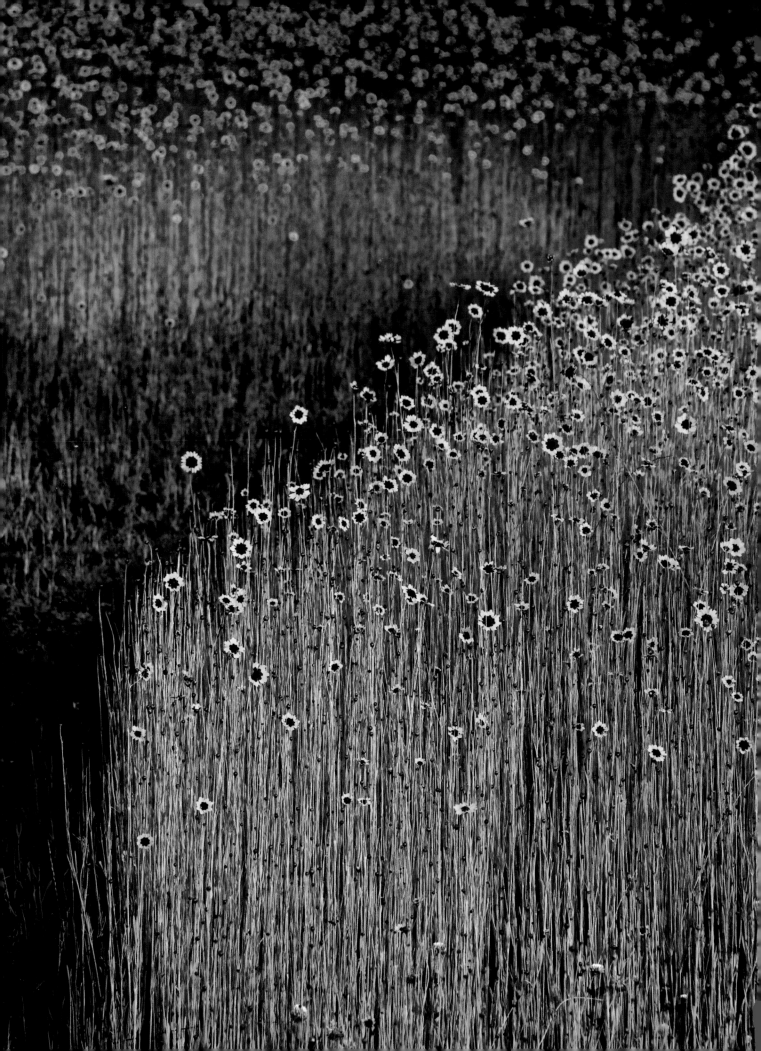

ANDRE BARANOWSKI

GARDEN WILD

MEADOWS, PRAIRIE-STYLE PLANTINGS, ROCKERIES, FERNERIES,
AND OTHER SUSTAINABLE DESIGNS INSPIRED BY NATURE

For Anna, Maciej, and Tara

RIZZOLI
NEW YORK

New York · Paris · London · Milan

First published in the United States of America in 2019 by
Rizzoli International Publications, Inc.
300 Park Avenue South
New York, NY 10010
www.rizzoliusa.com

2019 2020 2021 2022 / 10 9 8 7 6 5 4 3 2 1

Distributed in the U.S. trade by Random House, New York

Printed in China

ISBN: 9780847862139

Library of Congress Control Number: 2018956375

Artwork credits for LongHouse Reserve in "Inspired Nonconformity" chapter: Page 134: Atsuya Tominaga, *Ninguen*, 2008, marble, various dimensions, gift of the artist and Ippodo Gallery, 2012. Pages 136–37: Judy Kensley McKie, *Elephant Bench*, *Fish Bench*, and *Seagull Chair. Elephant Bench*, 2008, Bardiglio marble, 17½ x 70 x 25½ in., LongHouse Reserve Collection, partial gift of the artist and Pritam and Eames, with the generous support of the following donors: Elizabeth and Ted Rogers, Lauren Bedell and Michael Mills, Barbara Slifka, Katja Goldman and Michael Sonnenfeldt, Jack Lenor Larsen, and Jim Zajac. Page 138, top: Grace Knowlton, *Untitled (5 Round Forms)*, 1985, steel, meshed wire, concrete, Styrofoam, various dimensions, Larsen Collection, promised gift to LongHouse Reserve. Pages 140–41: Dale Chihuly, *Cobalt Reeds*, 2000, blown glass, various dimensions from 50 to 96 in. long each, LongHouse Reserve Collection, gift of the artist, 2003. Pages 142–43: John Chamberlain, *Pineapple Surprise*, 2010, colored aluminum, 185 x 130 x 126 in., Courtesy Gagosian Gallery. Pages 144–45: White tassels by Sunbrella. Sculpture at the end of the path: Fred Wilson, *The Mete of the Muse*, 2006, bronze with black patina. Page 146, top: Lawn chairs with Sunbrella fabric. Page 146, bottom: Jack Lenor Larsen, *Study in Heightened Perspective*. Page 147: Takashi Soga, *Eye of the Ring*, 2007, bronze sheet and painted steel, 109 x 122 x 98 in., private collection.

Contents

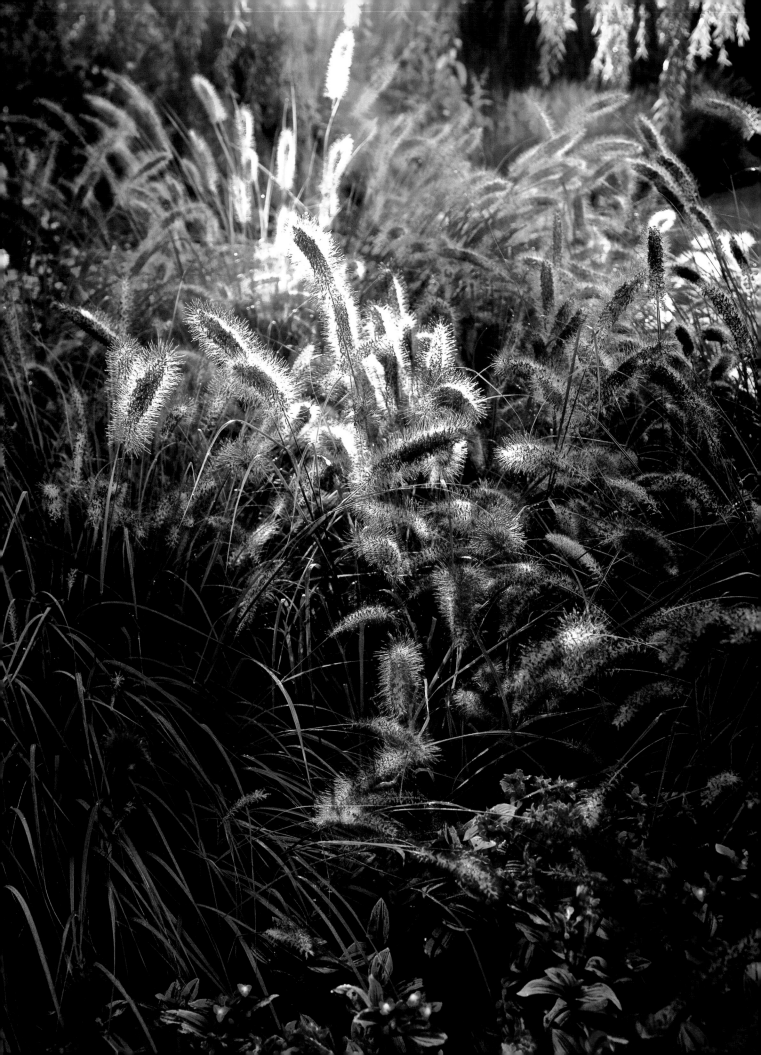

Foreword

DOROTHY KALINS

Former editor-in-chief of Garden Design *and founding editor of* Saveur

I try to imagine how Andre Baranowski made these garden photographs. Just how does he deliver this perfect intimacy that seems like there is nothing between us and the landscape? I picture him prowling the grounds, restless until he finds his image. Once it's framed, he plants his camera and roots himself as well, silent and unmoving as a tall tree. Then he watches, senses alert and still—always still—waiting, quietly waiting, sometimes for hours, until the light and the shadow and the wind align. When I ask Andre if I am right, he smiles. "Yes, I work in a meditative state. The camera is almost a part of my body. Sometimes I return to a garden as many as fifteen times. I really need a year to photograph a garden."

So there is something all the gardens in this book have in common, and it's not their location or their plant palettes or their horticulture. It is the way their photographer sees them. He paints with light and his canvas is borderless and vast. He uses the rectangular limits of his lens to frame the richness of the natural (and manmade) wonders he observes. But these are images without borders, the very opposite of the kind of garden set pieces—one-liners—that briefly intrigue but are soon forgotten.

In Andre's photographs, monumental landscapes can happen in a few feet: sunlight rims the tips of tall grasses, backlights and filters through lush patterns of leaves, as if you were stretched out on the ground looking up. Silhouettes are repeat motifs in these pages: the tracery of a leaf-bare winter tree against a snowy stand of ornamental grasses gone brown; a Japanese maple, impossibly sculptural in a robe of autumn leaves more stylish than couture; or a venerable oak, branches outstretched to welcome the centuries of life it has seen. Fog is the photographer's unexpected friend, hazing the background, just the way we'd encounter it on an

early morning walk, but rarely in a garden photograph. Traceries of roots on mossy ground studded with textured stones and a scattering of fallen birch leaves say worlds about Japanese design. Watery reflections—of a willow, or majestic rocks, or a row of bamboo—double our pleasure in the life they mirror. Age is celebrated in each well-worn, moss-green step, in every mottled stone wall and quirky sculpture that has seen many winters.

These photographs have a deceptive naturalness, because each composition, each shaft of light, each deep shadow, leads us deliberately toward a new way of seeing. Even though the gardens are often large-scale, these photographs convey intimacy. "Stop," the photographer asks us. "Observe carefully. You will behold a world."

And these are not just any gardens. In *Garden Wild*, the photographer makes a statement about the evolution of garden design. "Something is happening," he tells us, "something wild, a welcome naturalness and sustainability. The life around the garden, near the planned space, is just as exciting. We move through a garden the way we move though life." It's as if these gardens had a new motto: Plant and set them free. These photographs are best enjoyed the same way they were made—in stillness.

Concentrate.

Look.

And then look again.

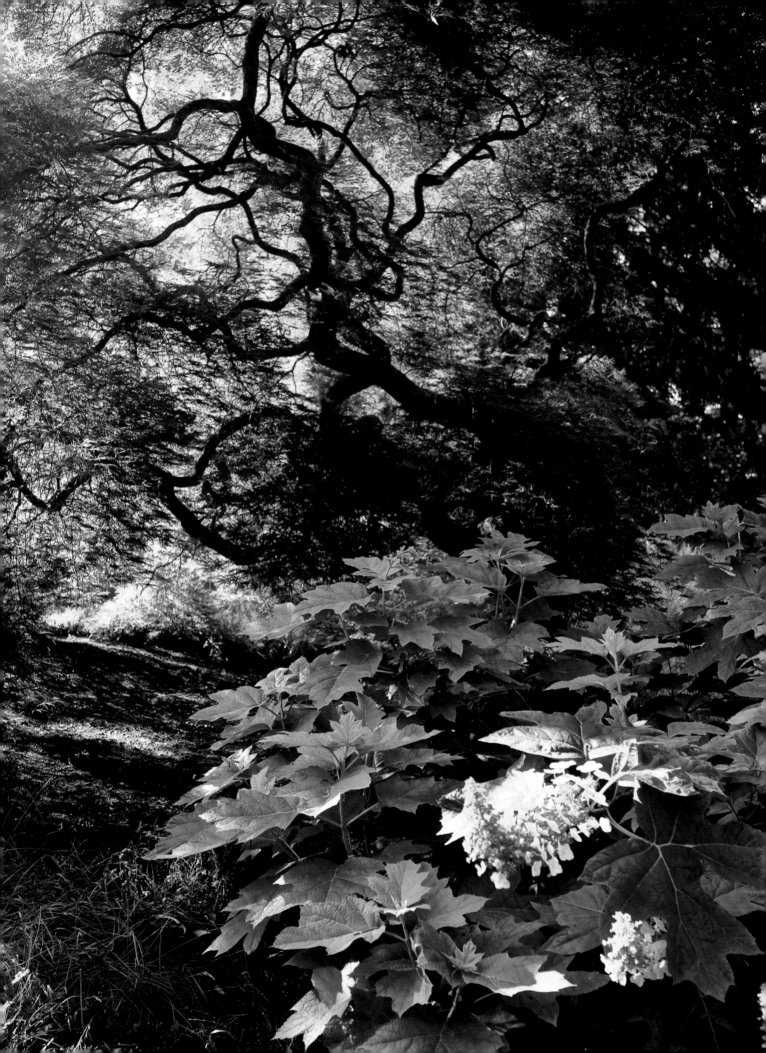

Introduction

ANDRE BARANOWSKI

I have been photographing gardens for almost thirty years. Everything from expansive land on private estates conceived by professional garden designers to small plots nurtured by enthusiasts who make the garden an integral part of their home: in all cases, it takes a special sensitivity, aesthetic, and intuition to create a beautiful space that accommodates both practical and spiritual needs while fitting perfectly within and enriching a surrounding environment.

But do we take away from nature by creating gardens in our own cultural image? Is a natural wild world perfectly balanced? Can we as humans carve a comfortable niche on this planet without disturbing or destroying the natural order of things?

Most of the gardens I have photographed for this book create a pleasing and comfortable space that blends seamlessly with the surrounding nature. A few are oases of wildness in a suburban or urban context—a reversal of a past when humans were surrounded by wild nature and survival was at best contingent. Now we're surrounded by concrete jungles where we must carve out precious acres of wildness to connect to our existential roots. Balancing both is still far from perfect, but I'm hopeful we'll find the proper proportions.

In the world of garden design, where changes usually occur at a glacial pace, James van Sweden and Wolfgang Oehme pioneered a sea change in how we design our landscapes. Intent on restoring diversity to our gardens, what was dubbed the "New American Garden" took inspiration from the country's prairies and emphasized spontaneous, loose, and exuberant plantings as an alternative to the monotony of the American lawn with its parsimonious clipped hedges. It was a radical departure from traditions of the English park, estate, and

home garden. Over the years, this once revolutionary approach trickled into the mainstream. Now, natural, native, and sustainable gardens are being nurtured in ever more creative ways by amateurs and professionals alike, to be appreciated in all four seasons just like nature. "Plant and set them free" is the new motto.

Gardens, like people, are fragile and have a life span; if not cared for properly, they will return to a natural state, erasing our cultural influences. This is why photography and documentation is so important—to preserve our artistic legacy and inspire future generations.

The call of the wild is strong for many of us. Interacting with nature can arouse spiritual epiphanies that go far beyond what might be offered by organized religions. Such is the power of nature and the garden.

As a photographer, I want to appeal to your emotions through the images I have been fortunate enough to capture and share in this book. I hope you might be moved, guided by your intuition and creative spirit, to nurture your own gardens. The ones presented in this book vary wildly in size and are designed by talented amateurs as well as respected and renowned professionals. I invite you to experience them to get a glimpse of what might be around the bend, or just over the hill, in the modern American garden.

A Waterfront View
WATER MILL, NEW YORK

In 1980, pioneering landscaper James van Sweden met sculptor Lila Katzen at one of her art openings. The week before, Lila had been out at the country home of her friends Alex and Carol Rosenberg, gallery owners and longtime stalwarts of the New York City art scene. Dismayed by the "little ditzy marigolds around the driveway," Lila urged the Rosenbergs to hire Oehme, van Sweden (OvS) to design their garden, the firm's first commission in the Hamptons.

The Rosenbergs, no strangers to taking design risks, proved to be dream clients who allowed the fledgling company free reign with their waterfront property. From the outset, OvS knew they wanted to depart from the staid and safe hedges, boxwoods, and perennial borders that dominated the East End at the time; coupled with the difficult growing conditions of the one-acre site, OvS instead planted low-maintenance grasses and perennials. What they accomplished was part of a paradigm shift that changed the gardening world forever.

Only native and ornamental perennials and grasses were used in the garden—plantings that were appropriate for the seascape, like lavender (*Lavandula*), sedums, willows (*Salix*), and magnolias (*Magnolia virginiana*). Waving in the wind, the vegetation seamlessly assimilated with the ecology of the place. Bringing ornamental grasses right up to the pool's coping was considered revolutionary at the time.

Walkways connect the property's four outdoor rooms, which include a vegetable garden, an open lawn stretching to the water's edge, and the pool. The lawn frames a magnificent view of the bay while columns of silver grass (*Miscanthus*) connect to the nearby marsh grasses. Throughout, strategically placed outdoor sculptures engage the fortunate wanderer with surprise, whimsy, and contemplation.

An ongoing inspiration for a more informal and sustainable approach to gardening, the Rosenberg Garden continues to reveal its many delights in all four seasons.

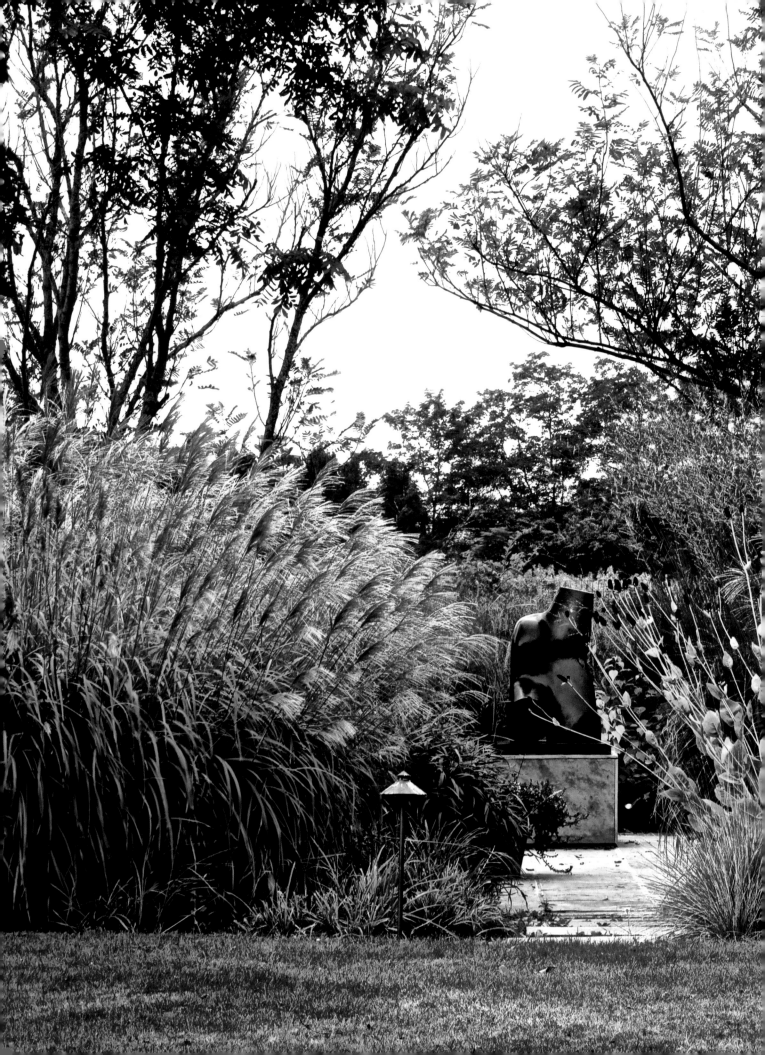

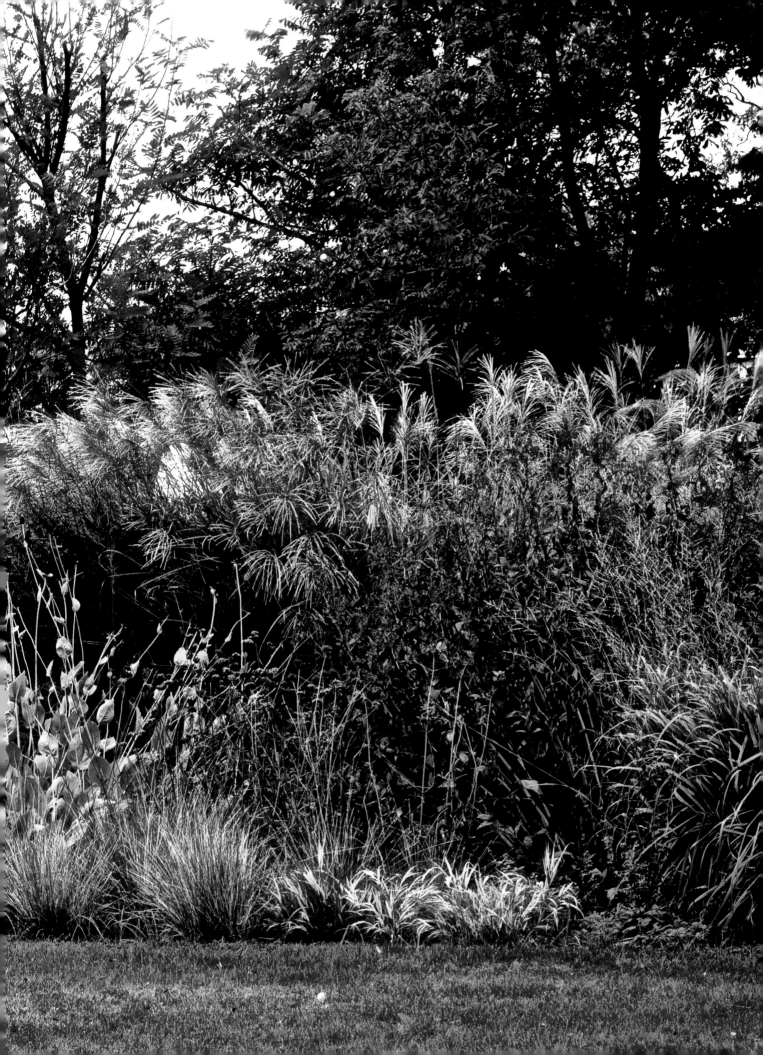

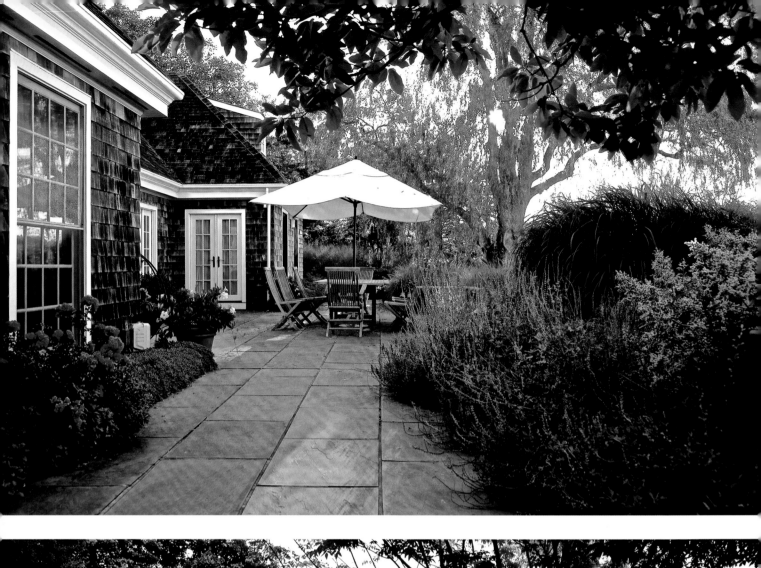

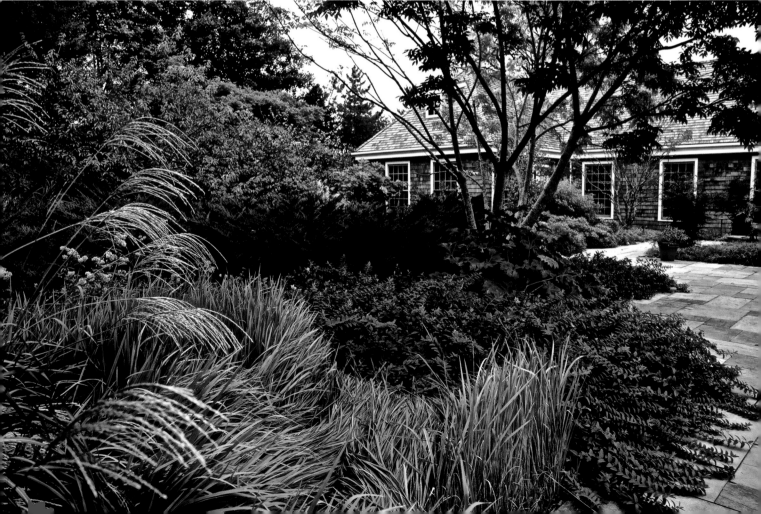

Mexican bush sage (*Salvia leucantha*), shrub rose (*Rosa* 'Crimson Meidiland'), *Maackia amurensis*, doublefile viburnum (*Viburnum plicatum tomentosum* 'Mariesii'), and other grasses and perennials mediate inner garden areas and the surrounding landscape along a trio of walkways. Previous spread: A Henry Moore sculpture sits among giant Chinese silver grass (*Miscanthus* 'Giganteus'), purpletop (*Verbena bonariensis*), Atlas fescue (*Festuca mairei*), and coneflower (*Rudbeckia maxima*) like a node of serenity framed by the dance of nature.

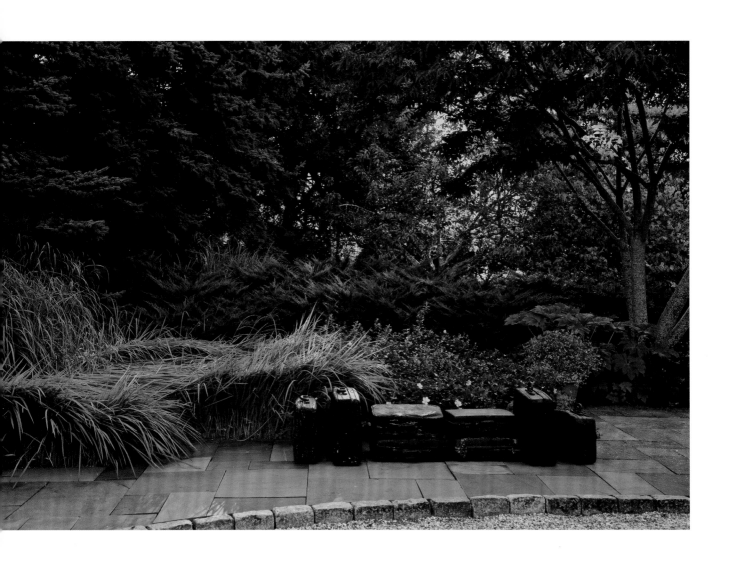

Above: A witty sculpture at the entry court foregrounds Pfitzer Juniper (*Juniperus chinensis* 'Pfitzeriana'), fountain grass (*Pennisetum alopecuroides*), and St. John's wort (*Hypericum* 'Hidcote'). Right: Mexican bush sage (*Salvia leucantha* 'Midnight') and Pacific Island silver grass (*Miscanthus floridulus*) soothe the senses.

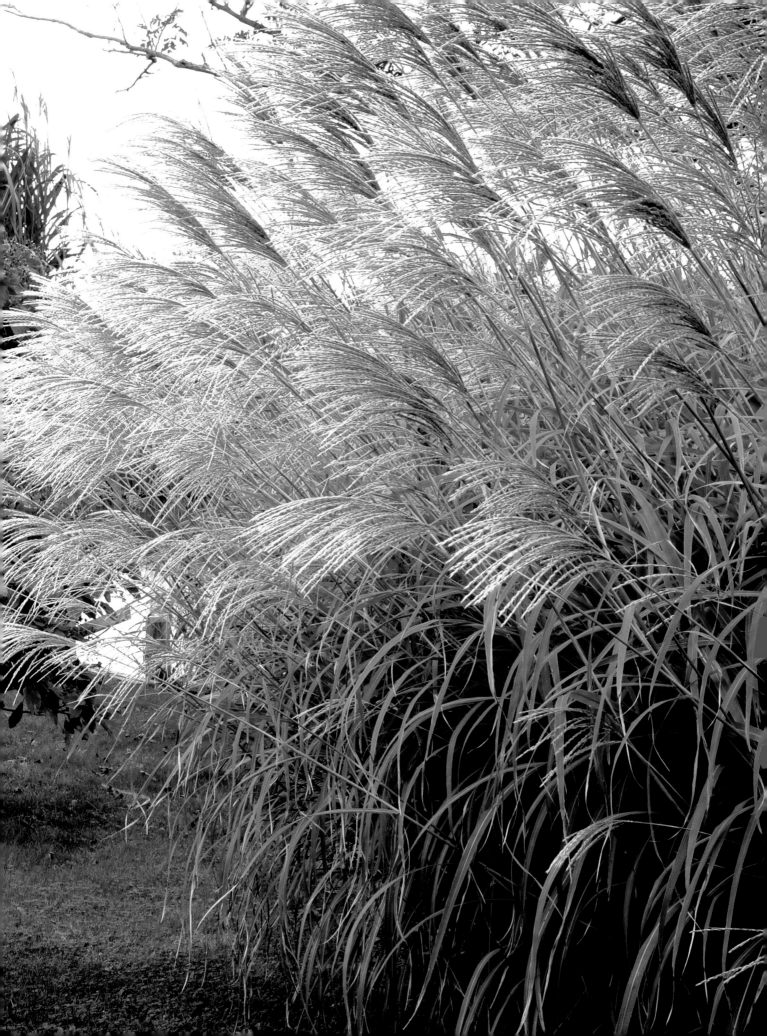

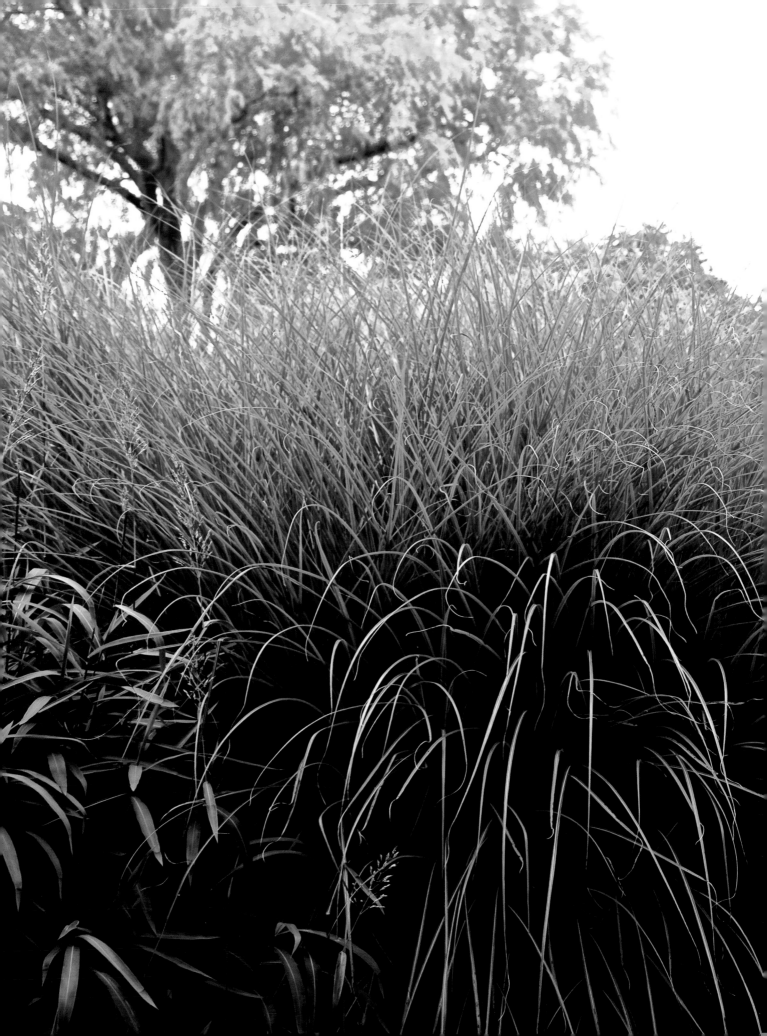

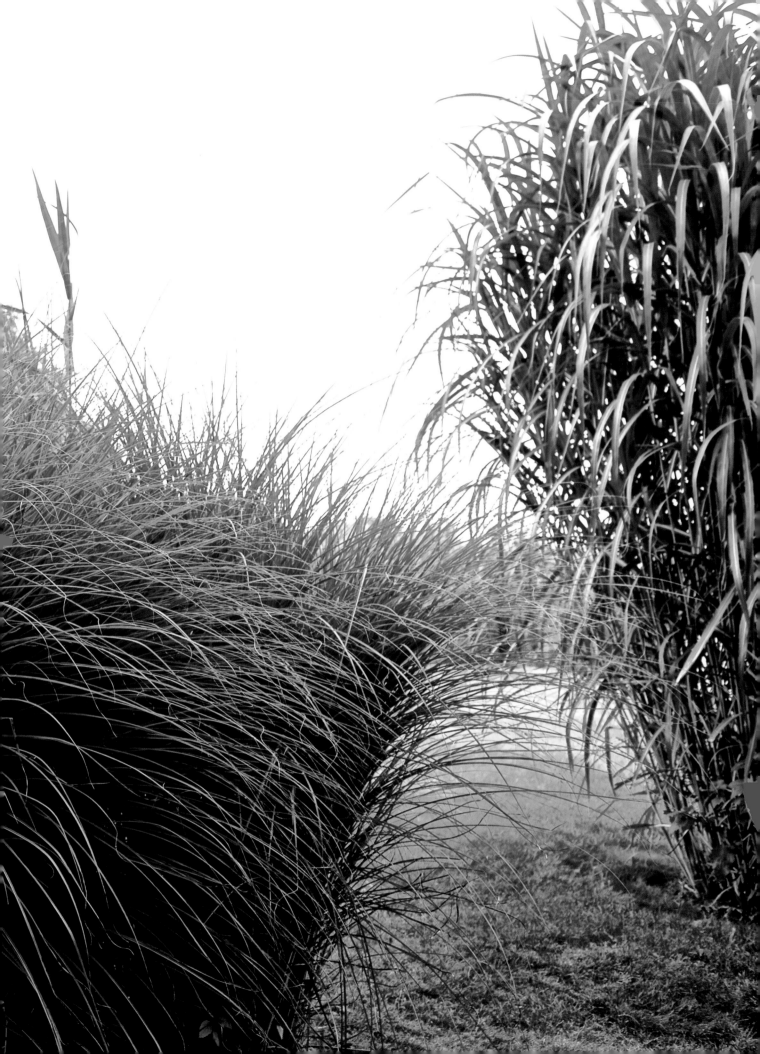

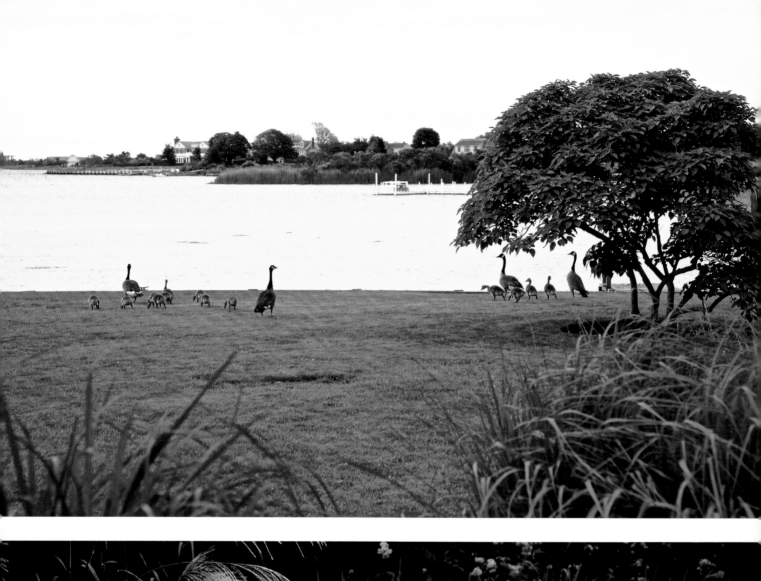
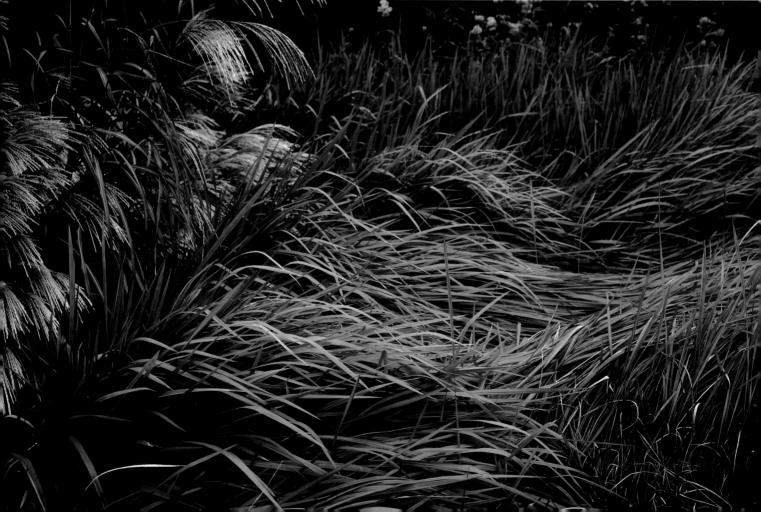

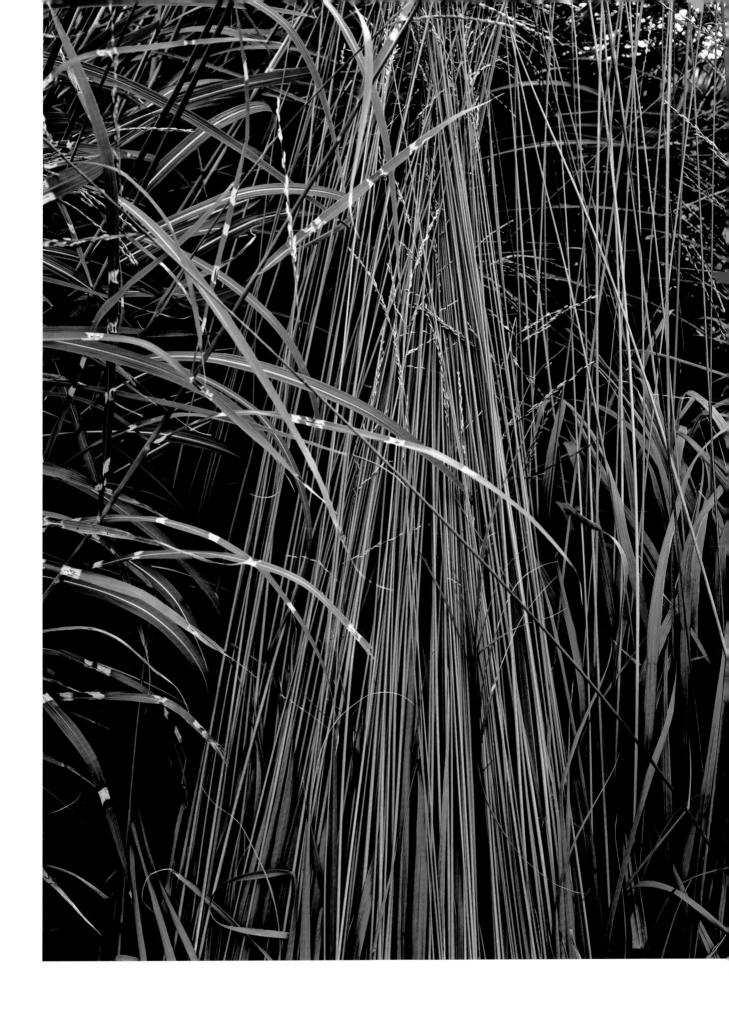

Sunset on Mecox Bay and the movement and
texture provided by a variety of grasses.

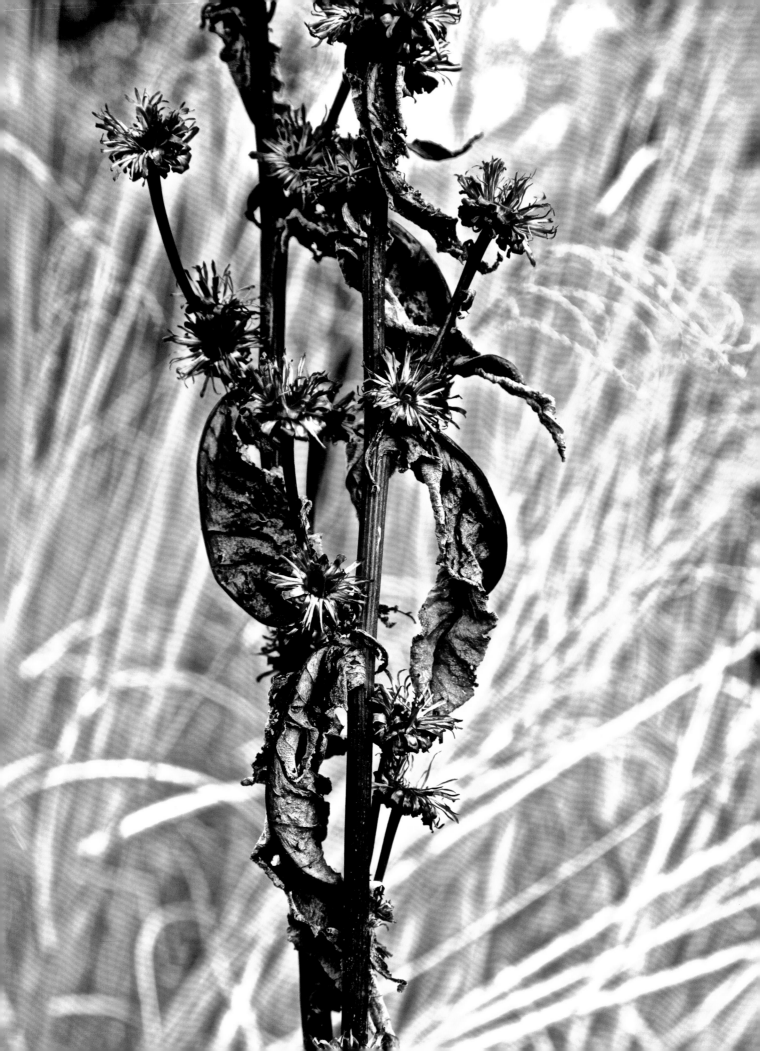

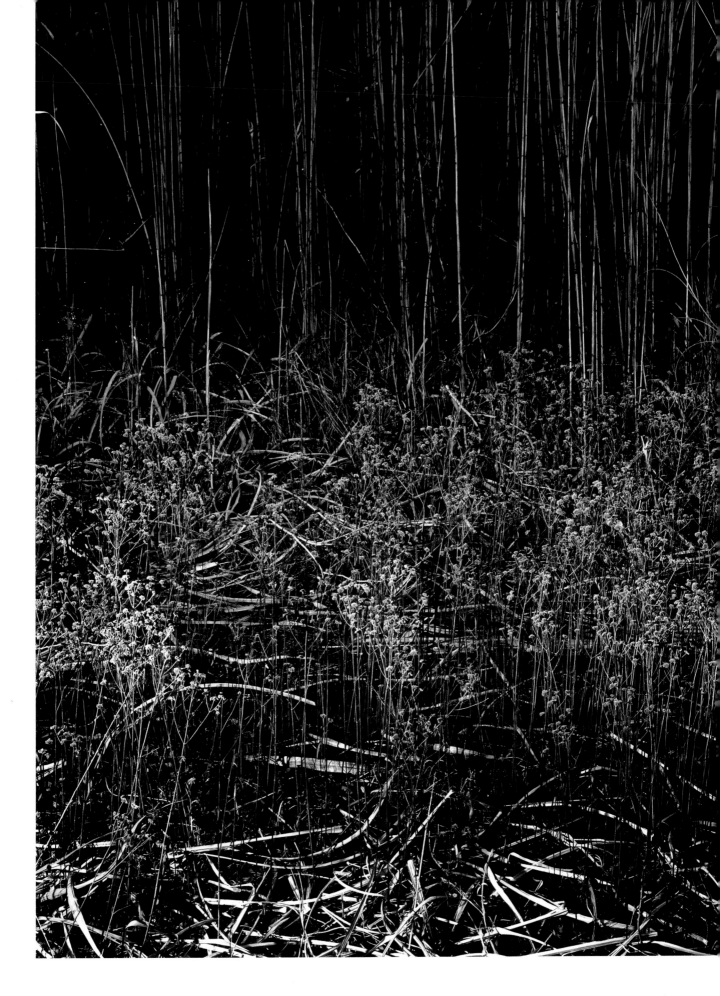

Winter grasses engage the eye
with texture and color like Jackson
Pollock abstract paintings.

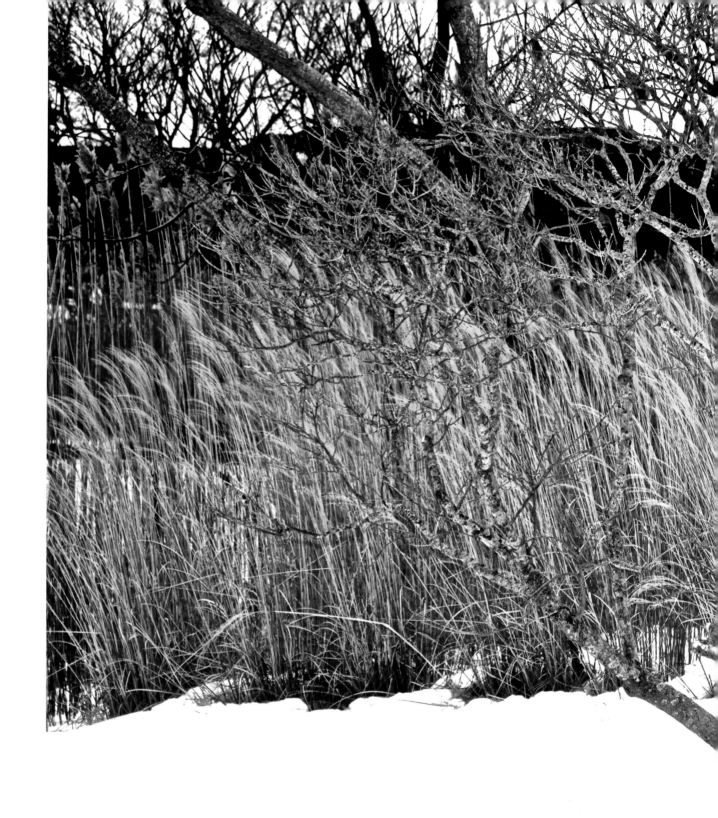

Ox eye (*Heliopsis helianthoides* var. *scabra*),
eulalia (*Miscanthus sinensis* 'Strictus'),
and Frikart's aster (*Aster x frikartii* 'Monch')
express the changing palette of the passing
seasons, pleasing the eye and maintaining our
connection to nature.

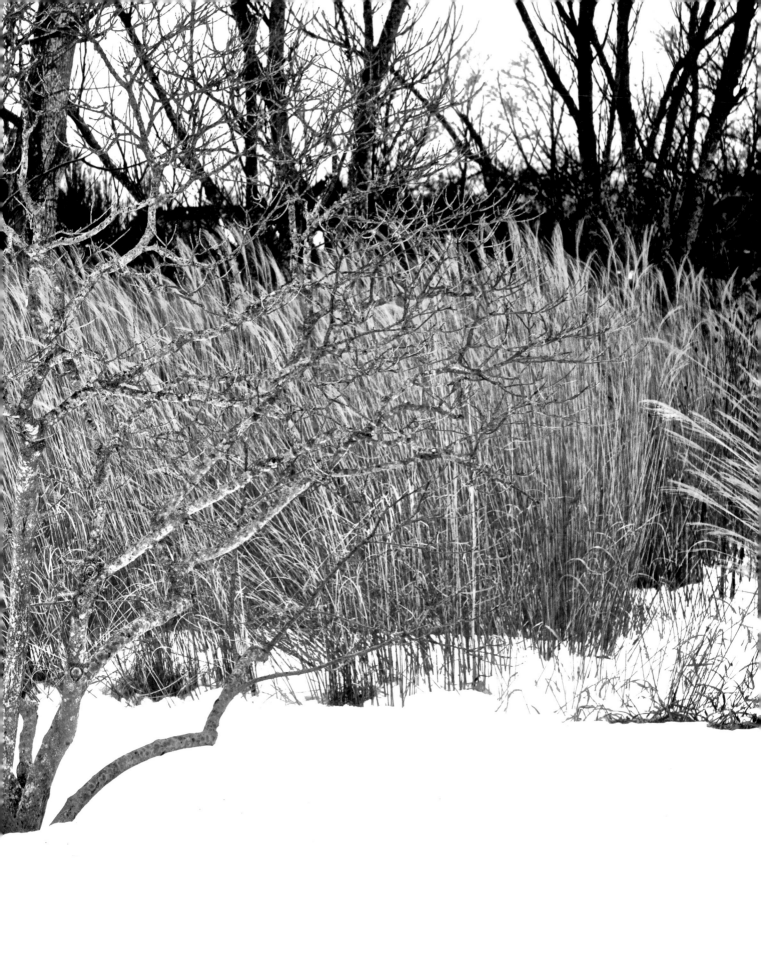

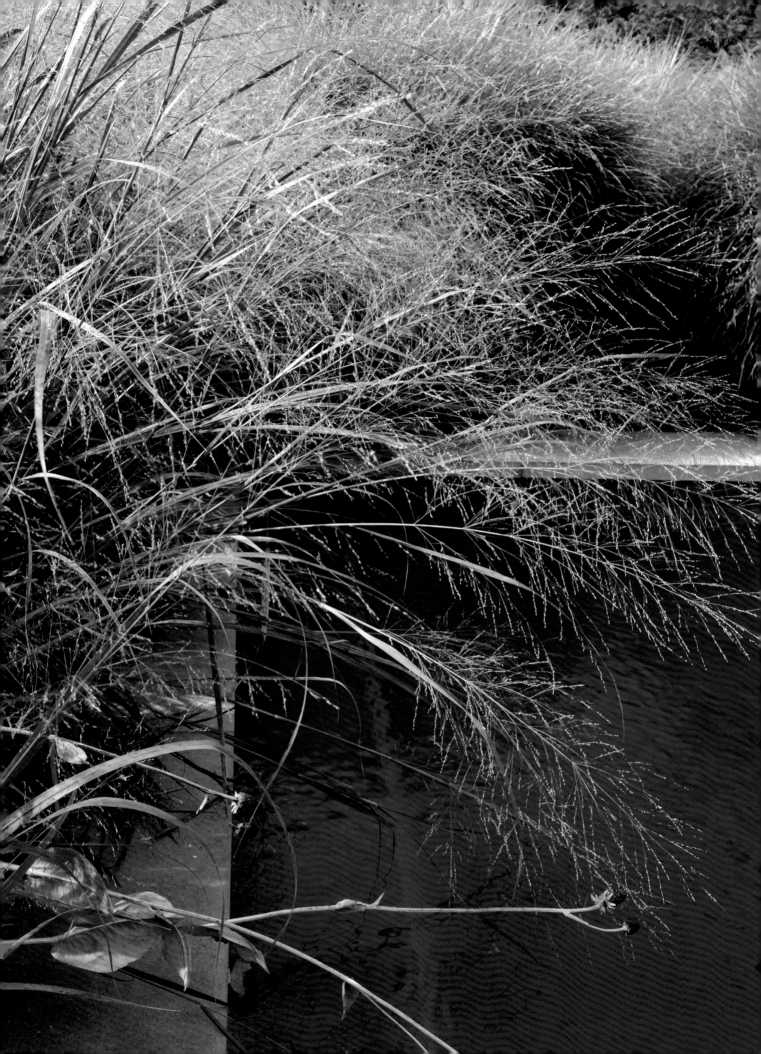

A Place to Gather

EAST HAMPTON, NEW YORK

When this garden's owner purchased the two-acre property that was to be her family home on the east end of Long Island, she described the existing site as a jungle of overgrown cedars with a kidney-shaped pool in the backyard that she called a bathtub. But just across the road was a scenic easement and protected marshland with a lovely view of Accabonac Harbor. As Eric Groft of Oehme, van Sweden (OvS) put it, "The site is uniquely situated between farms and horse paddocks on the inland side and meadows and wetlands on the harbor side. Our design goal was to merge these elements into a cohesive, sustainable design."

A key challenge was to screen out the road traffic just in front of the house without sacrificing the view. Ornamental grasses, a signature of OvS design, provided the ideal solution, while also deterring the persistent encroachment of the local deer population. Within the site, Eric unified the property by installing a rustic pathway between the main house—parts of which go back to the 1770s—a driveway, which was moved back and disguised by an arbor, and a sixty-foot rectangular pool, among other elements. The pool feels more like a pond encountered in a meadow, the way it's surrounded by a patchwork of sweeping grasses and perennials.

In selecting plantings for the garden, the focus was on a rich palette of primarily green, gold, and purple shrubs, perennials, and grasses that flourish in the microclimate. Annuals appear only in pots. The owner also loves *Calycanthus*, or sweetshrub, so there are many varieties from America and her native Italy. Wherever possible, Groft left mature plantings like old elms (*Ulmus*), flowering dogwoods (*Cornus florida*), and black locusts (*Robinia pseudoacacia*) in place, giving the landscape a more established presence. In addition to signature OvS

perennials (*Agastache, Pycnanthemum, Nepeta, Geranium*) and grasses (*Pennisetum, Panicum, Calamagrostis*), the garden's owner insisted on incorporating fruits and vegetables like figs, rhubarb, tomatoes, basil, blackberries, and raspberries throughout the garden.

From the fire pit to the swimming pool to the outdoor dining table and the porch, there are places to sit, converse, and eat under a calm, beautiful light. It is an easeful place to gather, where the design is evident in the year-round sense of warmth and inclusion.

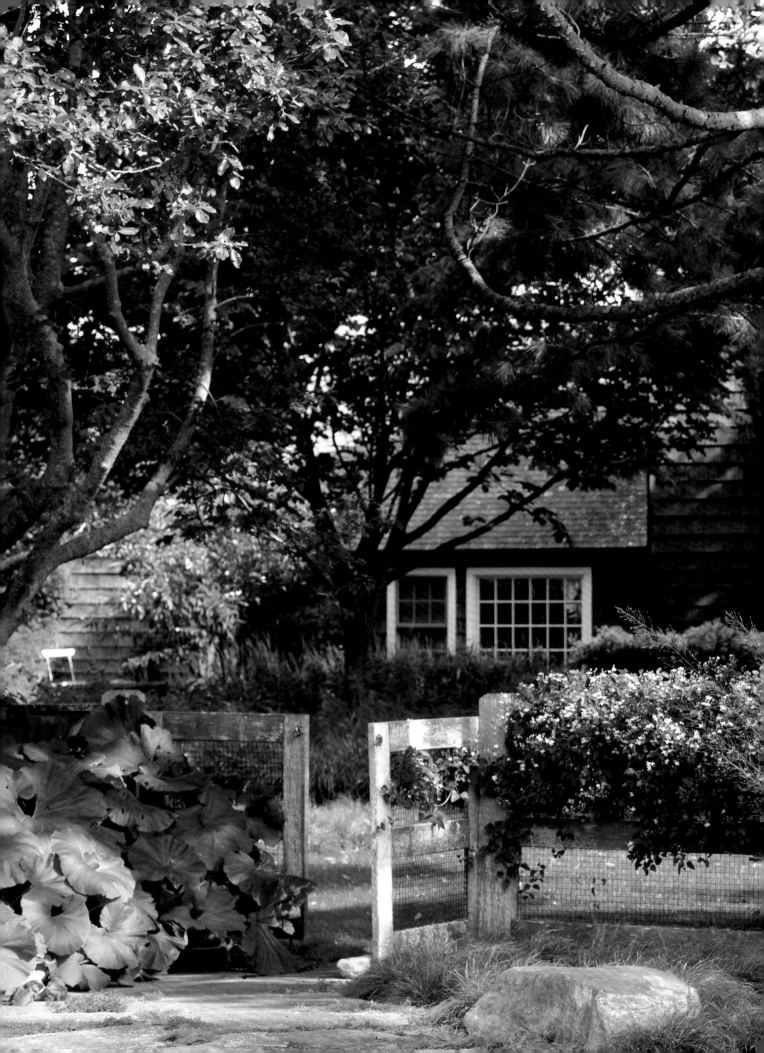

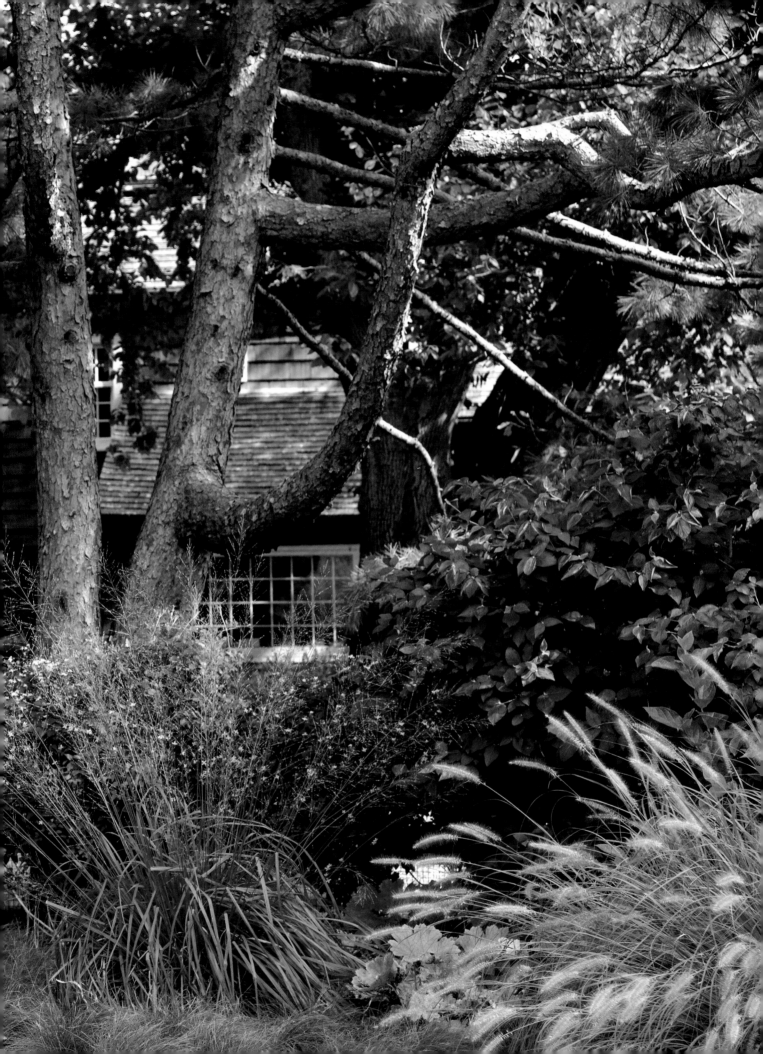

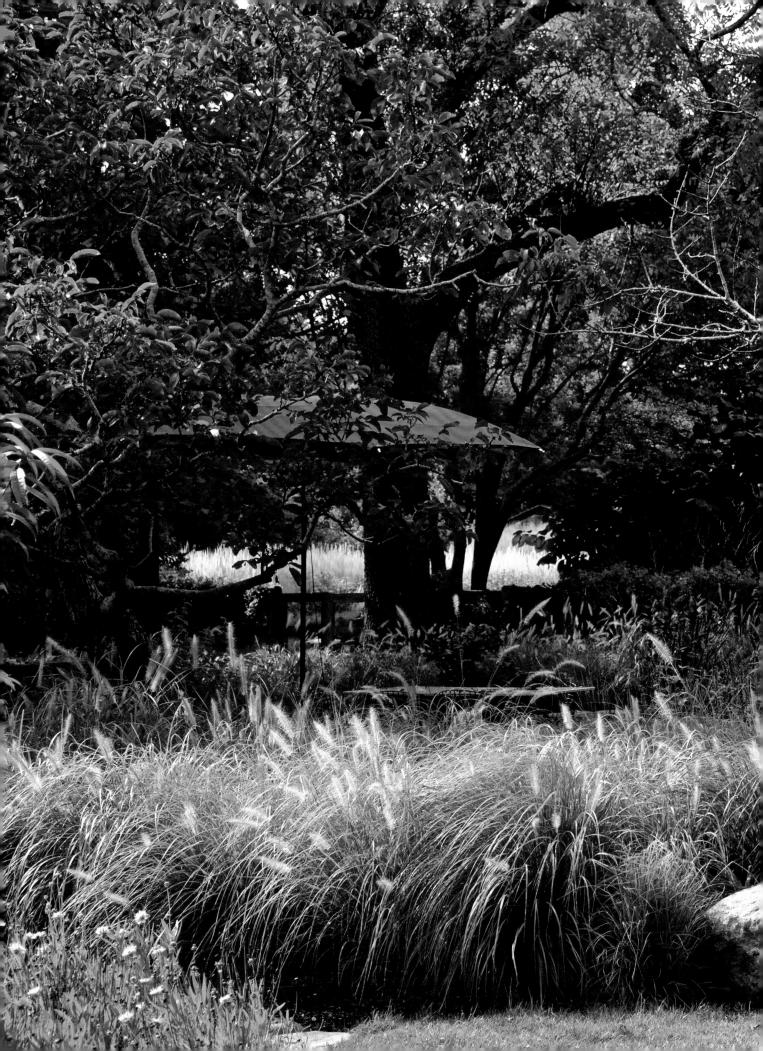

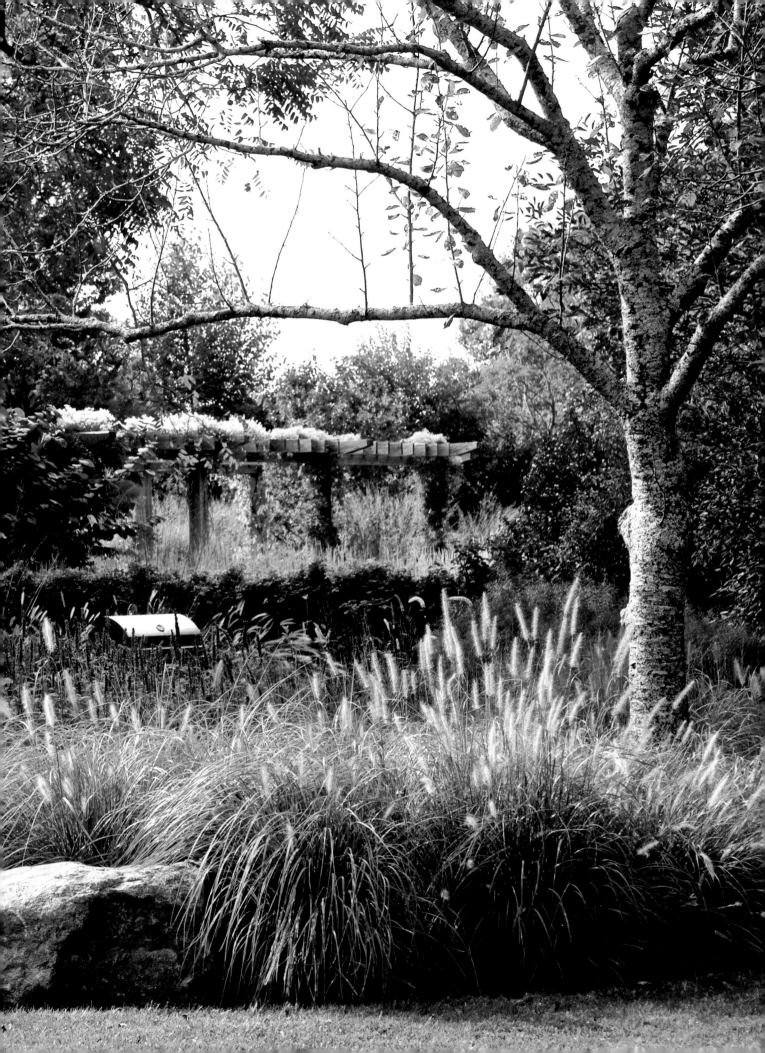

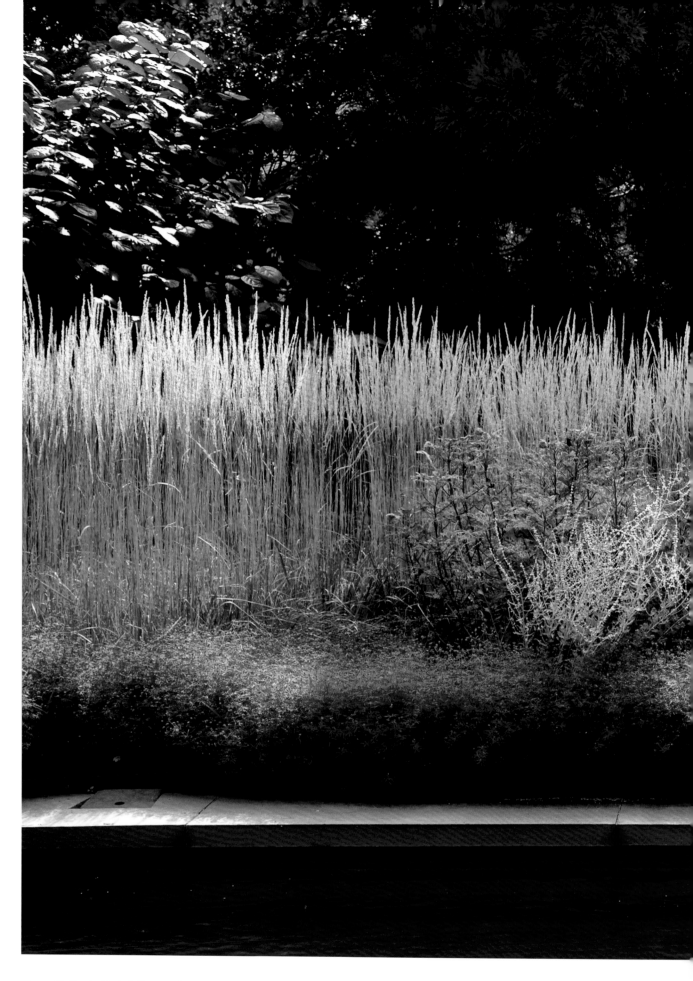

The pool is lined with dark tiles to enhance reflections, and its wide steps invite poolside confabs among the plantings of feather reed grass (*Calamagrostis x acutiflora* 'Karl Foerster'), Russian sage (*Perovskia atriplicifolia*), threadleaf coreopsis (*Coreopsis verticillata*), and hibiscus (*Hibiscus moscheutos*) leaning over the coping.

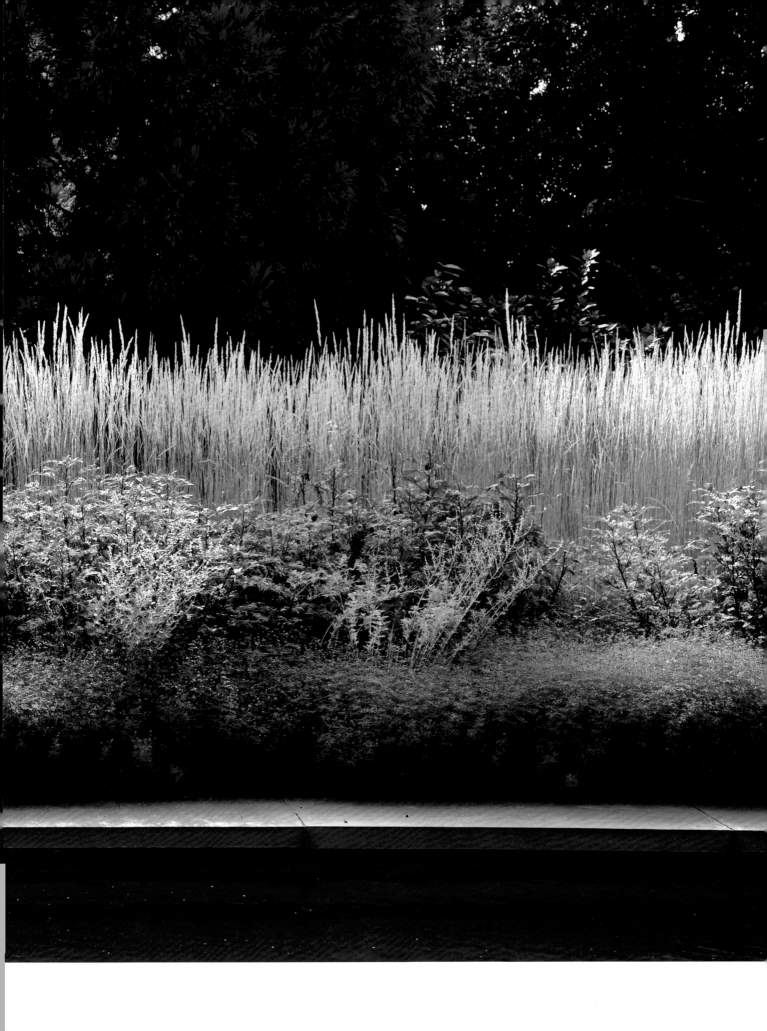

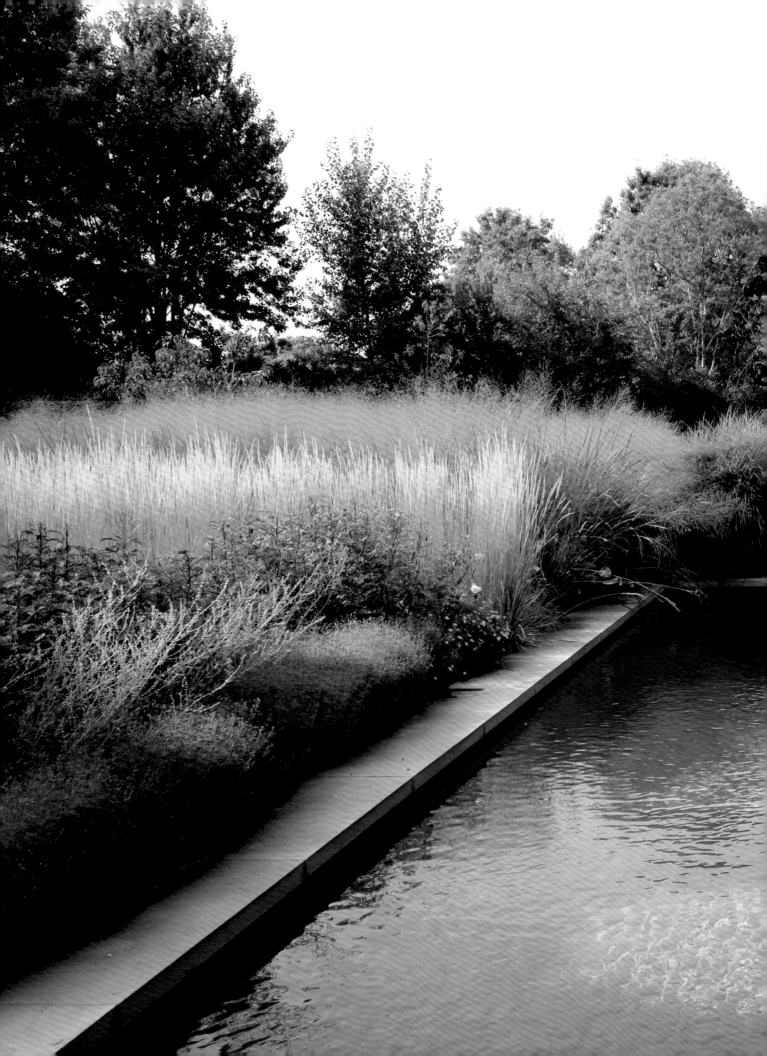

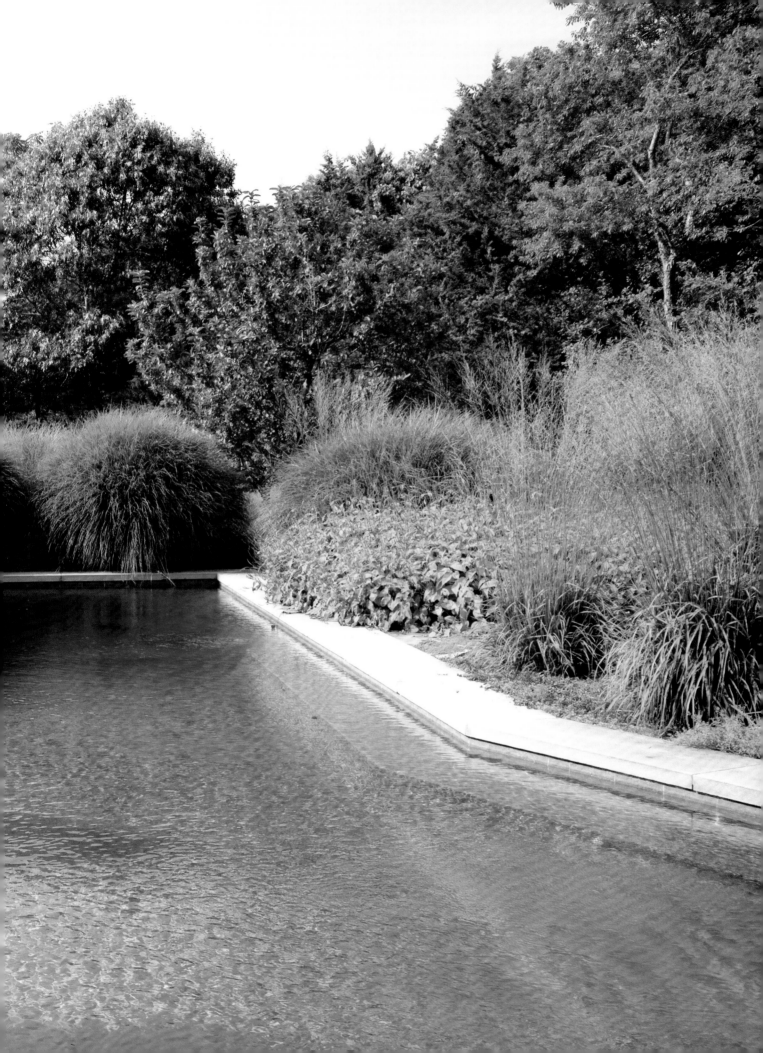

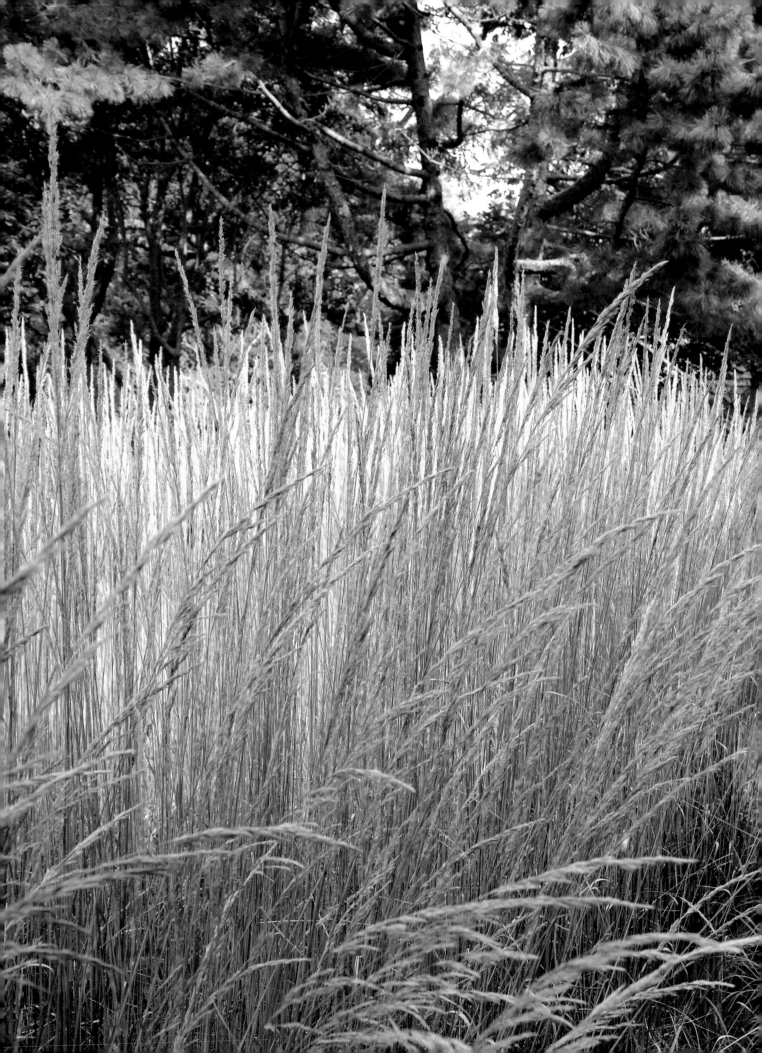

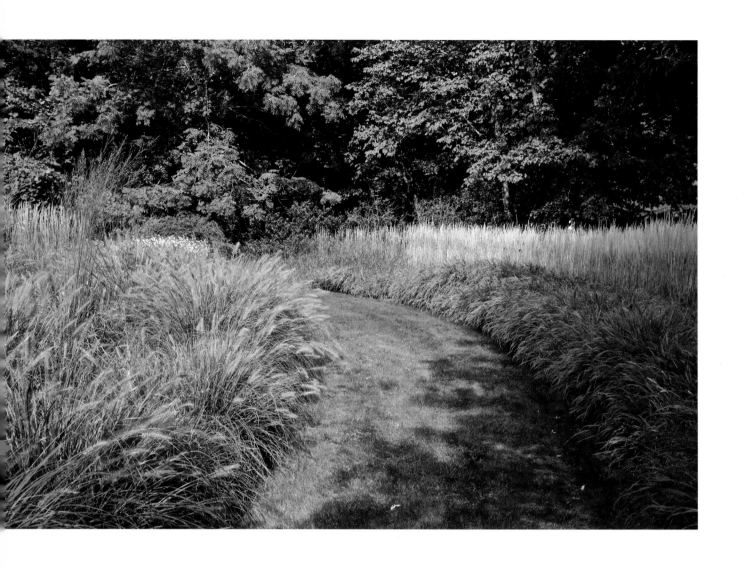

Generous swaths of fountain grass
(*Pennisetum alopecuroides*) and feather
reed grass (*Calamagrostis x acutiflora*
'Karl Foerster') honor the vernacular of field and forest with low-maintenance
perennials like threadleaf coreopsis
(*Coreopsis verticillata*) and hibiscus
(*Hibiscus moscheutos*).

Parts of the home, a farmhouse in
its previous life, date back to 1770.

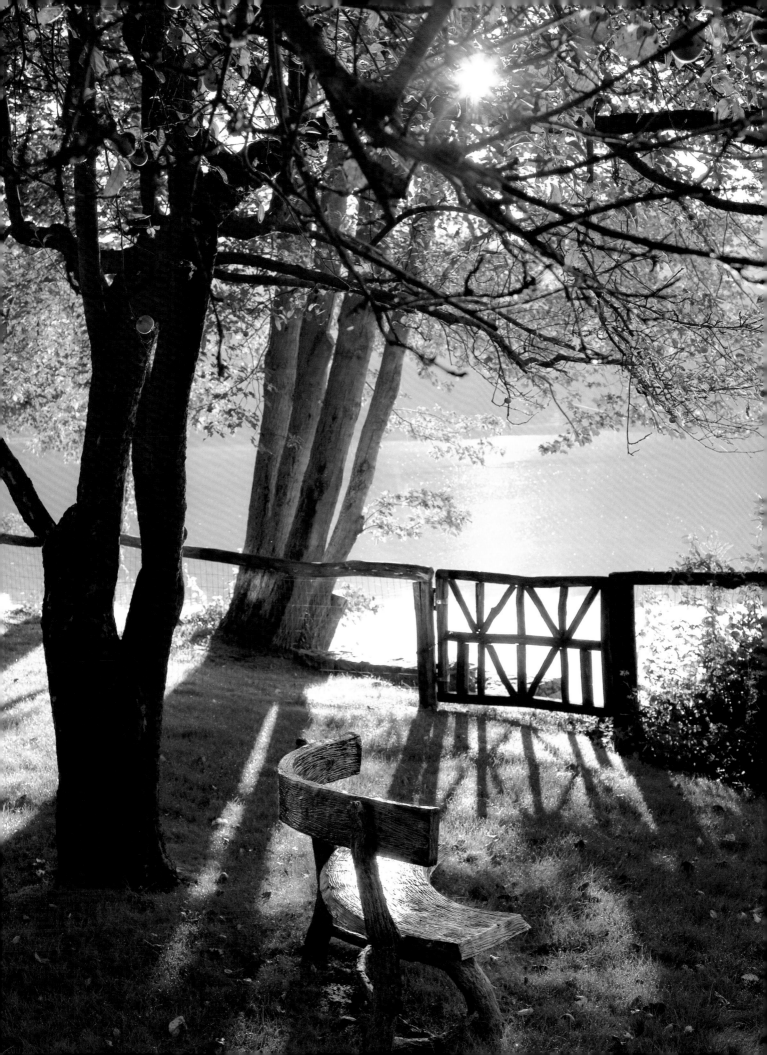

A Tapestry for the Senses

NORTH SALEM, NEW YORK

A lifelong gardener who has been a professional horticulturist and landscape designer for the past ten years, Kathy Moreau looks to bring people closer to nature through her designs, so that they can become better stewards of the land. It's her way to contribute to a more sustainable lifestyle.

Kathy found a client very much in line with her gardening philosophy on a placid lakefront property in New York's Lower Hudson Valley. Though ultimately she designed and refreshed several gardens on the quiet and peaceful expanse of the grounds, her first project was to build a garden to frame a narrow rectangular pool situated between the owner's home and the lake just a short stroll away. The challenge was to create a design that wouldn't obstruct the lake view. What Kathy found was a way to enhance an already resplendent panorama.

The solution was to create a fully walkable garden—literally a garden people can walk on. The plants Kathy selected form soft mounds that delight bare feet; the stepping stones only suggest a path through the garden. Up close, there is tremendous texture and detail to the plants and the patterns in which they have been planted. It's a garden that appeals to all the senses. In perspective, the garden "appears as a natural tapestry that lies along the horizon, blending with the view beyond." Even the existing stone coping around the pool shows variety and texture, joining river rock with rectangular slabs of stone.

Historically there have been gardens inspired by patterns in textiles and tapestry, expressed primarily through annuals; but Kathy was instead moved to plant low-growing perennials and herbs. And while there are still pockets of annuals like vinca to bump up the color throughout the summer when the garden shows best, the sedum and thyme retain some of their color even in winter.

Throughout the property Kathy has been replacing invasive plants with new native or environmentally responsive plantings. She employs a mix of native and exotics, always striving "for sustainable in the sense that they attract pollinators and do not require a lot of extra water or nutrients." As she has learned over the years, it takes time to understand the lasting impact of gardens. "With every garden," she says, "you have a chance to do more than provide a practical solution—for example, something pretty to look at, or screening from a neighbor. The best landscape design does that and more: it should be environmentally responsive and also artistic to fully engage both the people lucky enough to enjoy the garden and the breadth of other living things that depend on it."

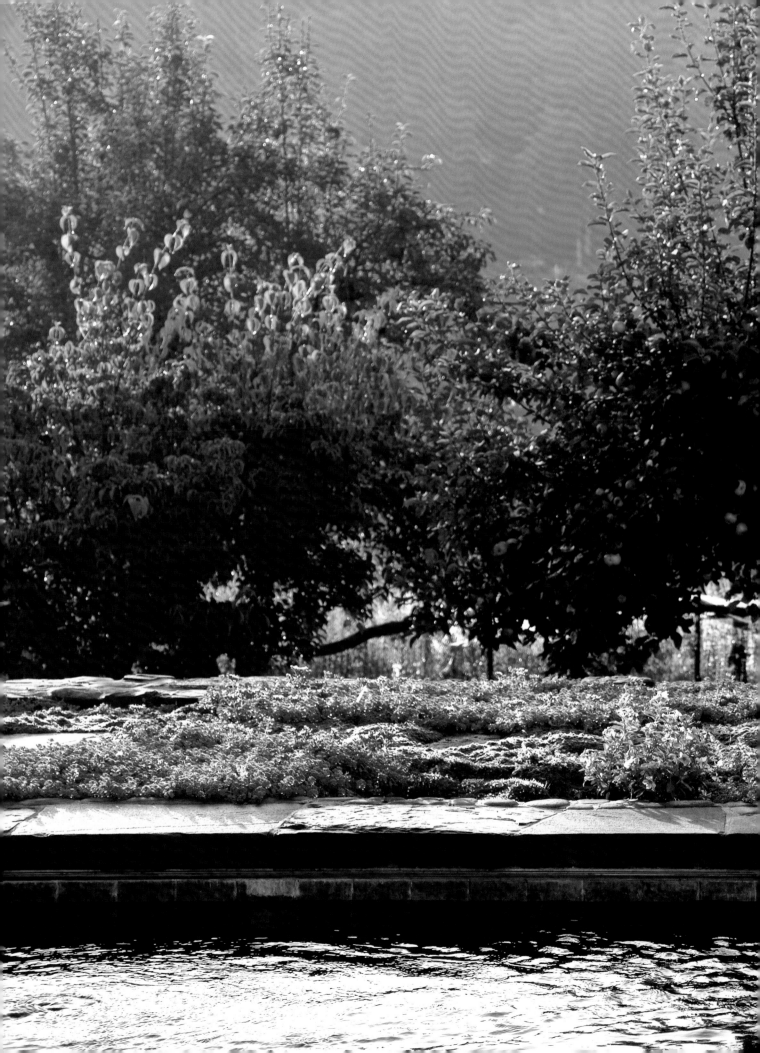

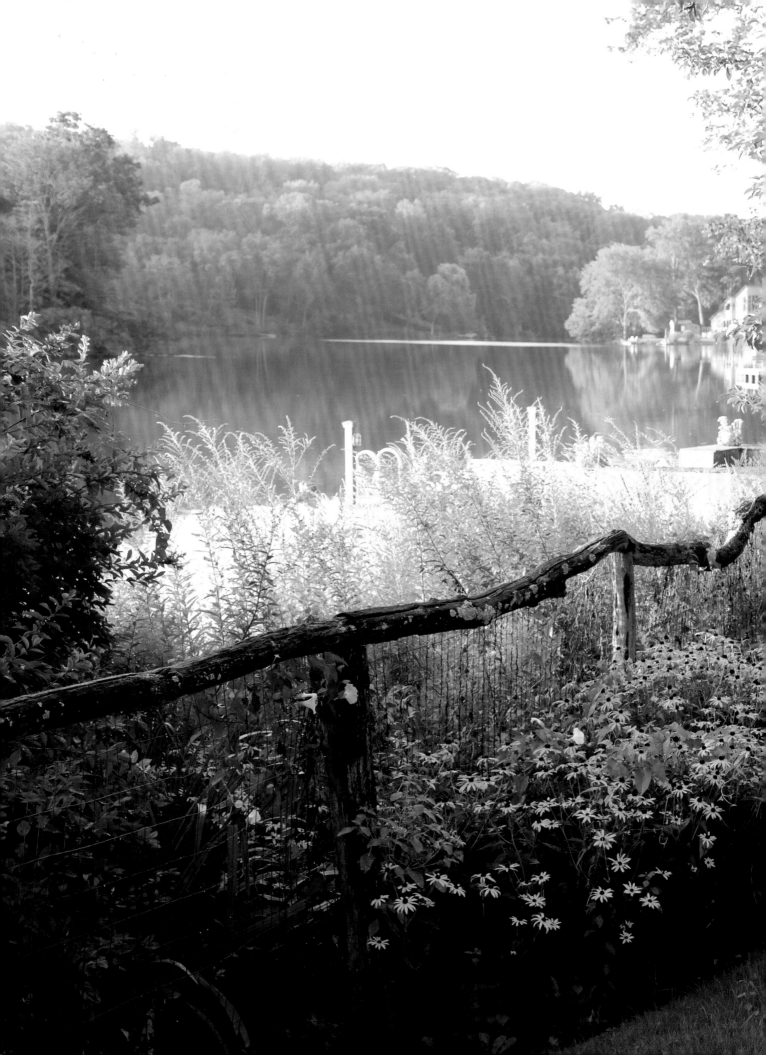

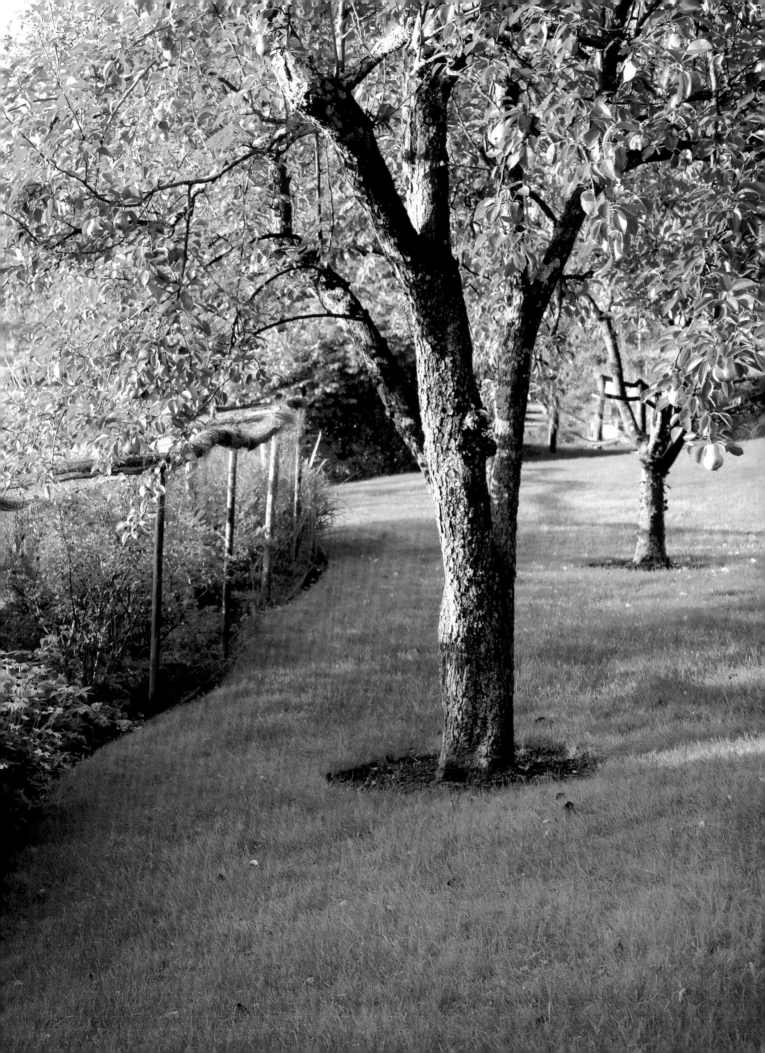

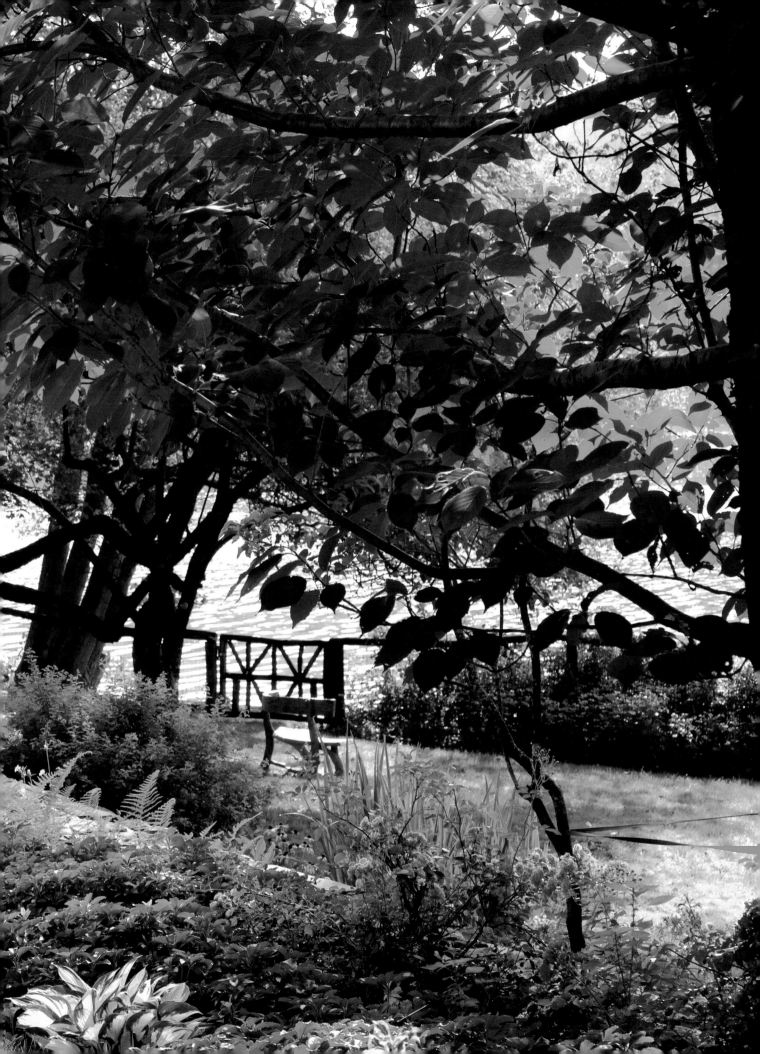

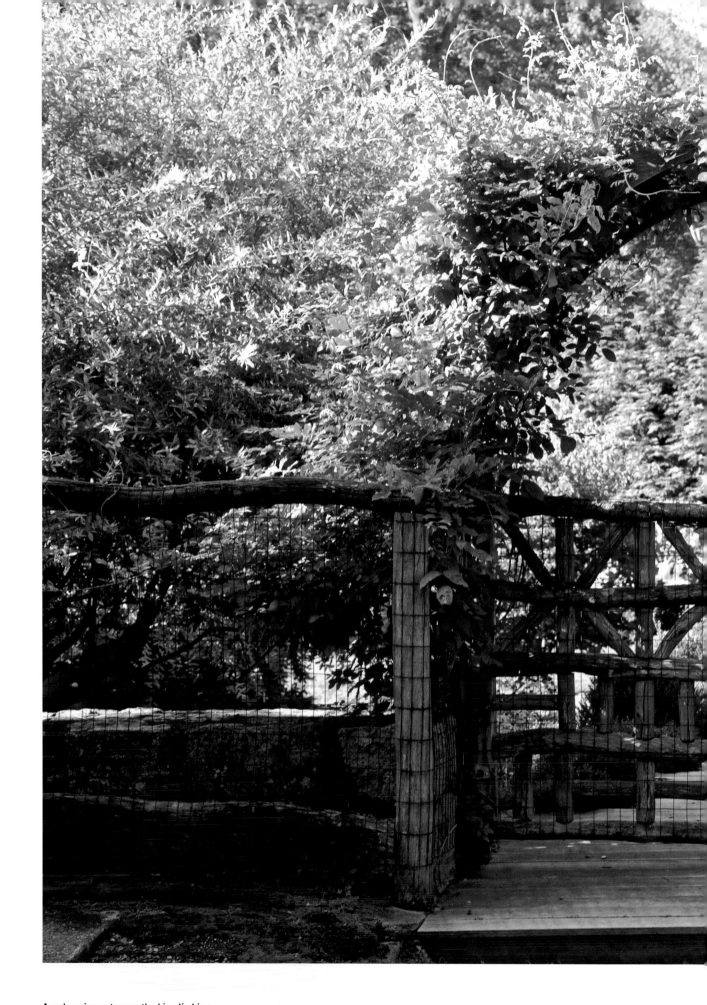

A welcoming gate wreathed in climbing
hydrangea (*Hydrangea anomala petiolaris*)
and clematis (*Clematis* 'Jackmanii').

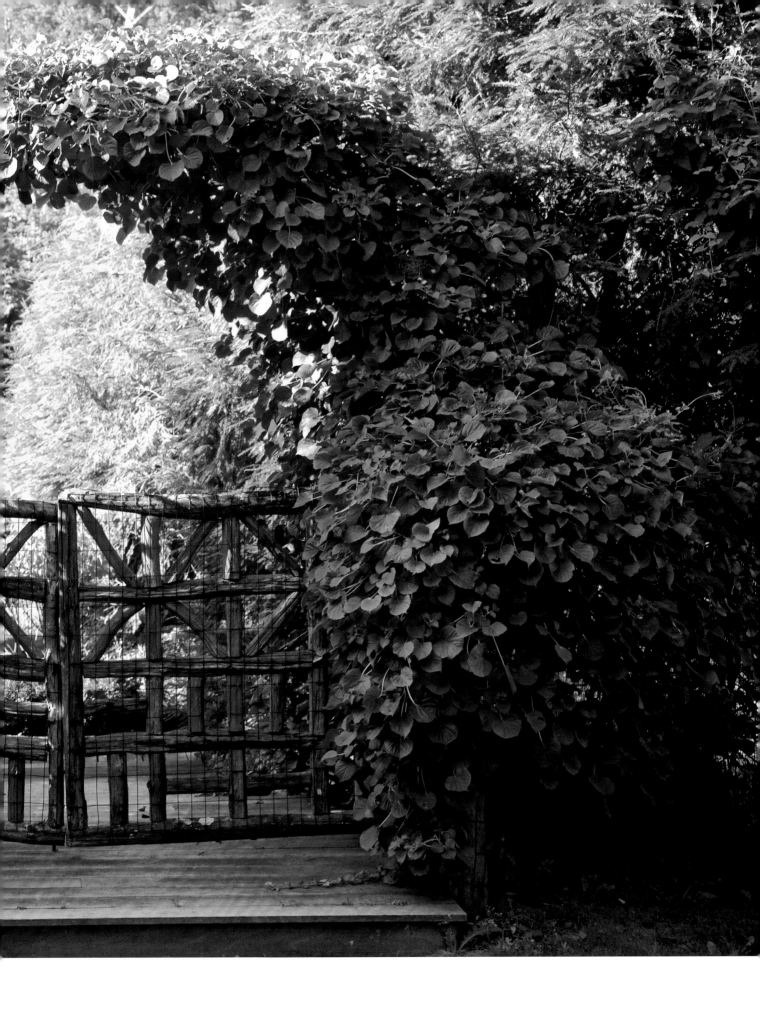

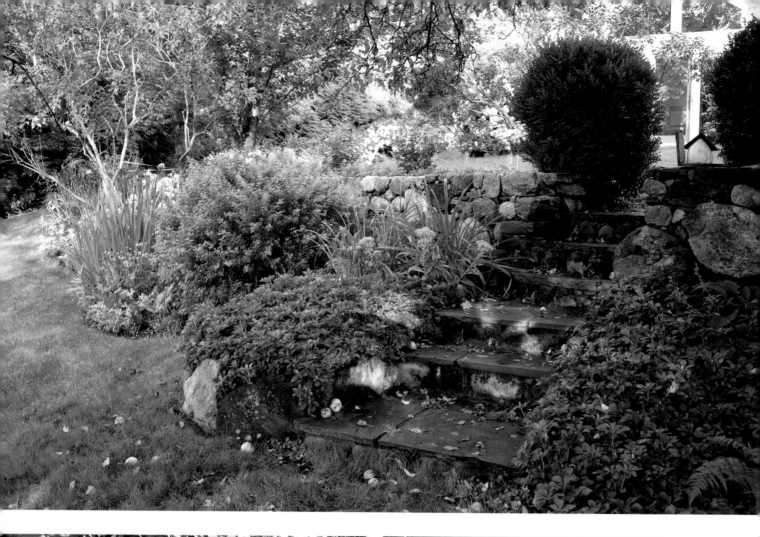

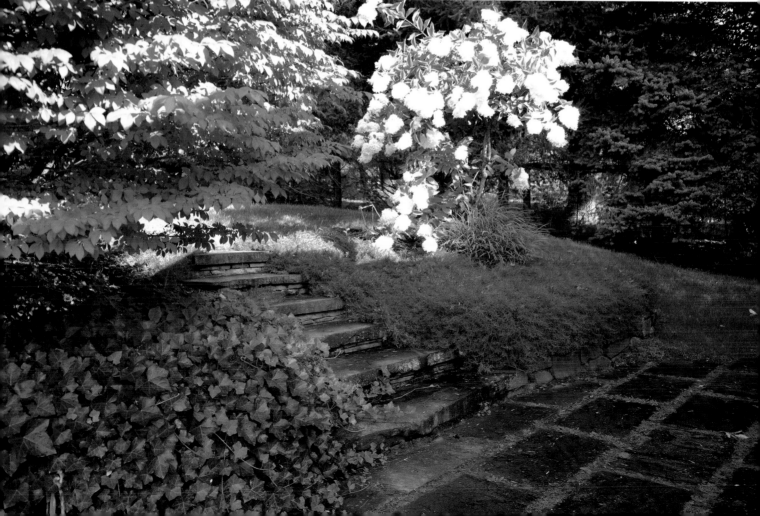

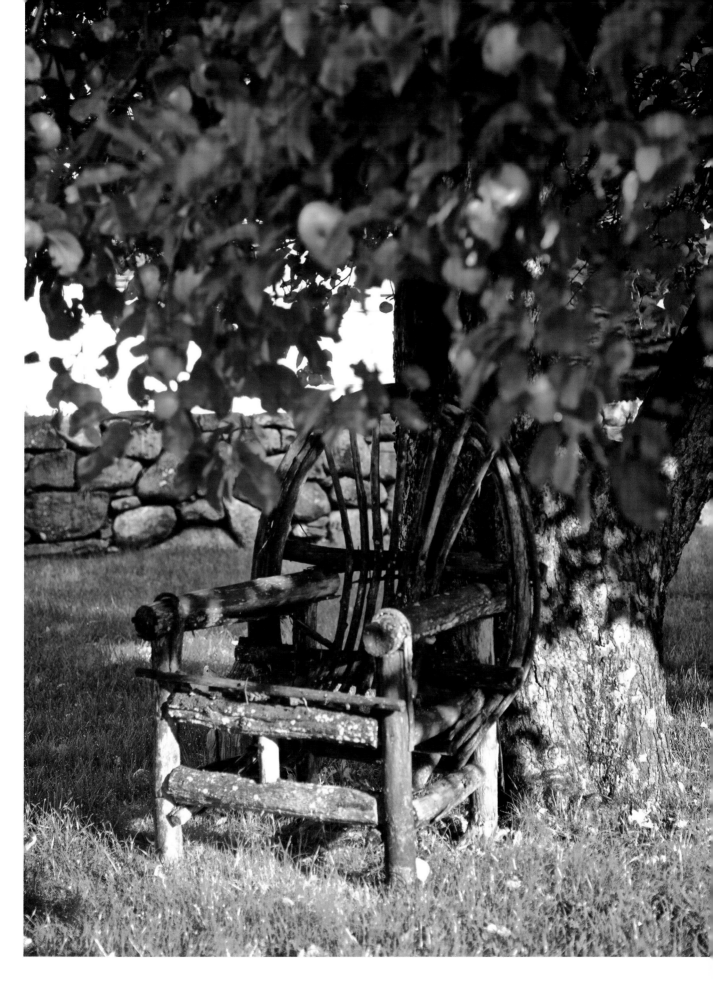

Opposite: Spirea and boxwood (*buxus*) line the native stone steps; perennials include roses flowering in the background, black-eyed Susans (*Rudbeckia hirta*) and Daylilies (*hemerocallis*), while pachysandra provides ground cover and Limelight Hydrangea shimmers in sunlight. Above: A venerable apple tree shades a weathered, rustic chair.

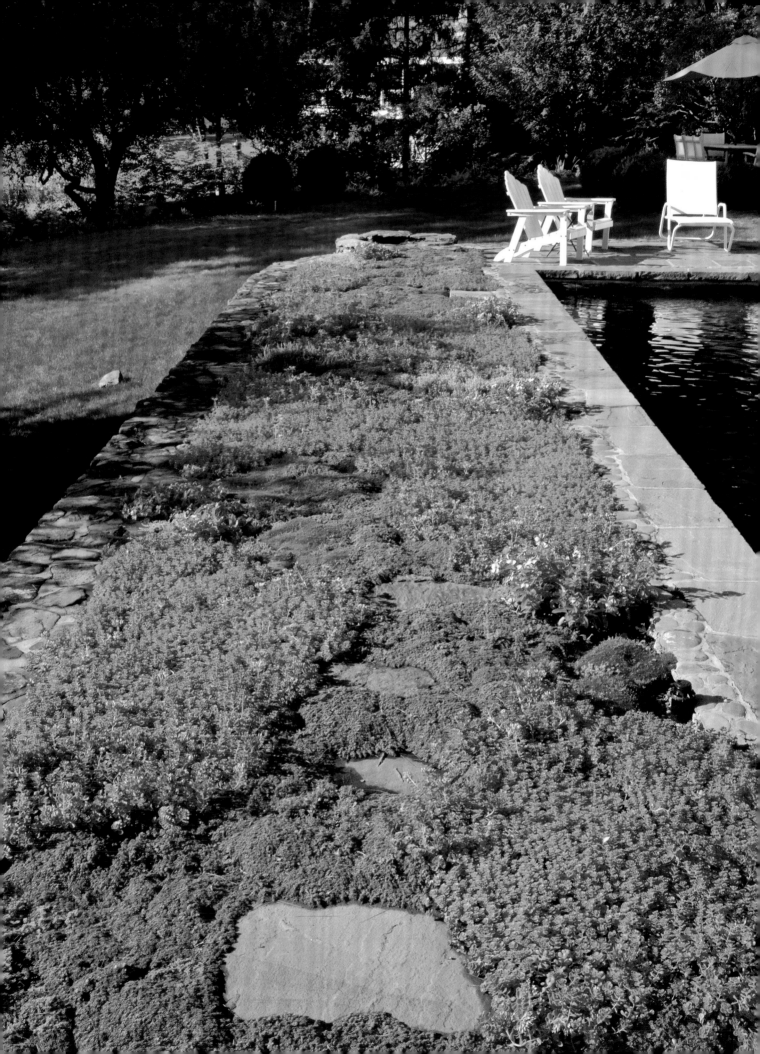

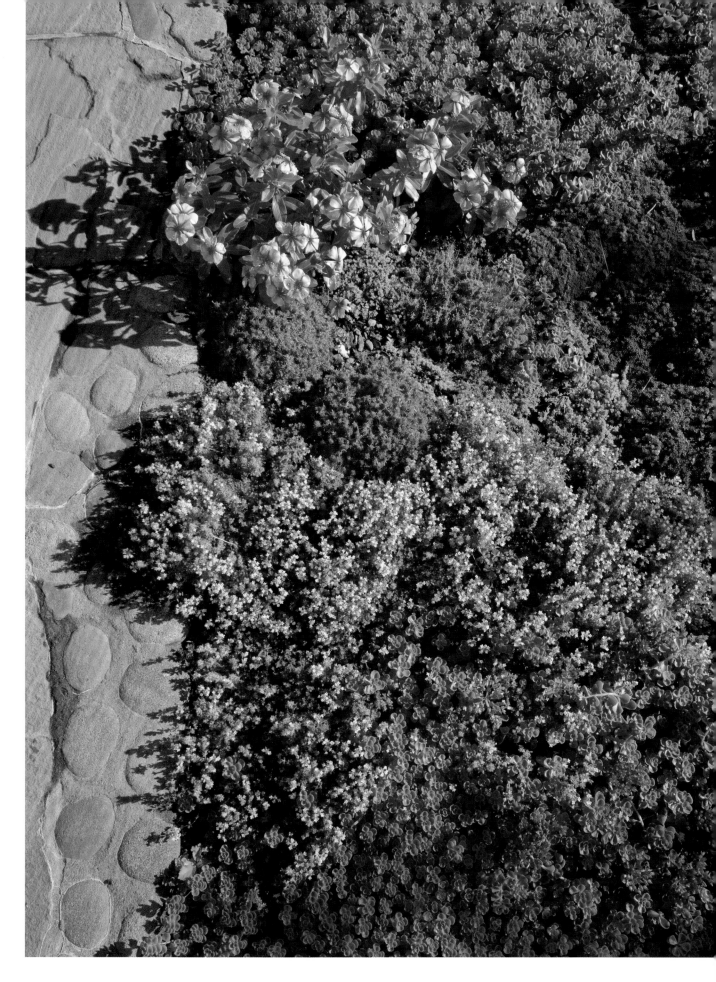

Barefoot bliss on groundcover like *Sedum* 'John Creech', *Thymus* 'Elfin', *Thymus* 'Highland Cream', Irish moss (*Sagina subulata*), and periwinkle (*Catharanthus roseus*).

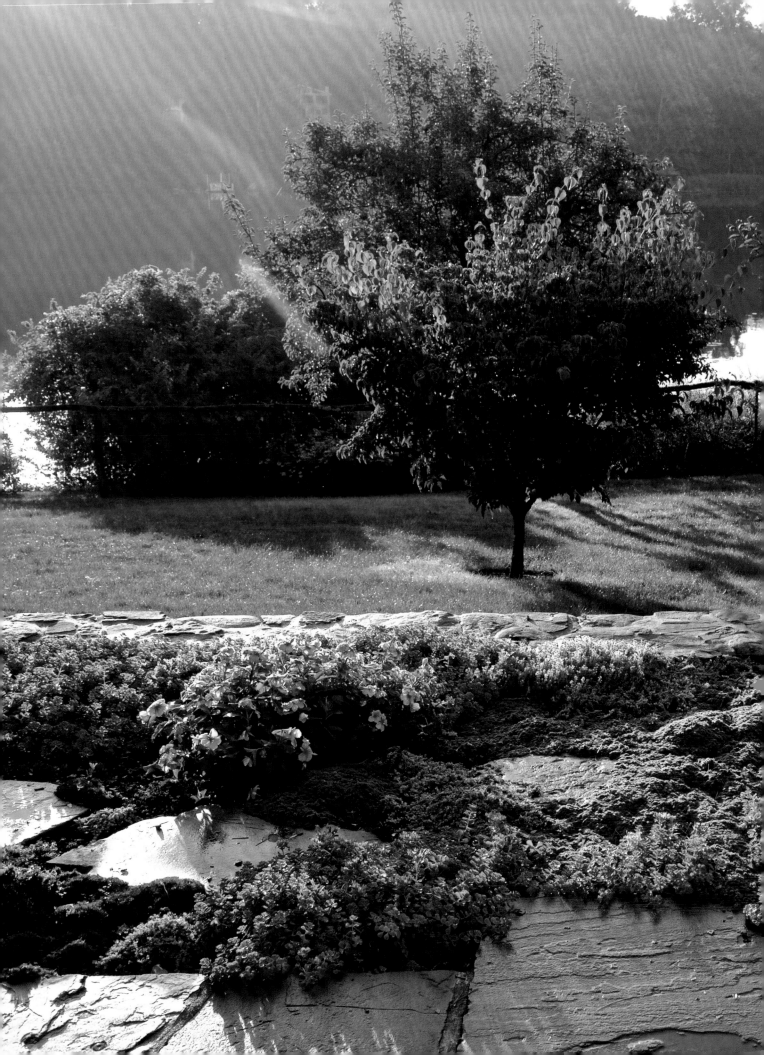

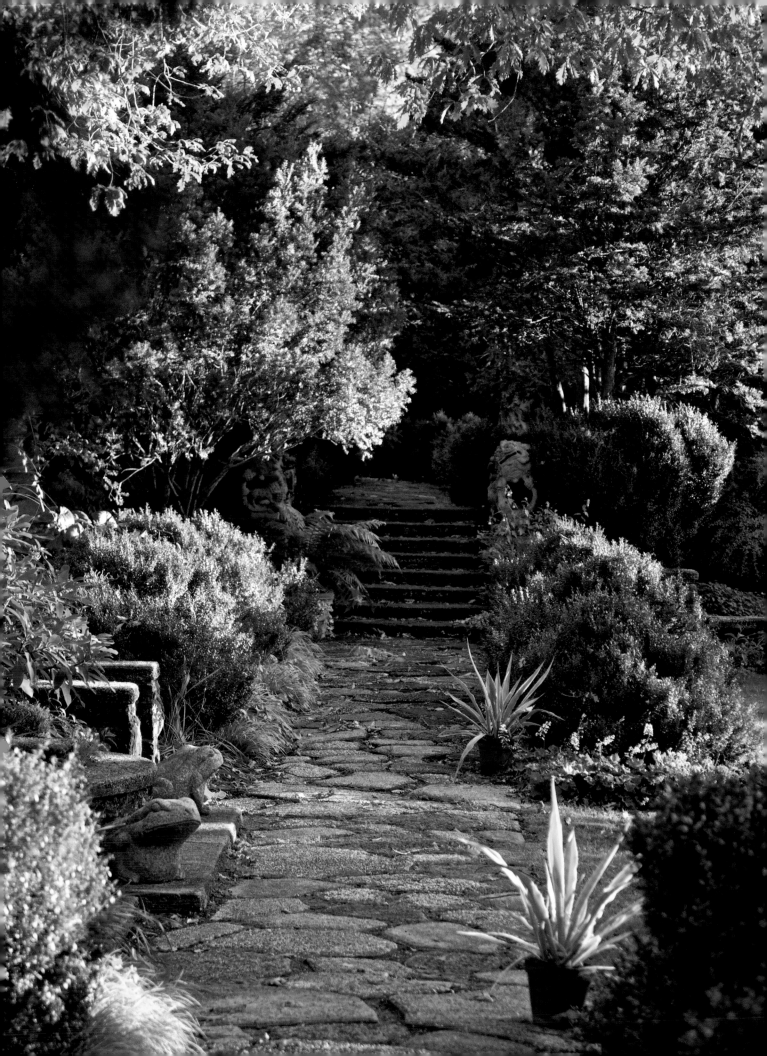

A Jewel in the Moss

SHORT HILLS, NEW JERSEY

Surrounded by 2,100 acres of preserved parkland located in the heart of suburbia, Greenwood Gardens boasts a variety of different landscapes within its twenty-eight painterly acres. Inside its deer-fenced purview, visitors encounter formal and rustic gardens, forest, meadows, and ponds, as well as farming areas, which presently harbor chickens, geese, and goats.

First established as a private estate shortly before World War I, the grounds became a public garden in 2002 under the guidance of conservationist Peter P. Blanchard III, who was fortunate enough to grow up on the property, which was purchased by his father in 1949. While much of the original garden design and architectural elements by William Renwick remain, the initial formality of the garden has given way, intentionally, to a sense of paradise regained. One can wander through Italianate water gardens, rustic stone summerhouses, long allées of majestic plane trees (*Platanus*), wildflower meadows, and pristine woodlands, and it is interesting to note that there is a staff beekeeper on hand to manage hives of honeybees that help maintain the garden's ecosystem. Peter explains, "We advocate selecting plants not only for their beauty, historic relevance, and botanical interest, but for the exploration of nature's intricacies and interconnections. Gardens should address the major concerns (or at the very least, raise awareness) of the critical problems of our age, including global warming, adjustment of flora and fauna to habitat shift and sea-level rise, environmental pollution, and the development of fossil-free energy."

Situated on the flanks of the second of three Watchung Mountains, the varied and gently undulating landscape lends itself to the various pathways, terraces, and overlooks of the garden that, as Peter notes, "carry visitors into another realm." The formal greenery of boxwood (*Buxus sempervirens*) and yew (*Taxus baccata*) endures, and flowering plants have regained their prominence after decades of absence. The various allées of Norway spruce (*Picea abies*), London plane trees (*Platanus x acerifolia*), and red maple (*Acer rubrum*) are hallmarks of changes that were made to the site under its second owner. At the outer edges of the garden, one can find native trees and shrubs, including the sugar maple (*Acer saccharum*), tulip tree (*Liriodendron tulipifera*), oak (*Quercus*), hickory (*Carya*), native dogwood (*Cornus*), and native azalea.

Like most gardeners, Peter has learned to roll with the punches. He acknowledges, "There will be many delivered both by Mother Nature and humankind." The result is a secret garden once referred to by the *New York Times* as "a jewel in the moss," where nature, horticulture, and artistry combine to perform both magic and revelation.

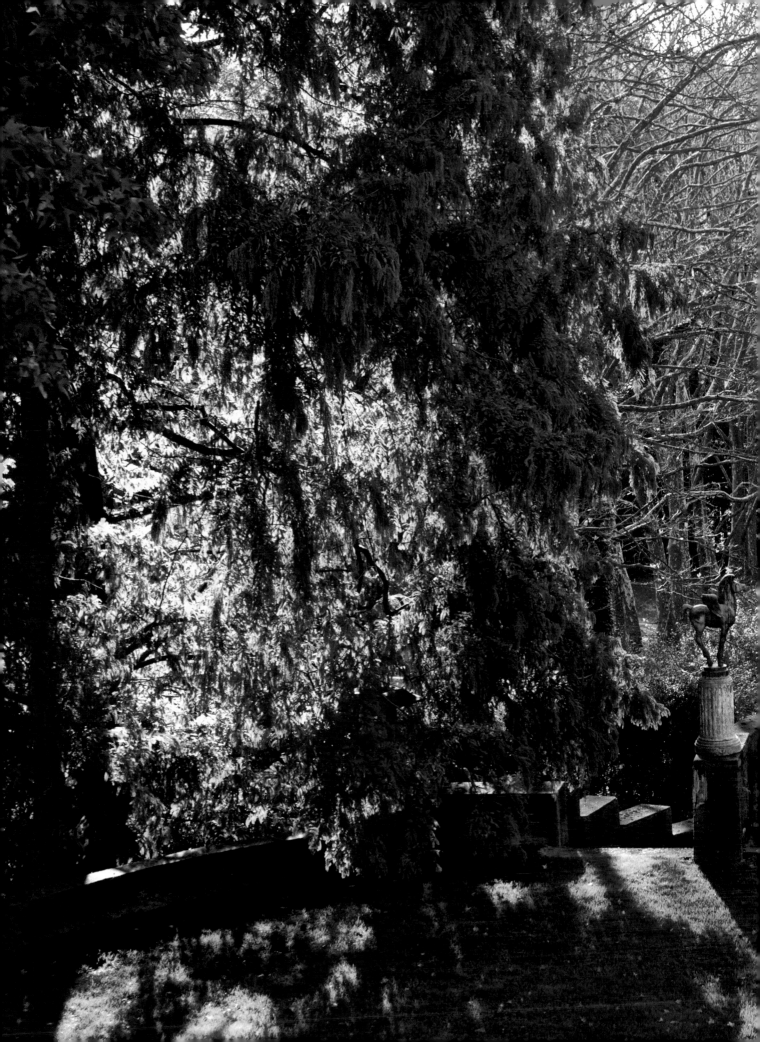

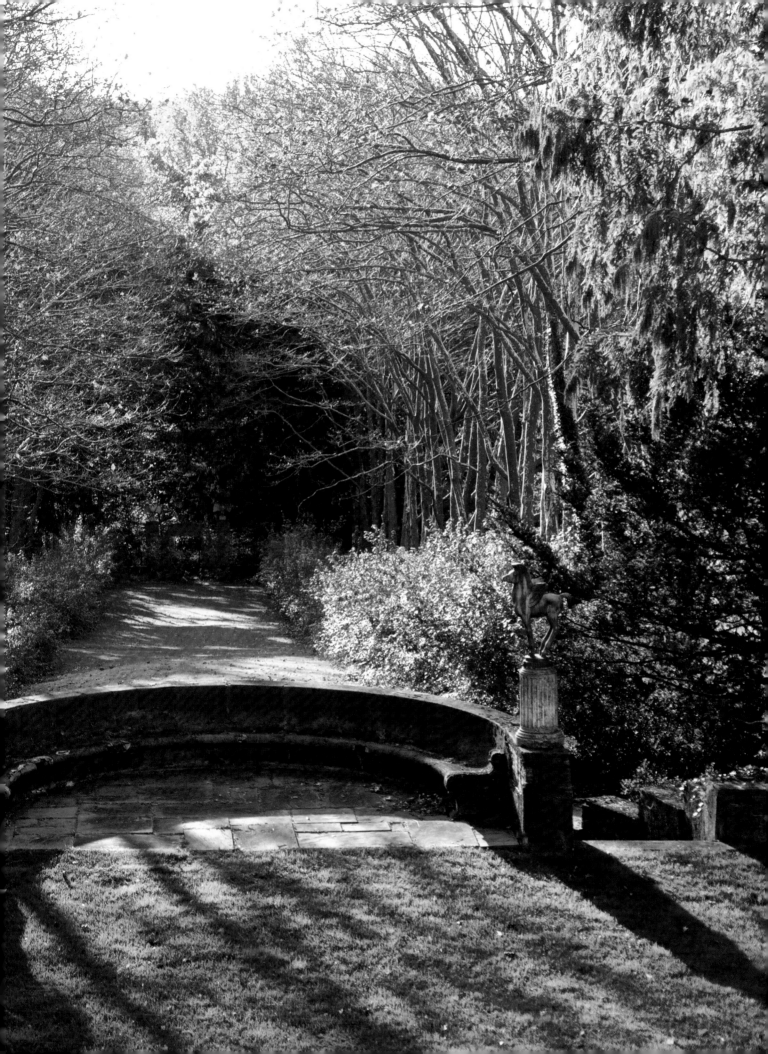

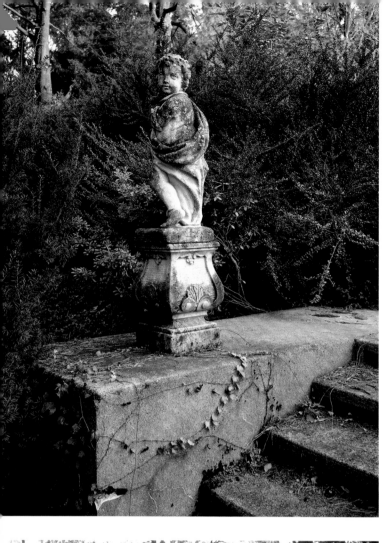

Sculptures interpreted as representing
either *Alice in Wonderland* characters or
chess pieces are truly gathering moss.

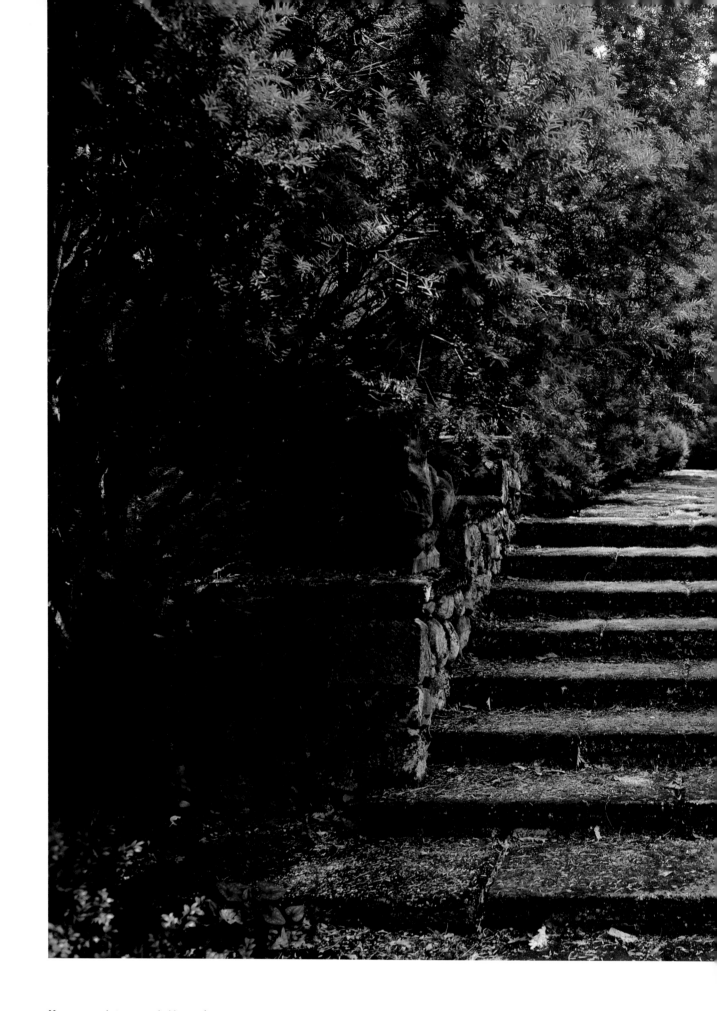

Moss-covered steps guarded by a pair of centuries-old Chinese dragons.

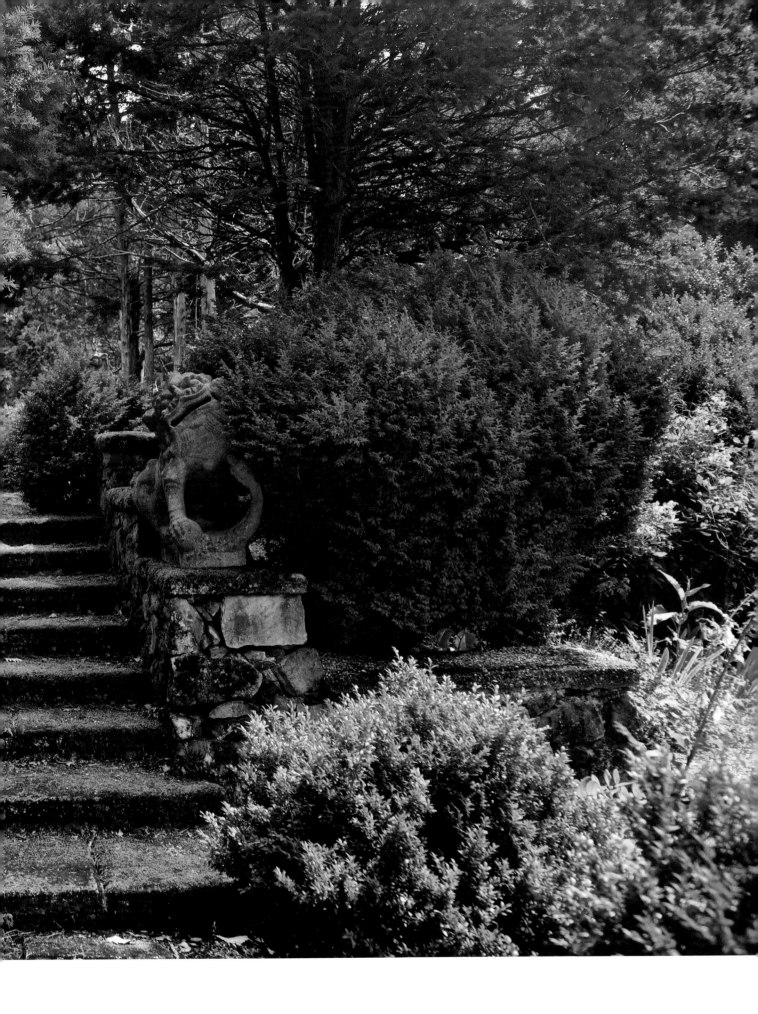

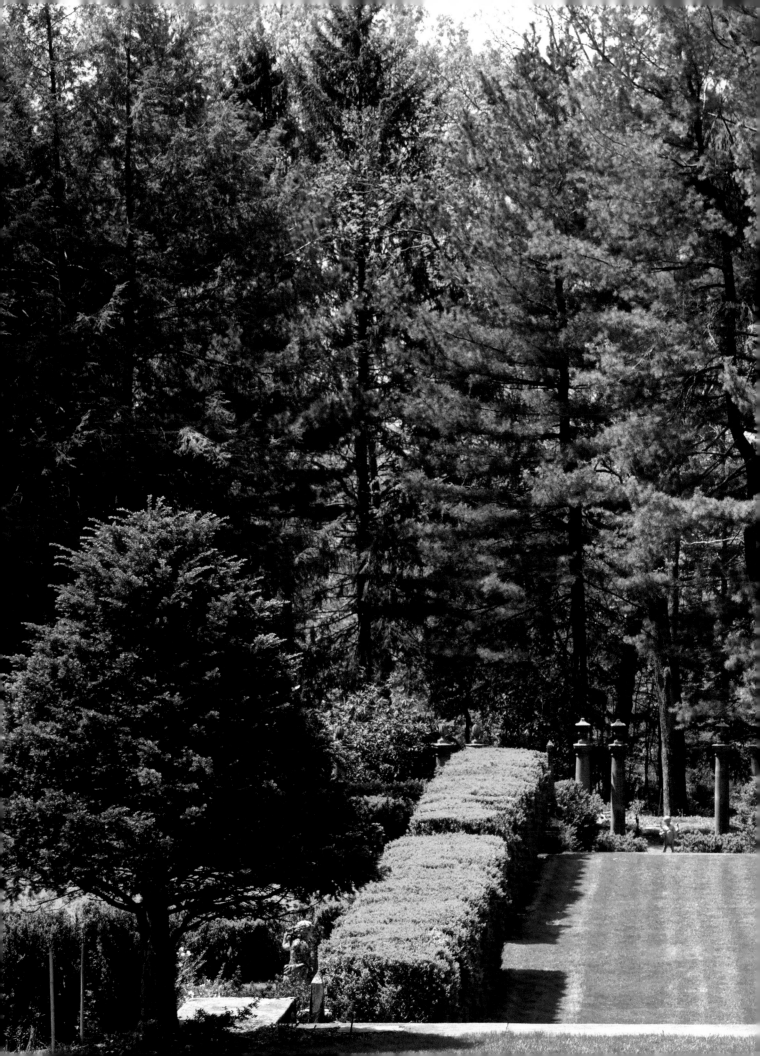

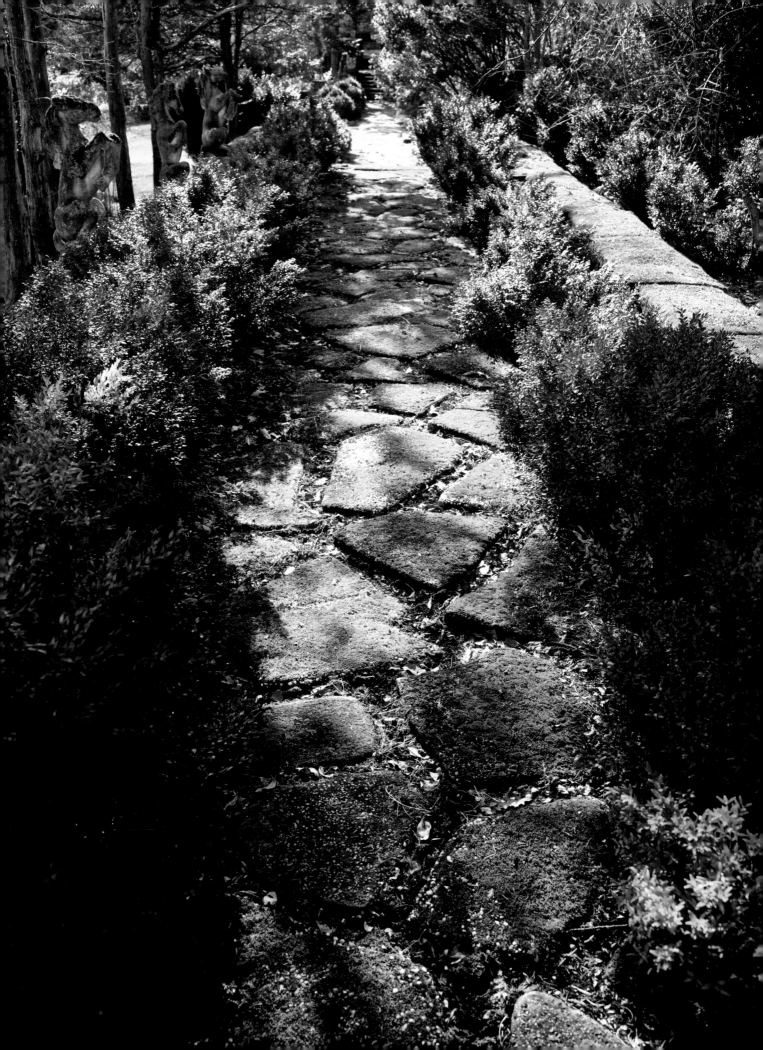

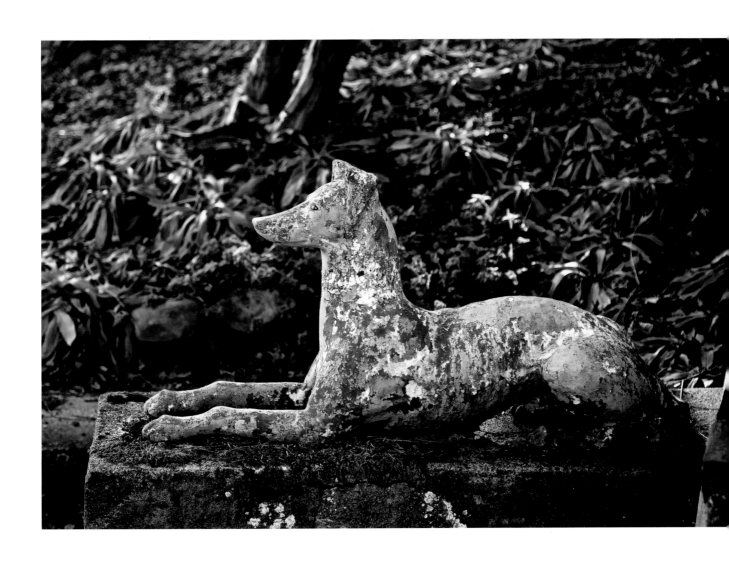

A boxwood-lined walkway with irregular
cement-and-pebble pavers and a lead
greyhound showing wear but still on guard.

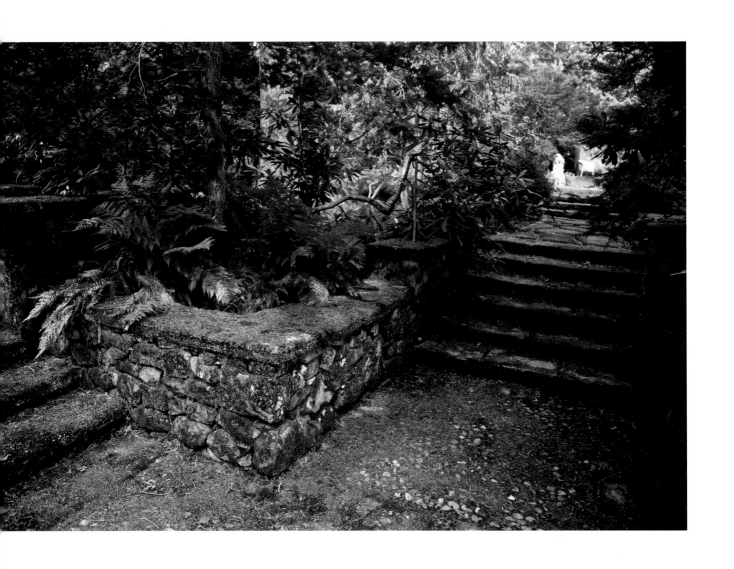

A juncture of walkways constructed around 1920. Just visible in the foreground is a section of walkway made of small cobblestones.

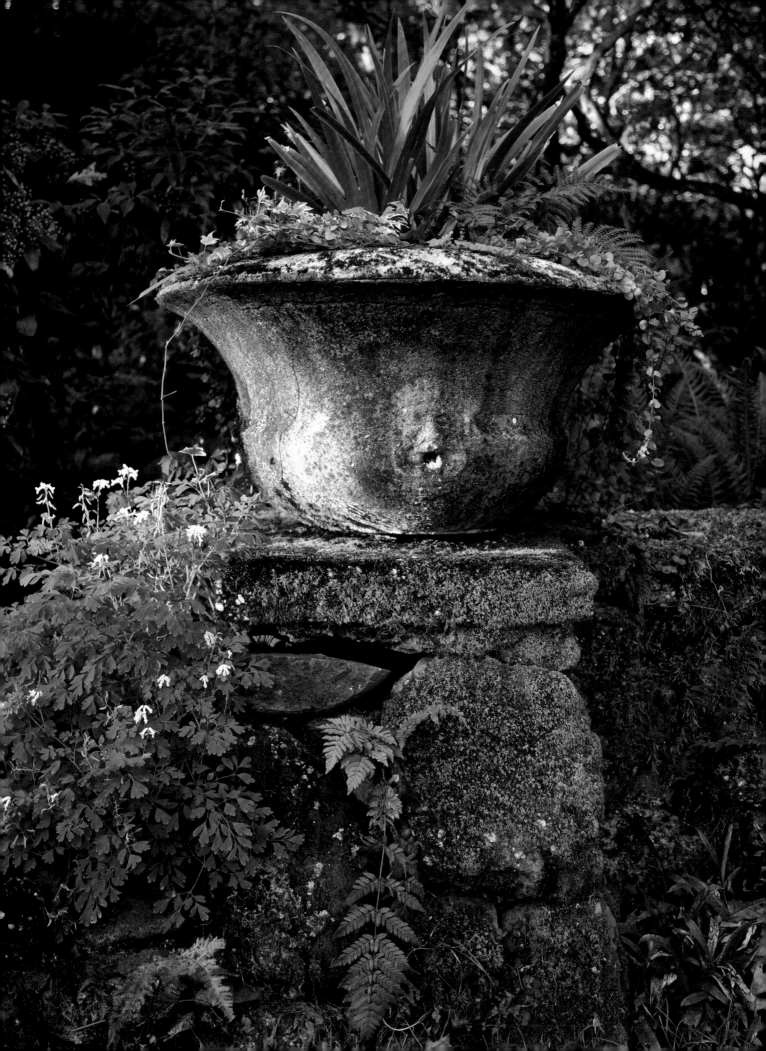

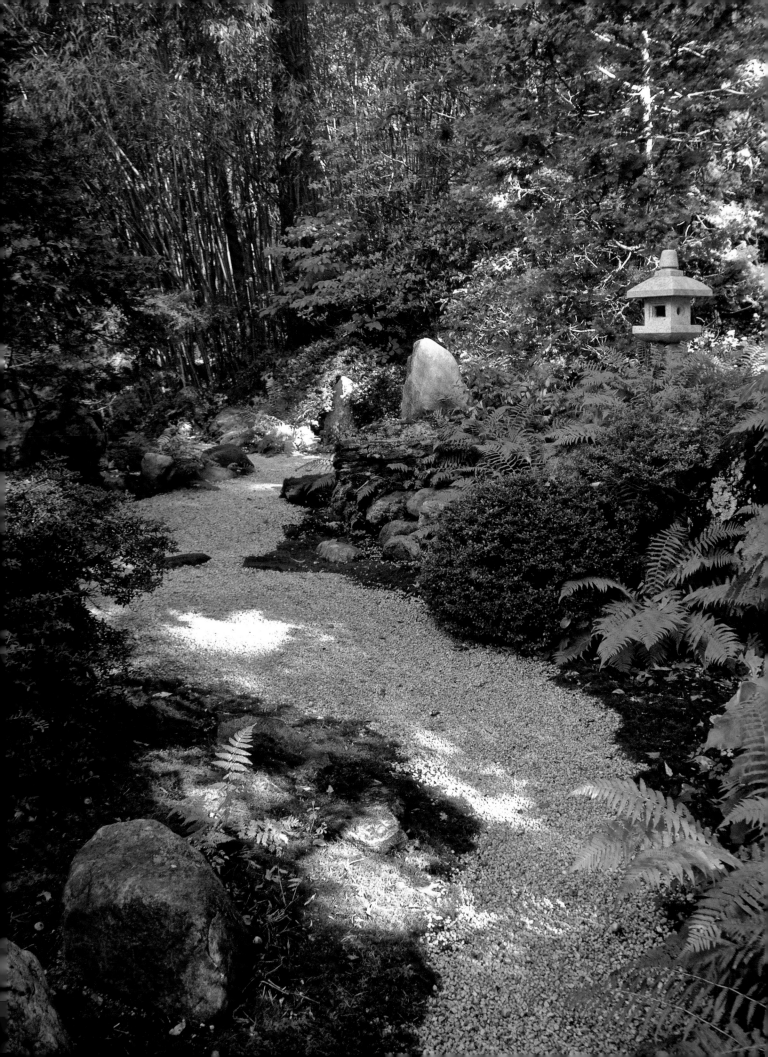

A Transcendent Retreat

MILL NECK, NEW YORK

The origins of this traditional Japanese stroll garden begin with a trip the former ambassador John P. Humes made to Kyoto, Japan, with his wife in 1960. Inspired by the contemplative beauty of the gardens and temples in Kyoto, the couple resolved to transform a two-acre corner of their Long Island estate into their very own garden retreat. After importing an authentic teahouse to be the centerpiece, they engaged first-generation Japanese couple Douglas and Joan DeFaya to develop the garden. Over four years, the DeFayas carved garden paths into the existing hillside terrain, set stones by hand, and planted the understory with a variety of shrubs and groundcovers. A half century after their original plantings around the teahouse, hinoki cypress (*Chamaecyparis obtusa*), laceleaf Japanese maple (*Acer palmatum*), weeping hemlock (*Tsuga canadensis* 'Pendula'), and katsura tree (*Cercidiphyllum*) still stand as testament to the DeFayas' vision and skill.

The defining feature of the Humes garden is its path, designed as a walking meditation on life's journey. While the direction of the path is determined by the existing contours of the land, the asymmetrical, unfolding movement of the path heightens the sense of journey and discovery. Eventually the path leads to a small rustic teahouse set by a pond, offering a peaceful retreat from worldly affairs. Throughout, the plant palette is kept simple and repetitive. The native forest remains largely intact, and just enough spontaneous growth is allowed to preserve a sense of naturalness and also to respect the existing ecosystem. Flowers are used sparingly to add subtle accents and seasonal grace notes. Signature Asian plants provide the most significant Japanese touch, such as the aforementioned trees, as well as bamboo (*Bambusoideae*) and Japanese cedar (*Cryptomeria japonica*). Ferns and moss (*Bryophyta*) are grown throughout, providing continuity, depth, and a sense of age. Shades of green are emphasized, and evergreens are given precedence as they provide a sense of tranquility.

In the late 1970s, Hume began exploring the possibility of opening the garden to the public. Landscaper Stephen A. Morrell oversaw the transition, and in 1985 the garden officially became a public oasis. Over the ensuing decades, the garden has received thousands of visitors, offered classes and exhibitions focusing on traditional Japanese arts, and regularly conducted both private and public garden tours and tea ceremony demonstrations. Nurtured by its timeless sense of transcendent retreat, many students who have worked at the garden have gone on to pursue careers in horticulture and garden design. In short, the garden has touched many lives.

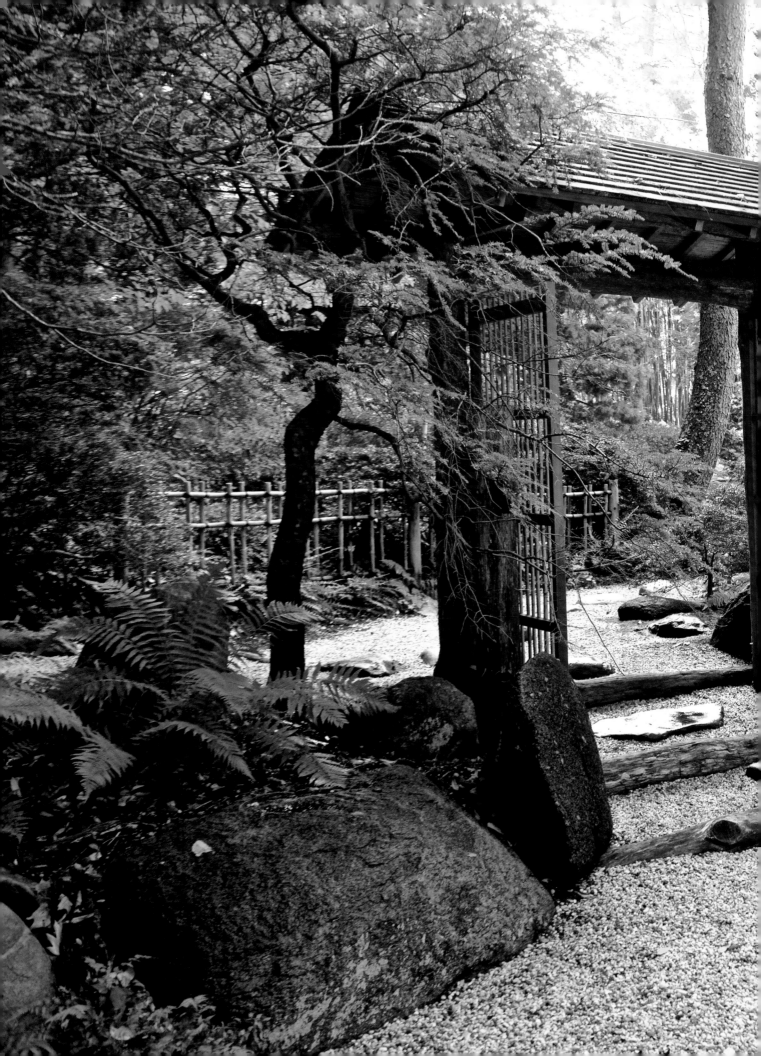

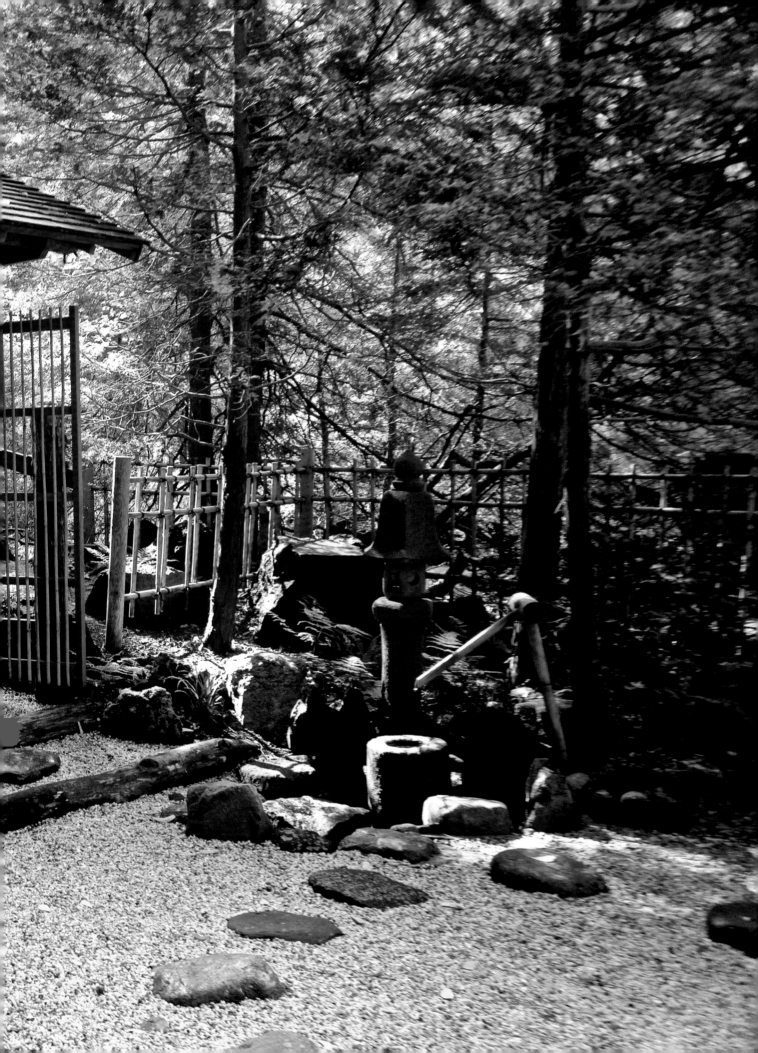

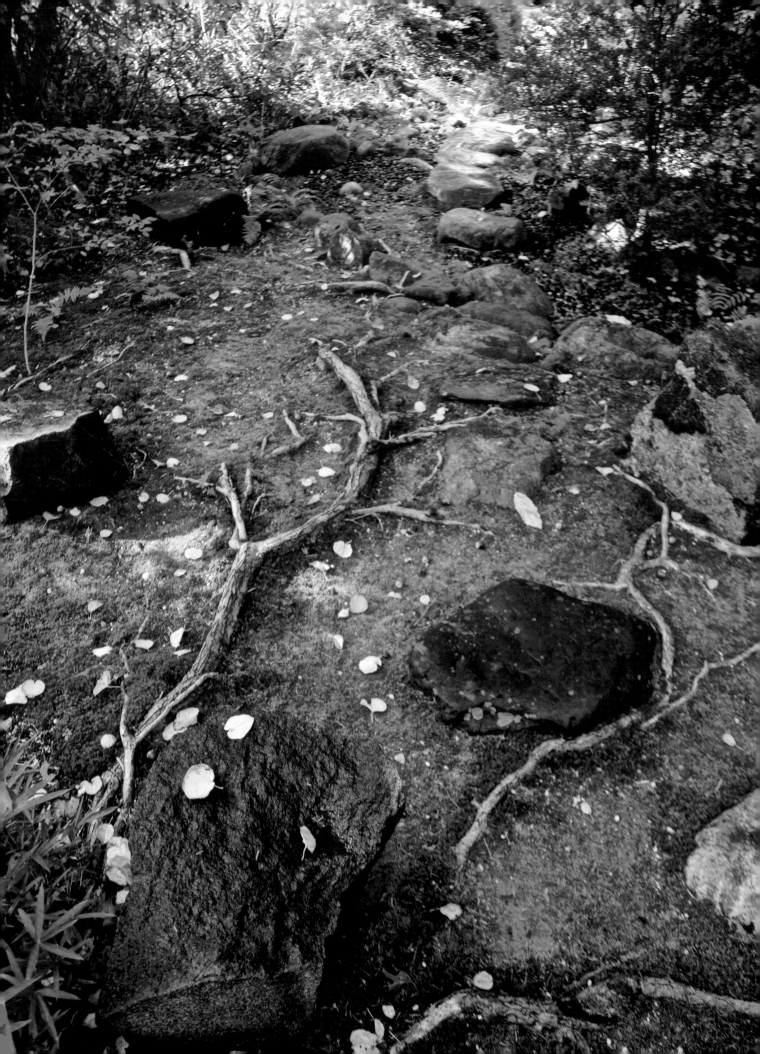

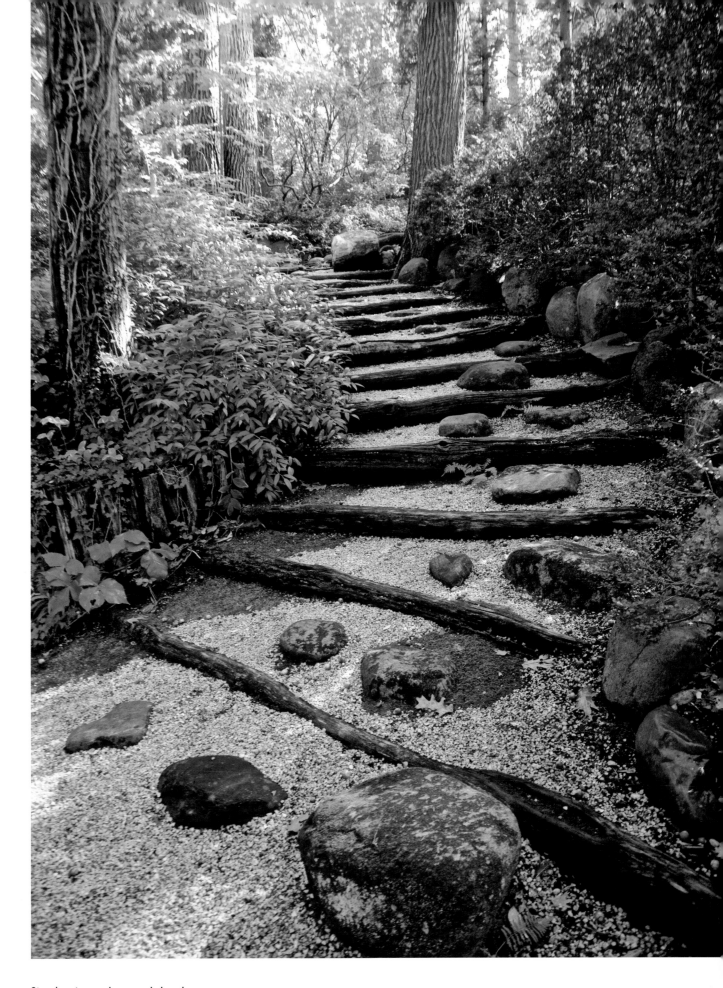

Stepping stones, chosen and placed
by the DeFayas, control the rate at
which one moves through the garden,
encouraging a parallel inward journey.

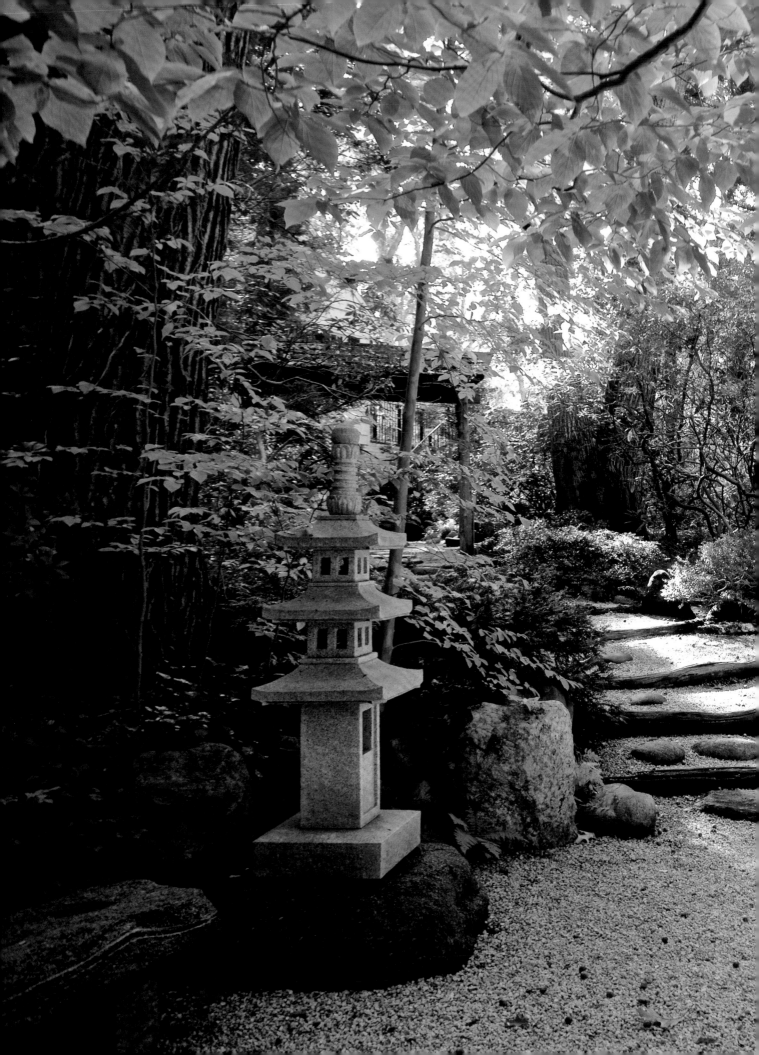

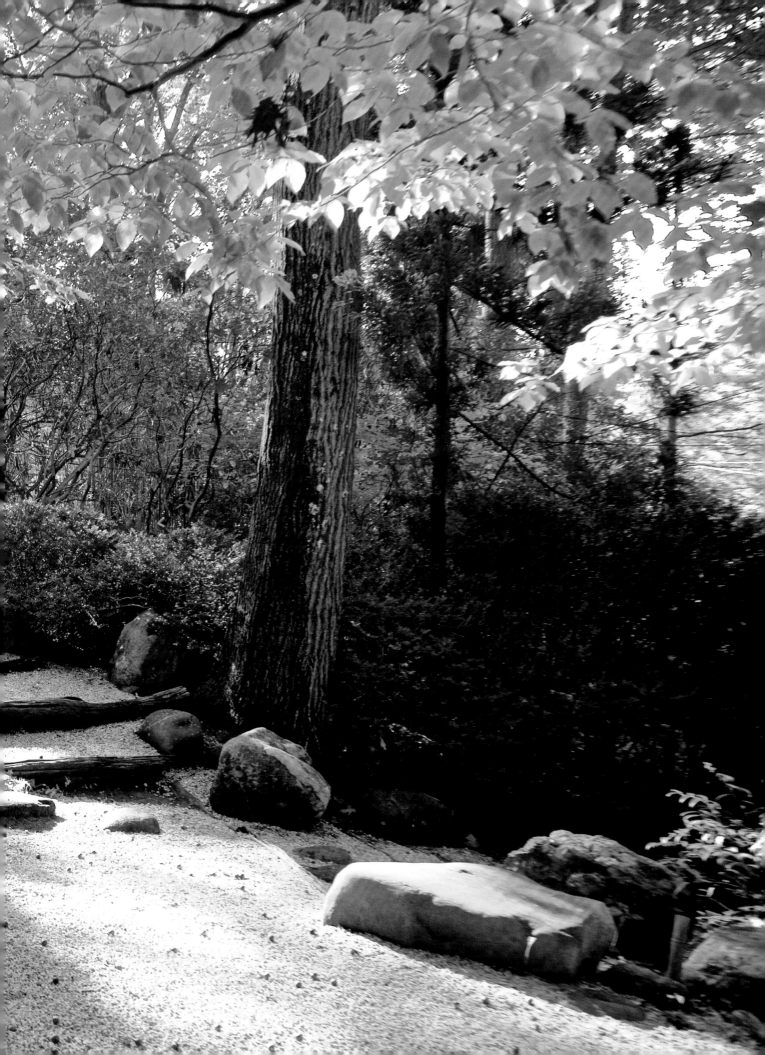

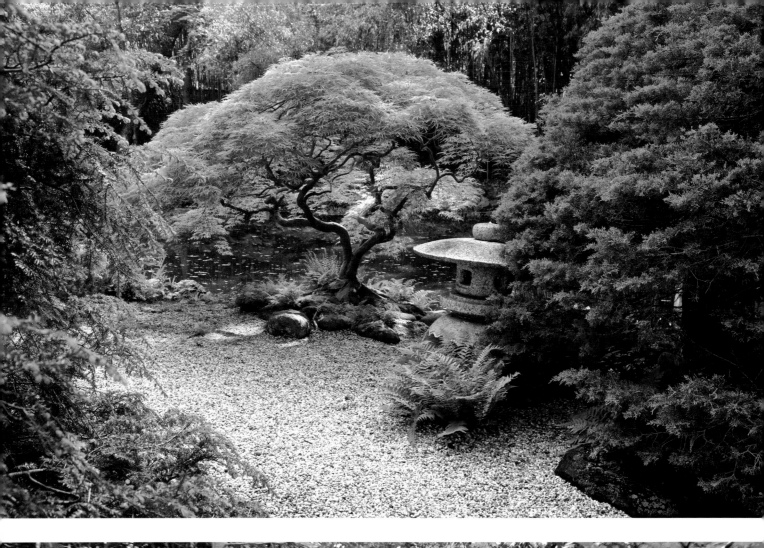

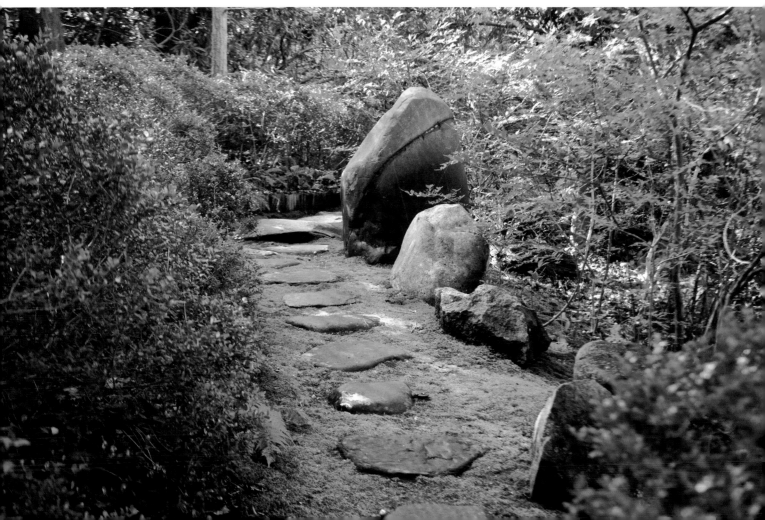

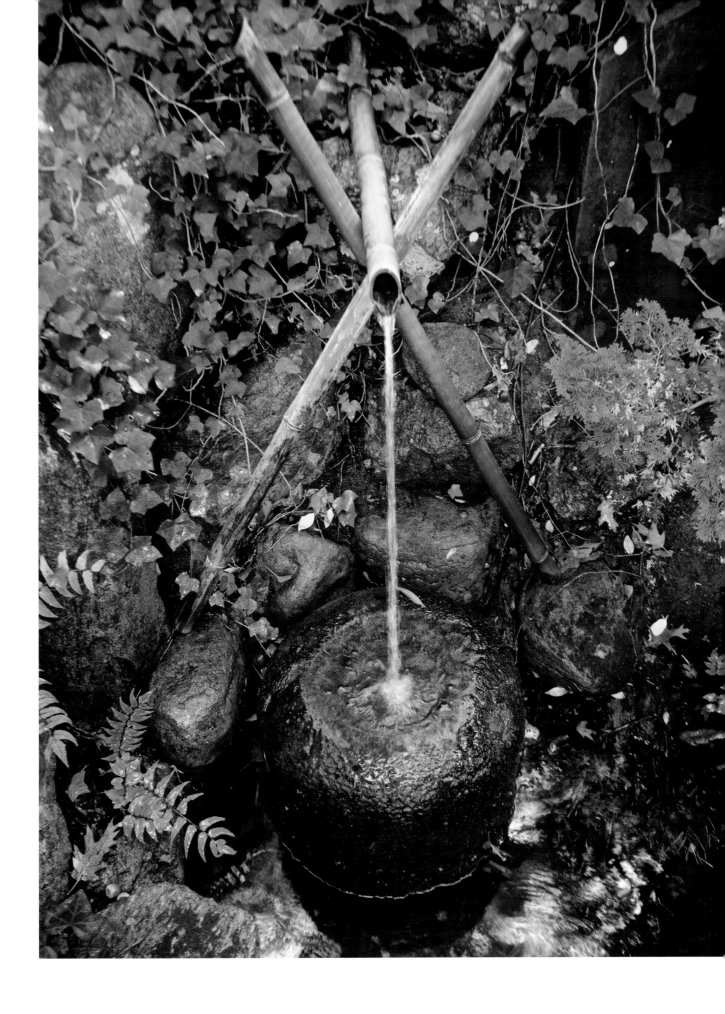

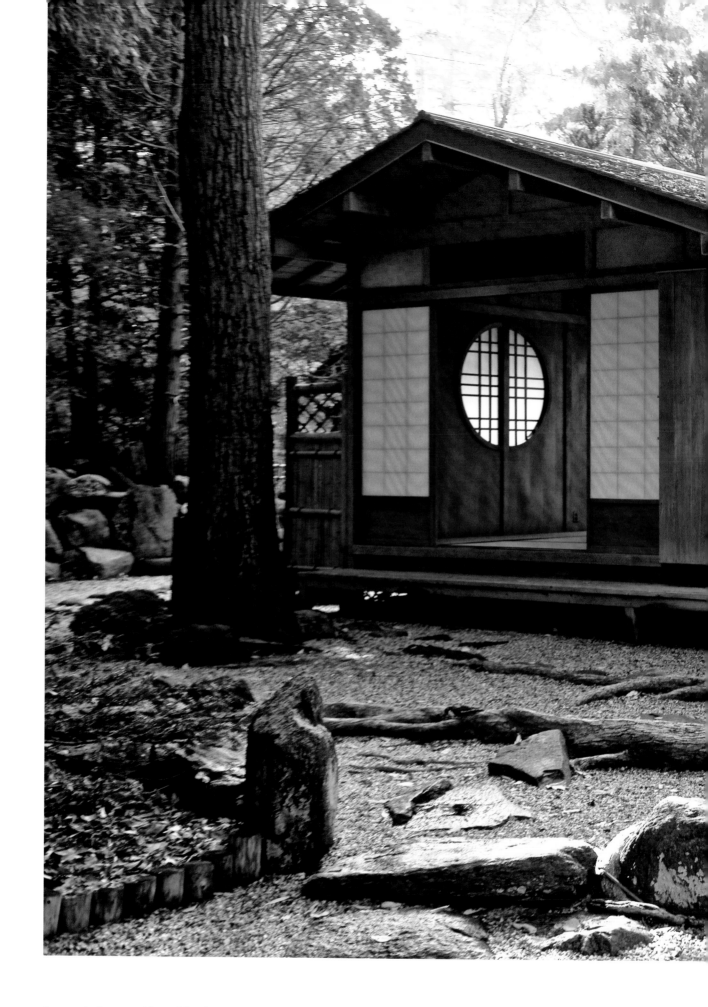

Japanese teahouse used for traditional
tea ceremony gatherings.

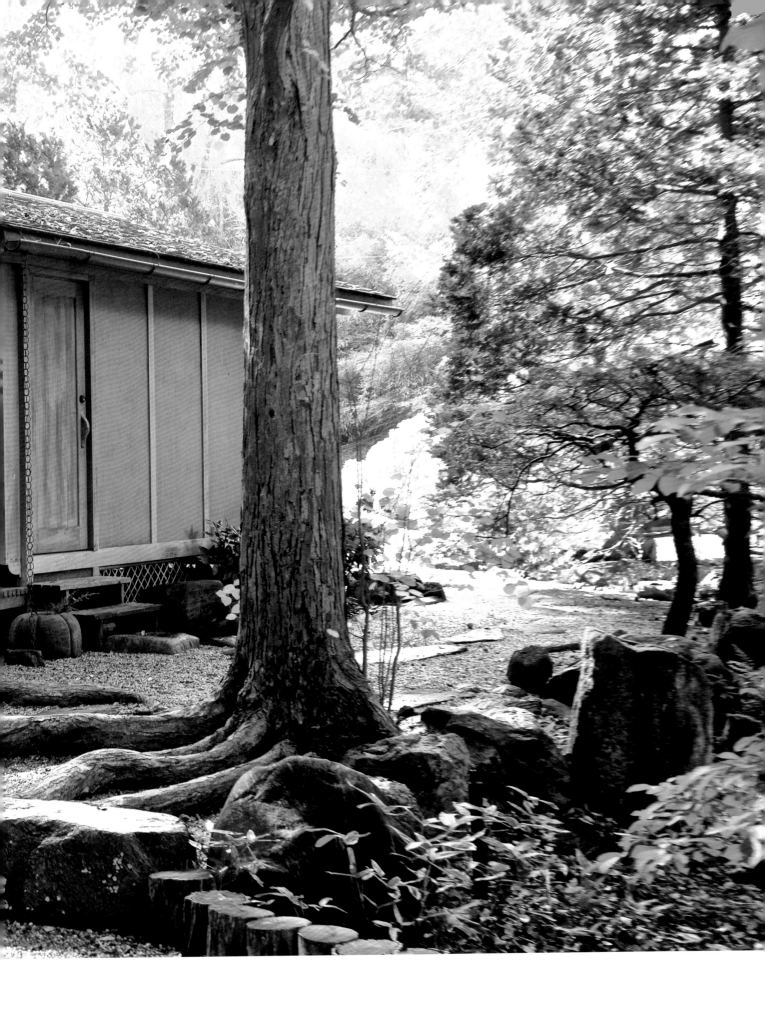

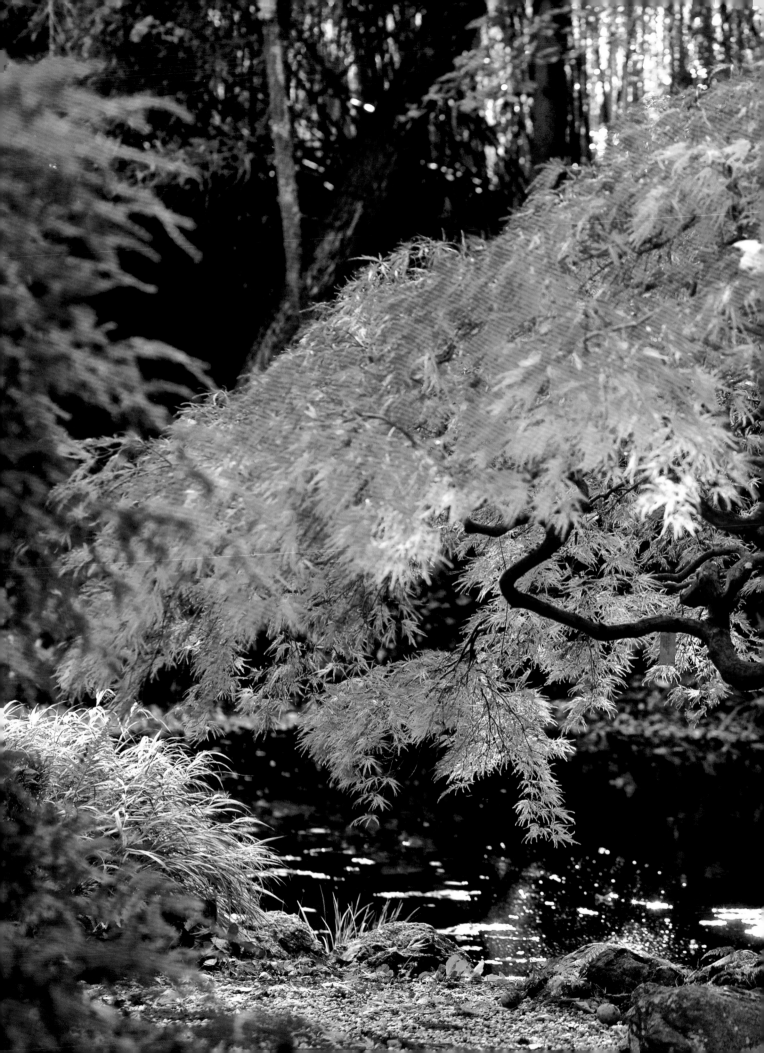

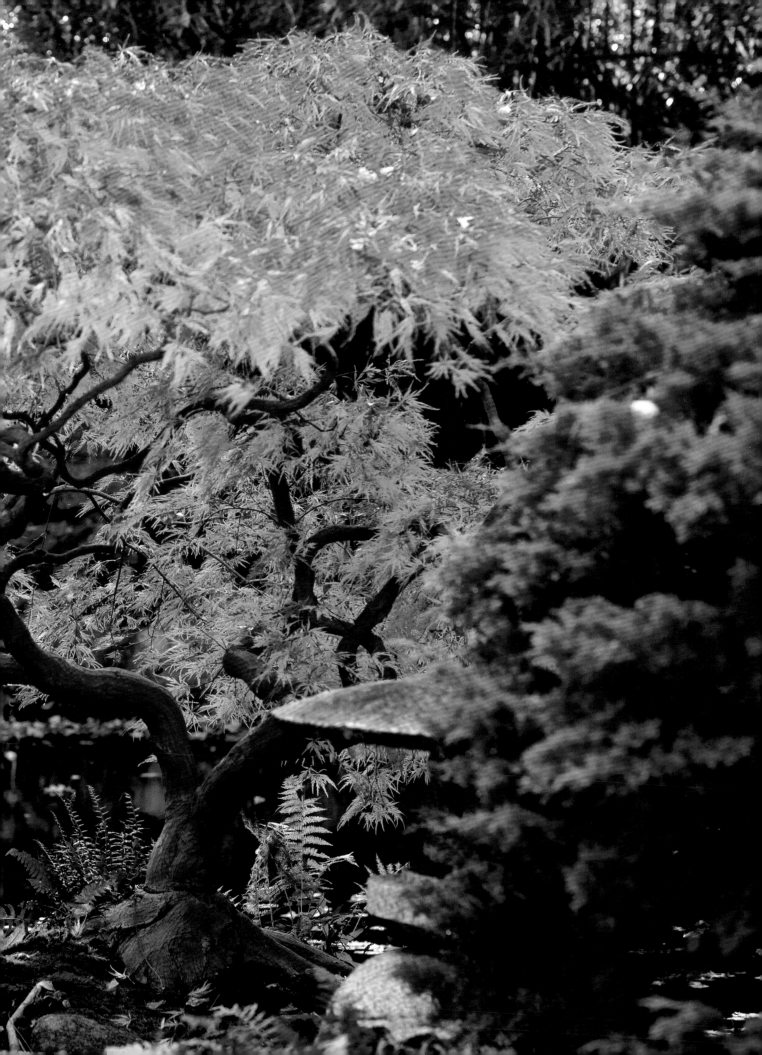

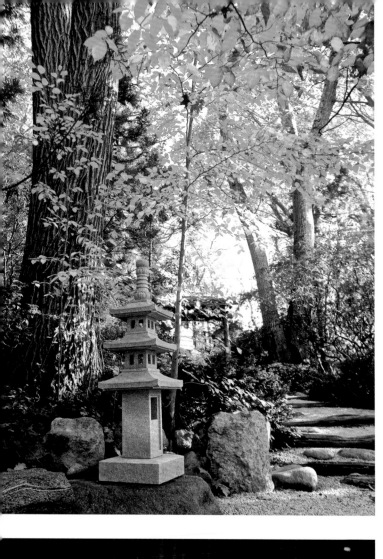
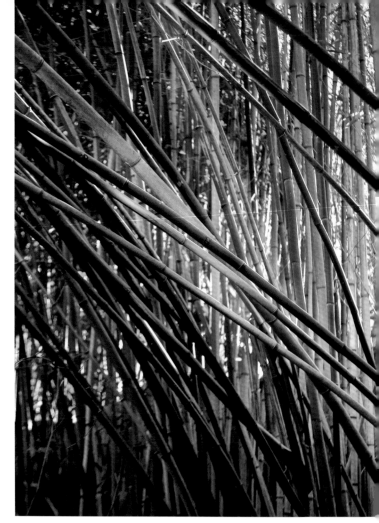

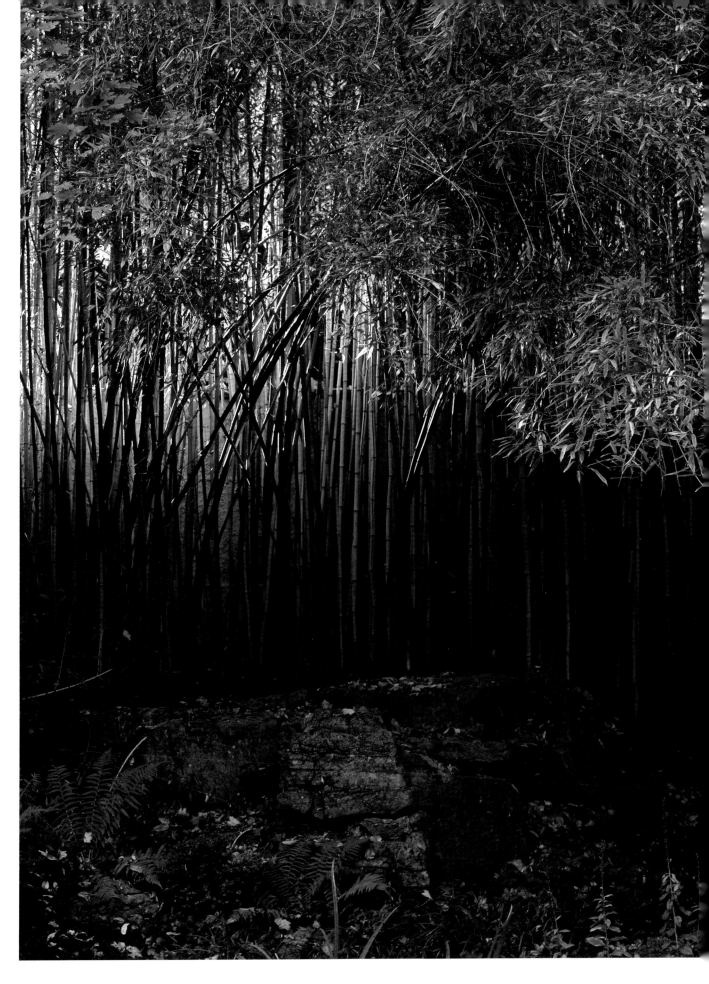

Of special interest in the stroll garden
are the winding stepping-stone
walkways and gravel paths, stone
lanterns, bamboo groves, over eleven
varieties of moss, and a waterfall
emptying into a koi pond. The bamboo
is used for fences, for the floor of
the teahouse, and as a water pipe.

91

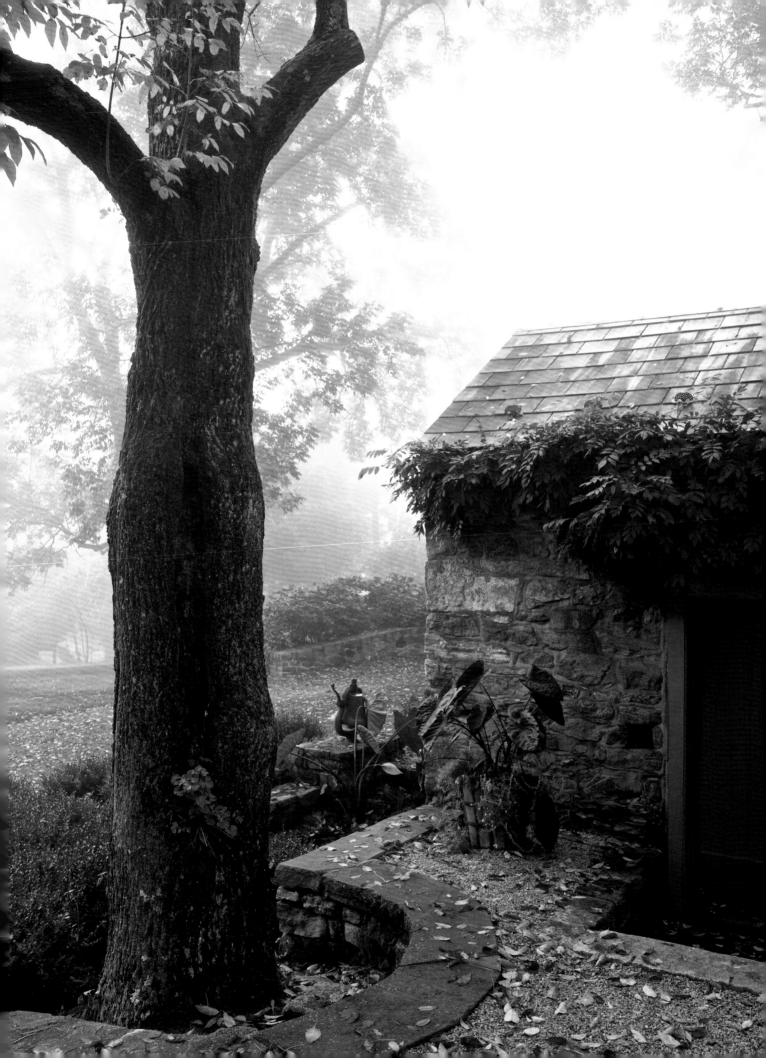

Ancient Geometries

POTTERSVILLE, NEW JERSEY

Originally a working nineteenth-century farm, Bird Haven Farm is now the home of jewelry designer Janet Mavec and her husband, Wayne Nordberg, an investor who grew up on a nearby farm. When Janet first moved onto the one-hundred-acre property by way of marriage, she found the existing conditions, while promising, a bit too disordered. In the way a rug can bring a room together, she felt the property needed an organizing principle that would not upend the continuity of the existing landscape. Serendipitously, Janet came across a monograph of Spanish landscaper Fernando Caruncho. Struck by his capacity for creating order with a light, organic, and noninvasive touch, she and her husband visited Fernando's home outside Madrid. The following year, Fernando returned the favor and agreed to his second American commission.

While Janet felt the property was an inelegant hodgepodge of buildings, Fernando felt he had arrived at "a little medieval town in the middle of the forest." To that end, he created paths between the existing buildings and built a series of field-stone walls to contain Janet's kitchen gardens. He also constructed an elliptical reflecting pool in front of the original stone cottage, echoing the natural pond nearby. Janet describes Fernando as "a great simplifier," and the organizing principle he established came by simply moving back the forest on the hill behind the house, creating an open ellipse-shaped field. Garden designer Lisa Stamm and architect Dale Booher were also instrumental in helping the garden meet its potential, designing among other features what Janet calls the "chicest deer fence" she's ever seen.

"Fernando created the framework of the garden," Janet explains, "but left the details for us to fill in. Each spring I replant the vegetable garden, which for me is like getting the chance to redecorate."

Lately, she has been working with local garden designer Christina Chrobokowa, who stresses sustainability and using native plants—gardening "where purpose, design, and nature align." Janet explains that Christina "has been really helpful in creating a balance between beauty and maintenance."

Today, the farm includes vegetable and landscaped gardens, a stroll garden, an apple orchard, and a monastery garden the couple built after a trip to Italy, featuring a boxwood labyrinth that riffs on the oval geometry Fernando installed. Janet acknowledges fall as her favorite season in the garden, but the jewelry she crafts in her studio reflects the year-round inspiration she finds in all the garden's delights.

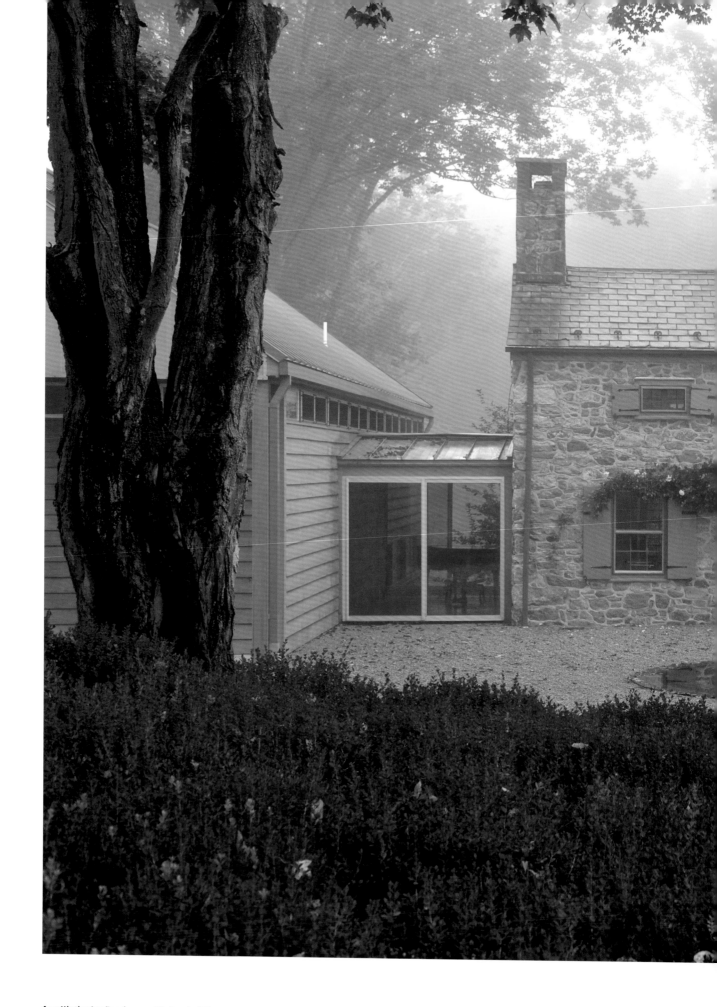

An elliptical reflecting pool in front of the
original stone cottage echoes the nearby pond.

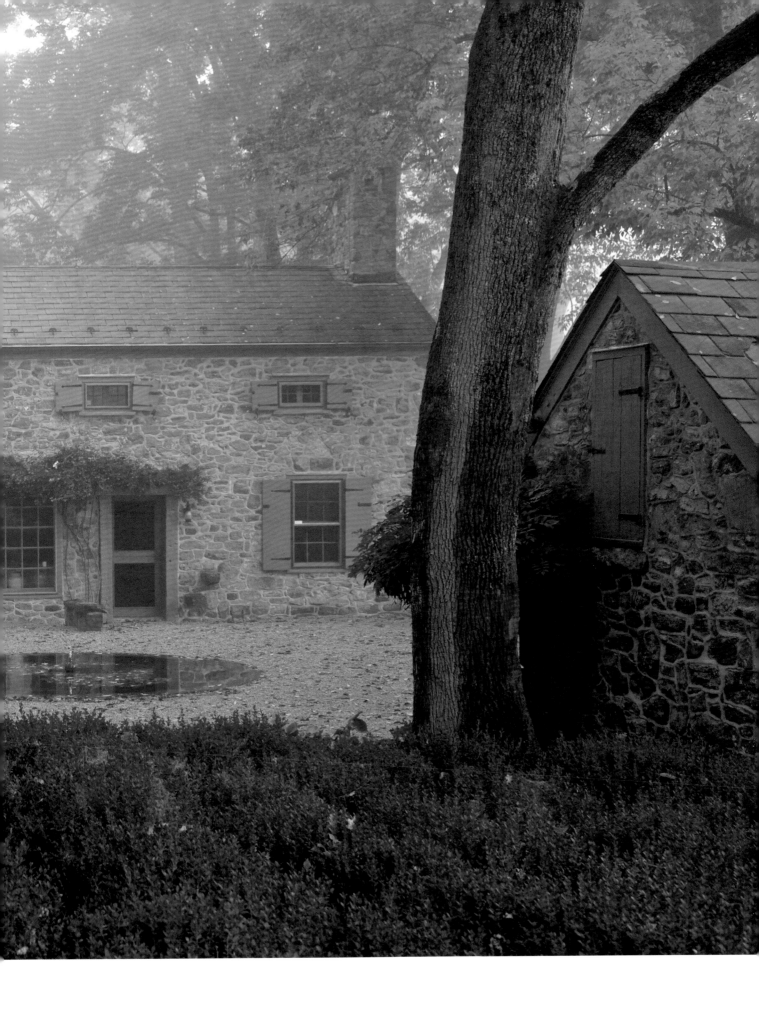

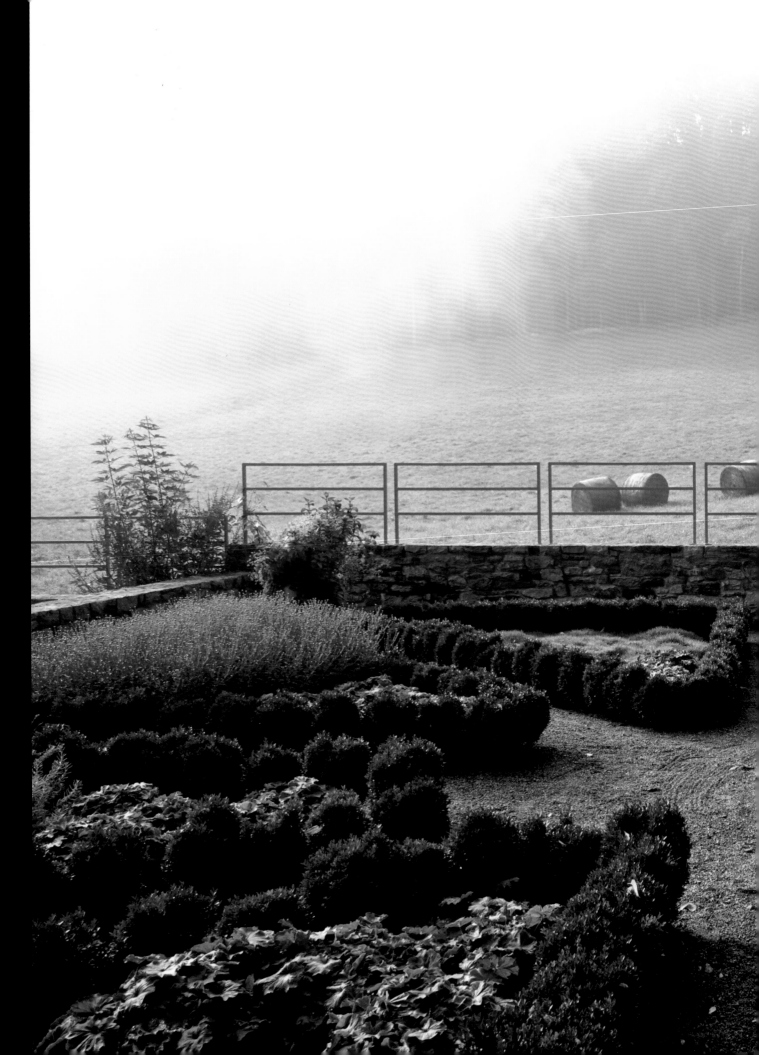

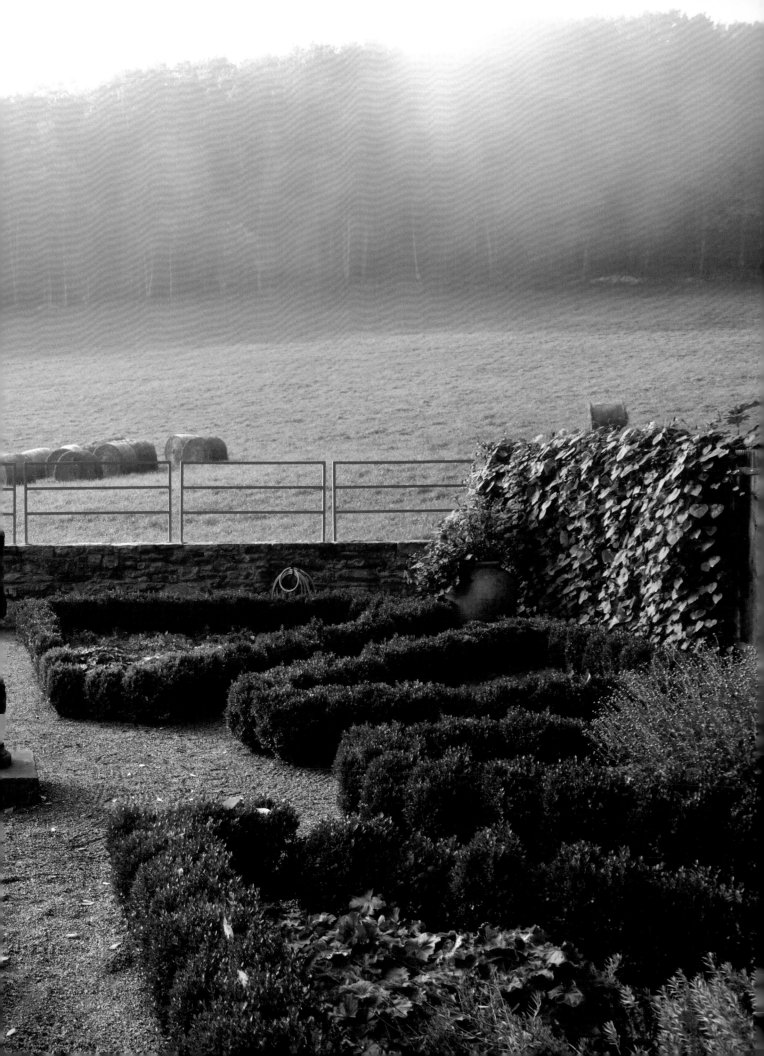

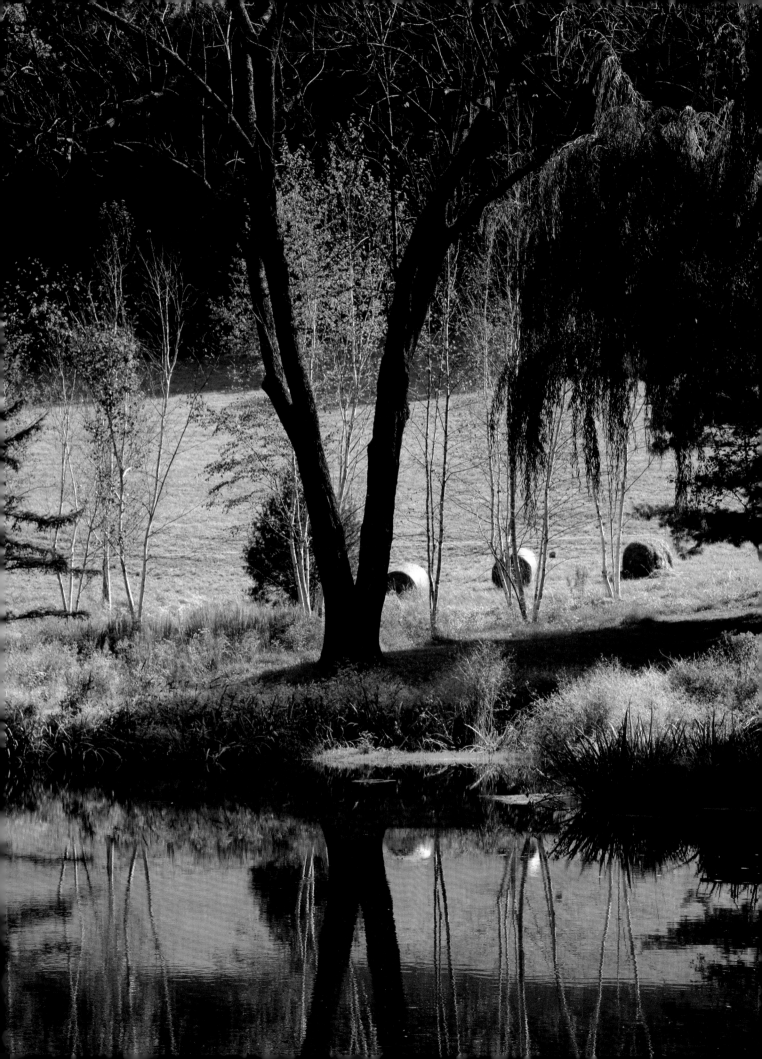

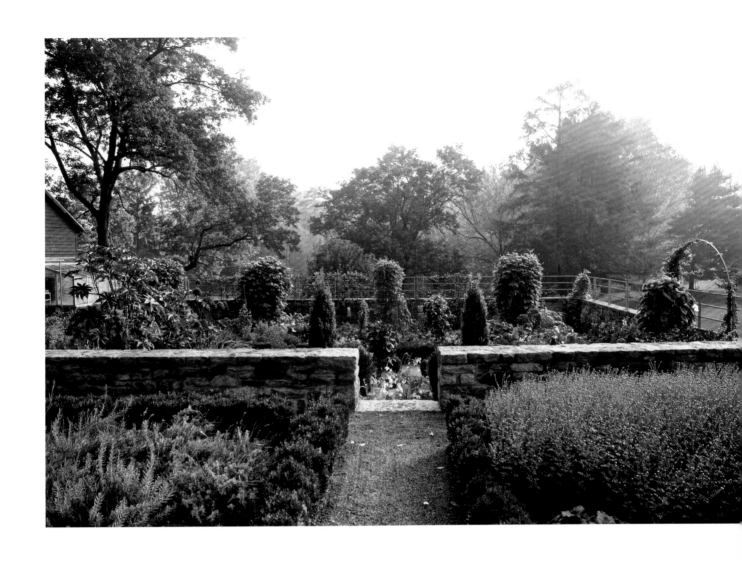

The farm includes vegetable and
landscaped gardens, a stroll garden,
and an apple orchard. In the vegetable
garden Janet grows carrots, Mexican
cucumbers, celery, parsnips, tomatoes,
and other seasonal vegetables.

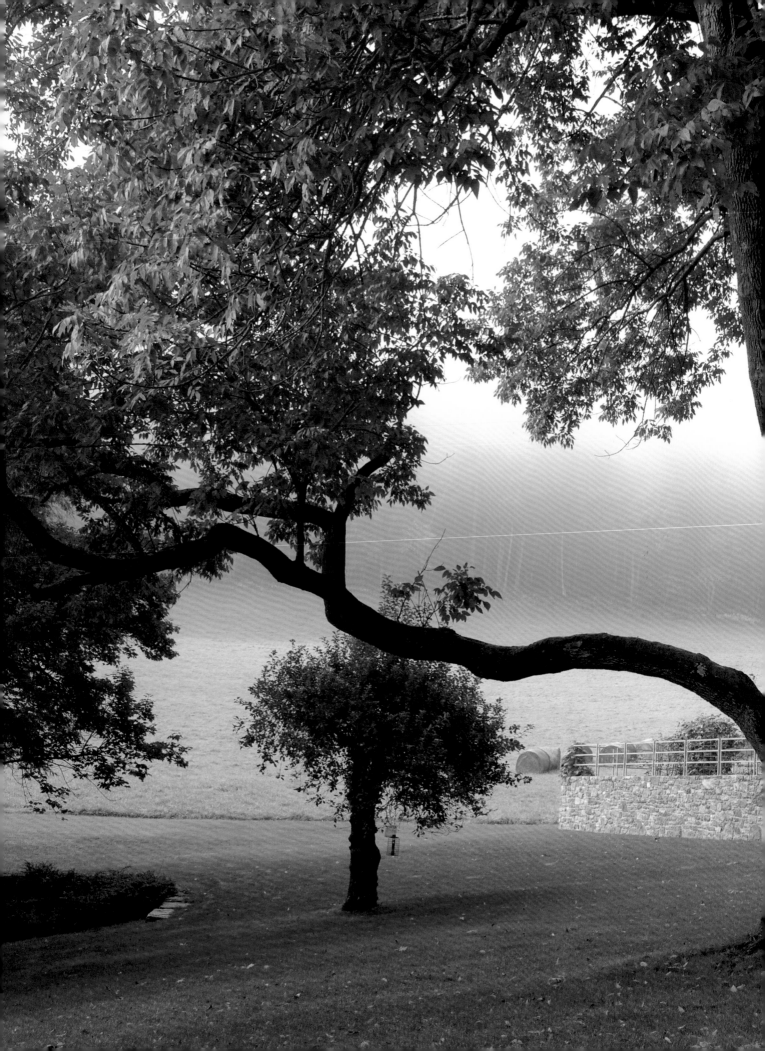

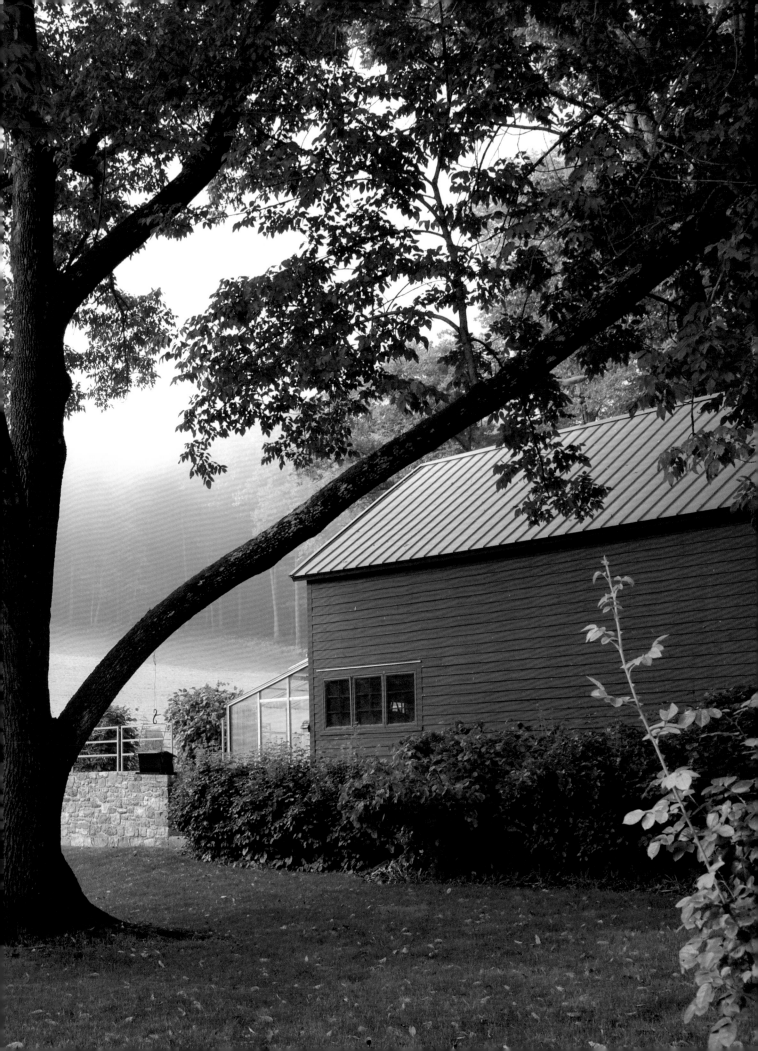

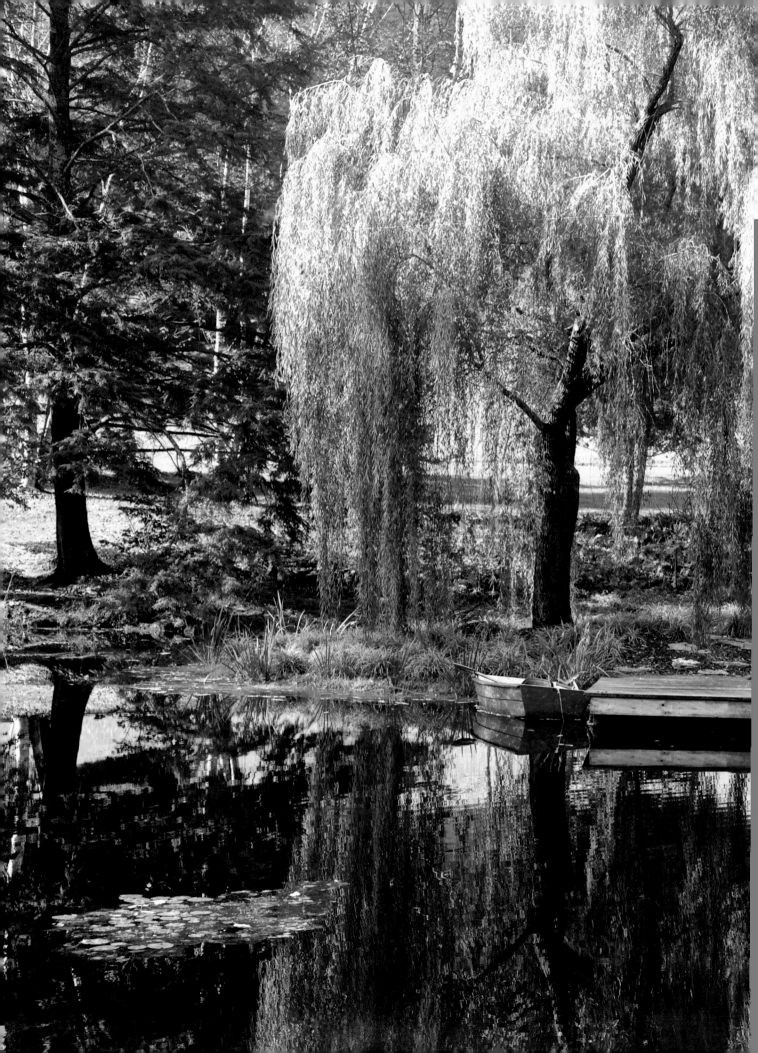

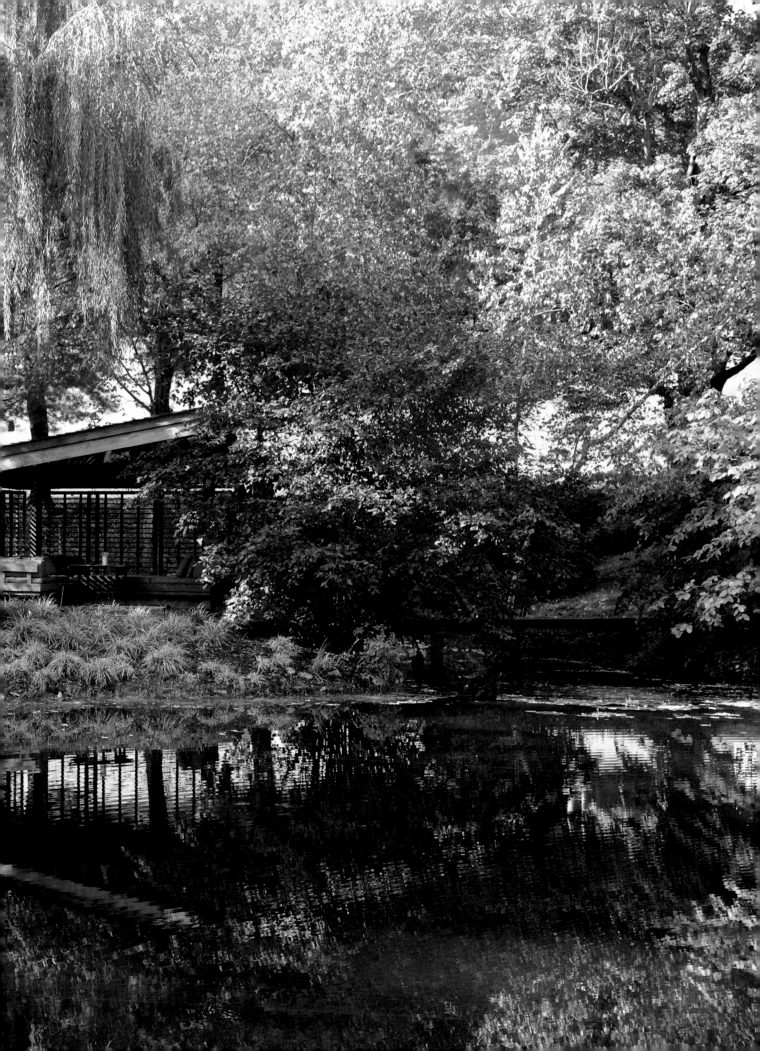

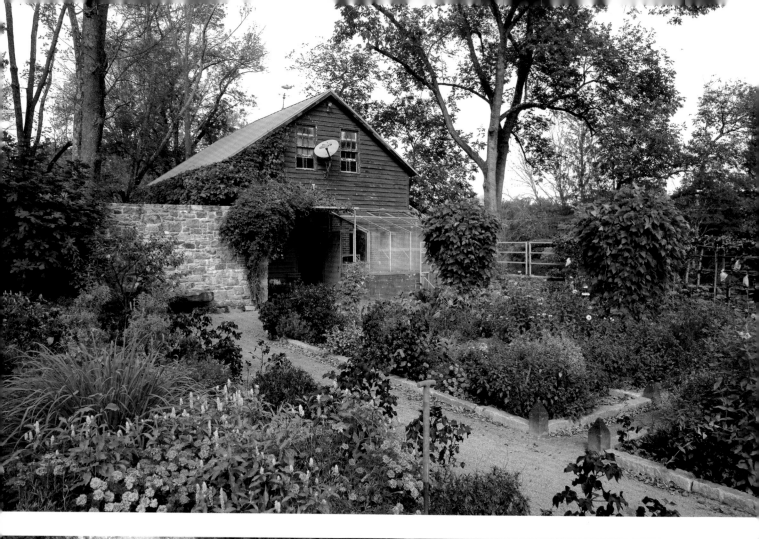
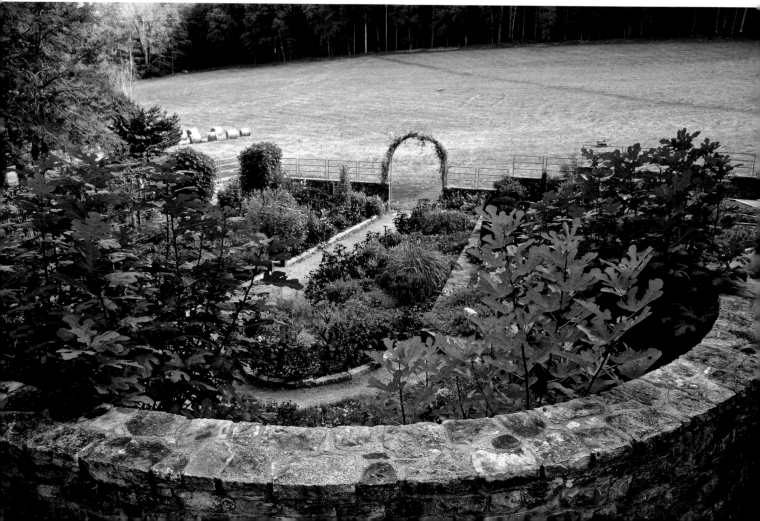

More views of the vegetable garden
and its geometric stone walls.

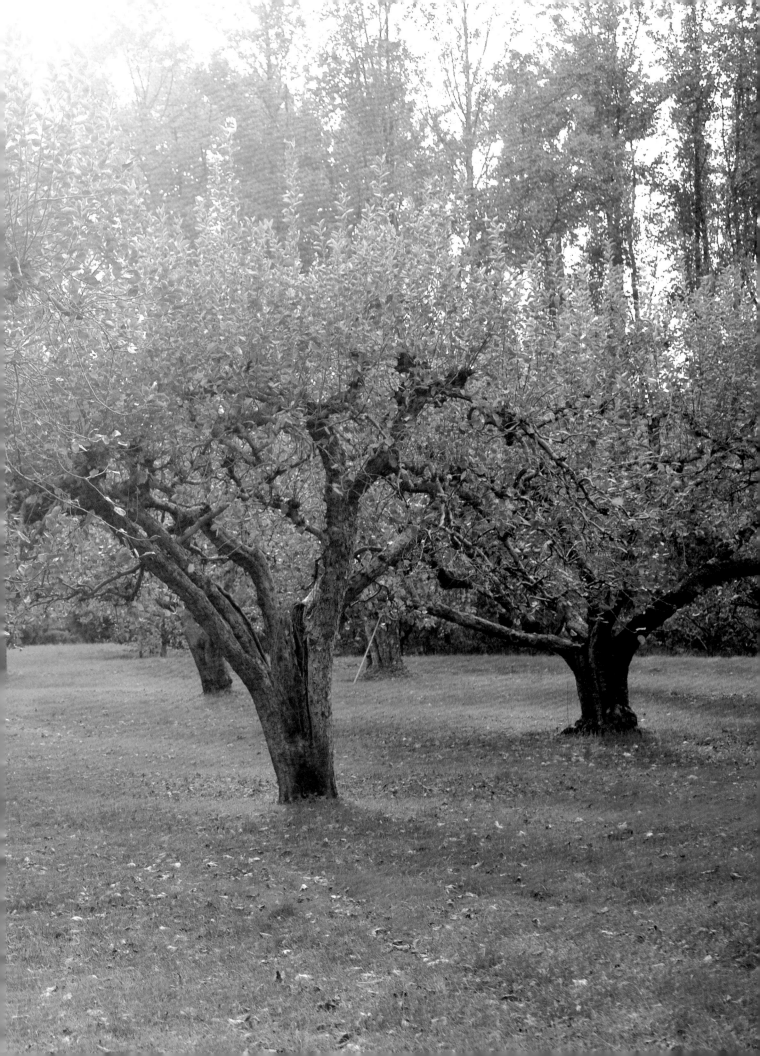

Careless Rapture

MOUNT KISCO, NEW YORK

The late Henriette Granville Suhr and her husband, William, acquired the thirteen-acre property then known as Rock Hill Farm in 1956. For two decades, and without any gardening experience, the couple lovingly transformed what was once wild rocky woodland and brambly meadows into one of the country's preeminent garden jewels. Guided by trial and error, and aided only by visits to botanical gardens and the pages of gardening books, the artistic and well-traveled couple cultivated a living feast for the senses, a horticultural riot that in 1977 became their permanent home.

With their own strong aesthetic impulses, the Suhrs gradually and organically developed the different elements of the garden over the ensuing decades. In fact, they never stopped. Though the garden was always in a state of transformation, the one principle they adhered to was to maintain the property's natural integrity. Existing stone walls were worked into the garden's ongoing design, as were any uncovered outcroppings. Only serious hazard trees were removed from the property's woods. The Suhrs were never cowed by failed plantings and at the same time nurtured strong relationships with local nursery people. They were also strongly against the use of herbicides, and insisted on weeding only by hand. Even as the gardens grew to their current sizes, unwanted plants were removed manually as opposed to chemically.

Five years after the Suhrs acquired what is now known as Rocky Hills, they excavated a small patch of land outside their screened-in porch to build a small pool. The difference in grade between this new area and the first garden they worked on led to the installation of a small waterfall, over which a bridge was soon built. All of these changes initiated a sense of movement and circulation that the Suhrs intentionally nurtured and maintained, and from there the rest of the garden followed.

Known for its robust beds of azaleas and rhododendrons and roaming clouds of forget-me-nots (*Myosotis scorpioides*) in May and June wherever they might drift, the garden features a vibrant mix of the old and new. Whether following trail or brook through hills and terraces, walls and paths, and fern woodlands, visitors will find original plantings of weeping hemlock (*Tsuga canadensis* 'Pendula'), black walnut (*Juglans nigra*) and ash (*Fraxinus*), as well as newer inhabitants like weeping beech (*Fagus sylvatica* 'Pendula'), dawn redwood (*Metasequoia glyptostroboides*), dogwood (*Cornus*), and an impressive collection of magnolias and conifers (*Pinophyta*).

Now a public strolling garden just a short drive north of New York City, Rocky Hills remains a rapturous work of garden art and a breathing testament to the loving vision of Henriette and William Suhr.

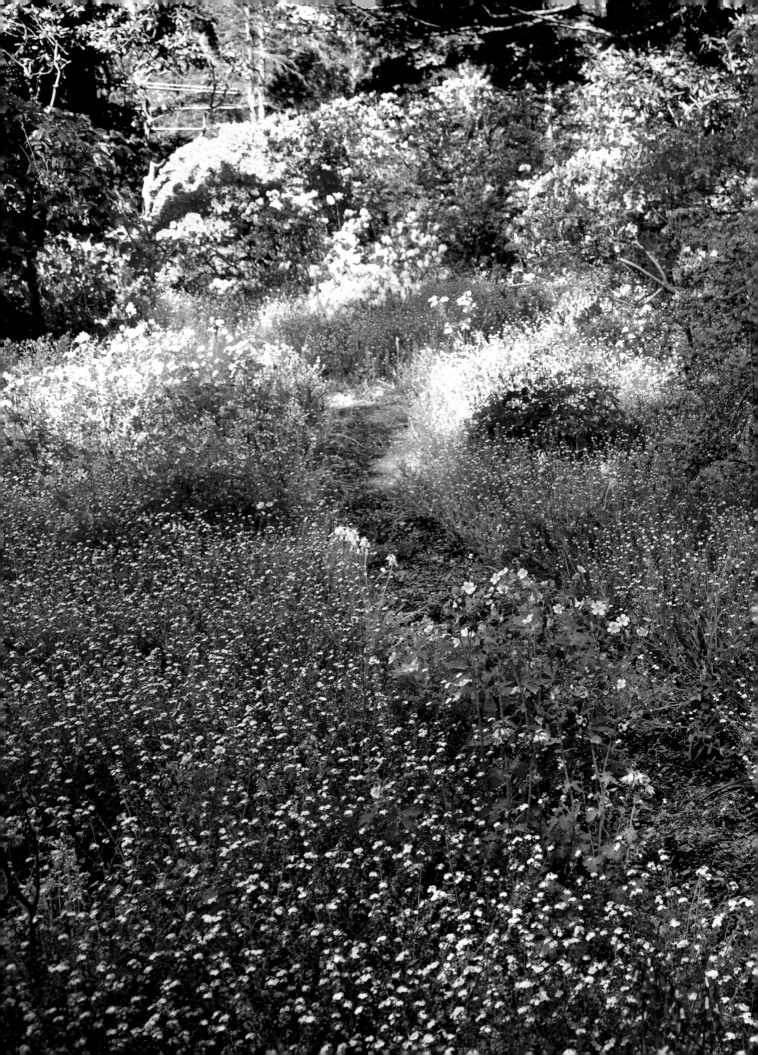

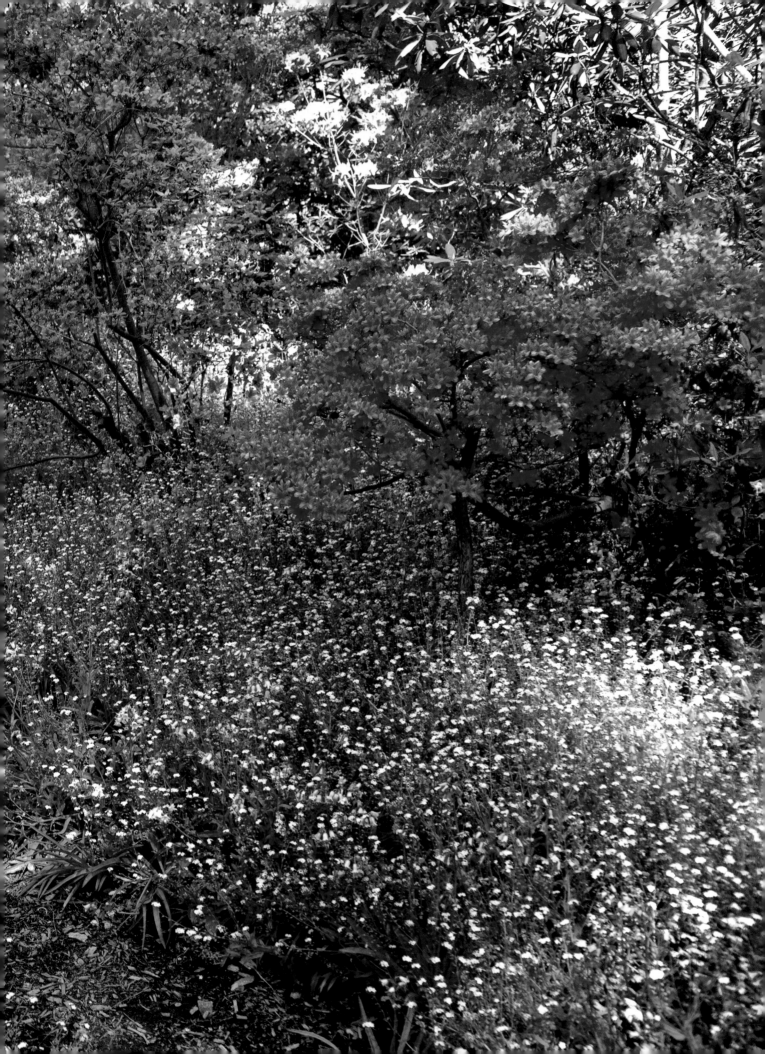

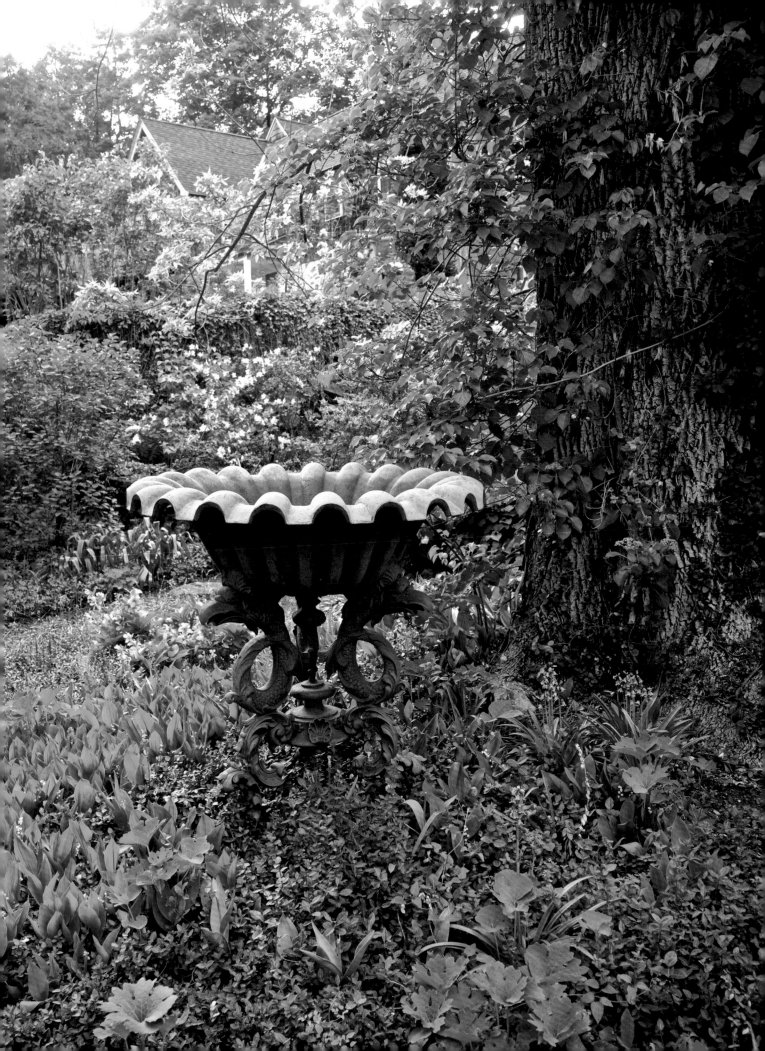

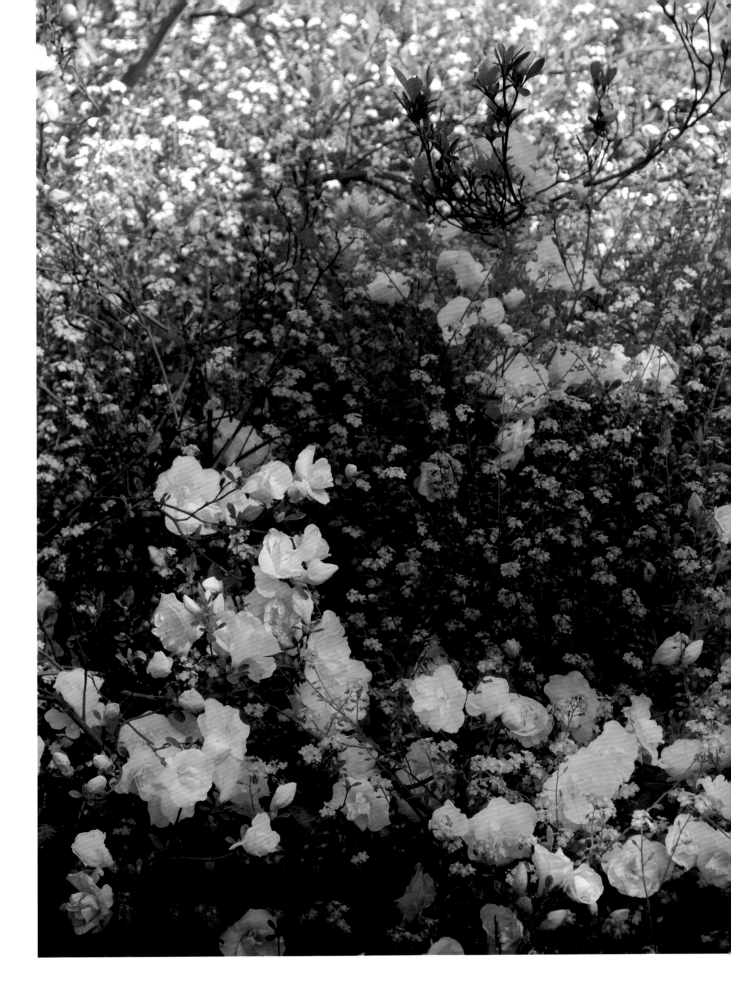

Above and previous pages: Romantic and
free-growing combinations of azalea,
magnolias, and forget-me-nots.

113

Views of the original stone walls around
which William and Henriette Suhr
began planting some fifty years ago.

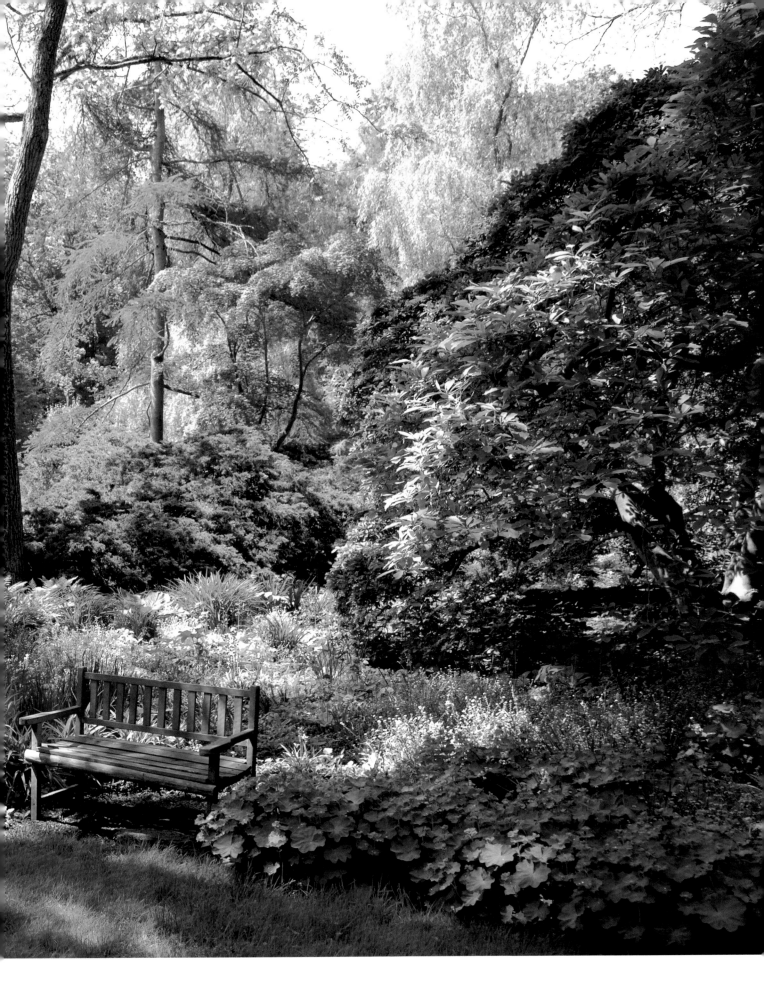

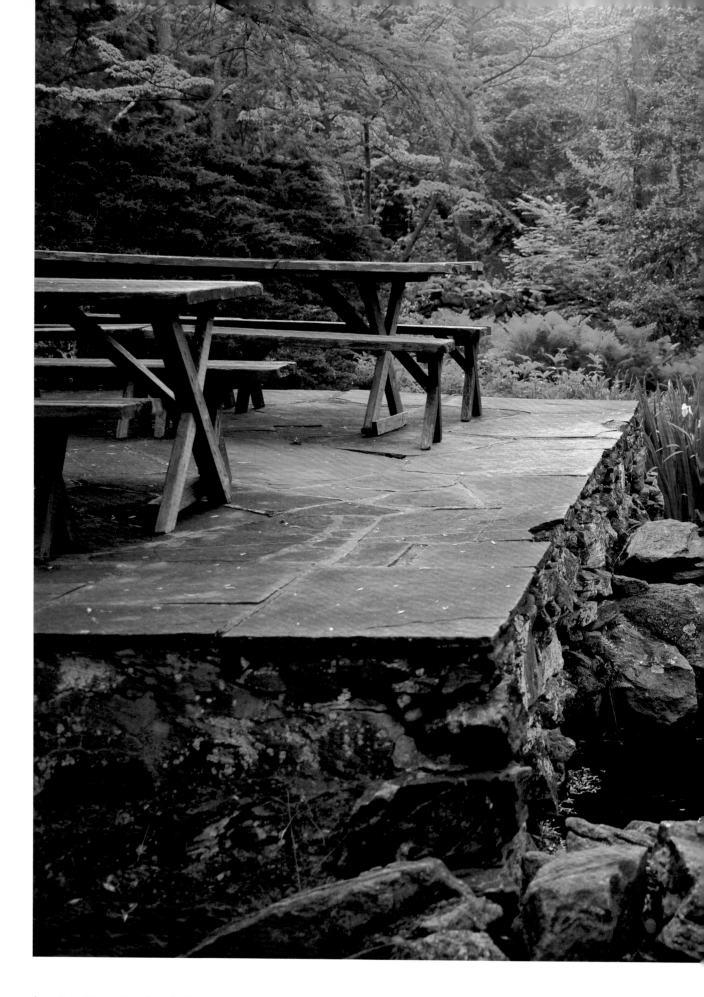

A small pond lined with yellow iris (*Iris pseudacorus*), pink evening primrose (*Oenothera speciosa*), and leafy hostas.

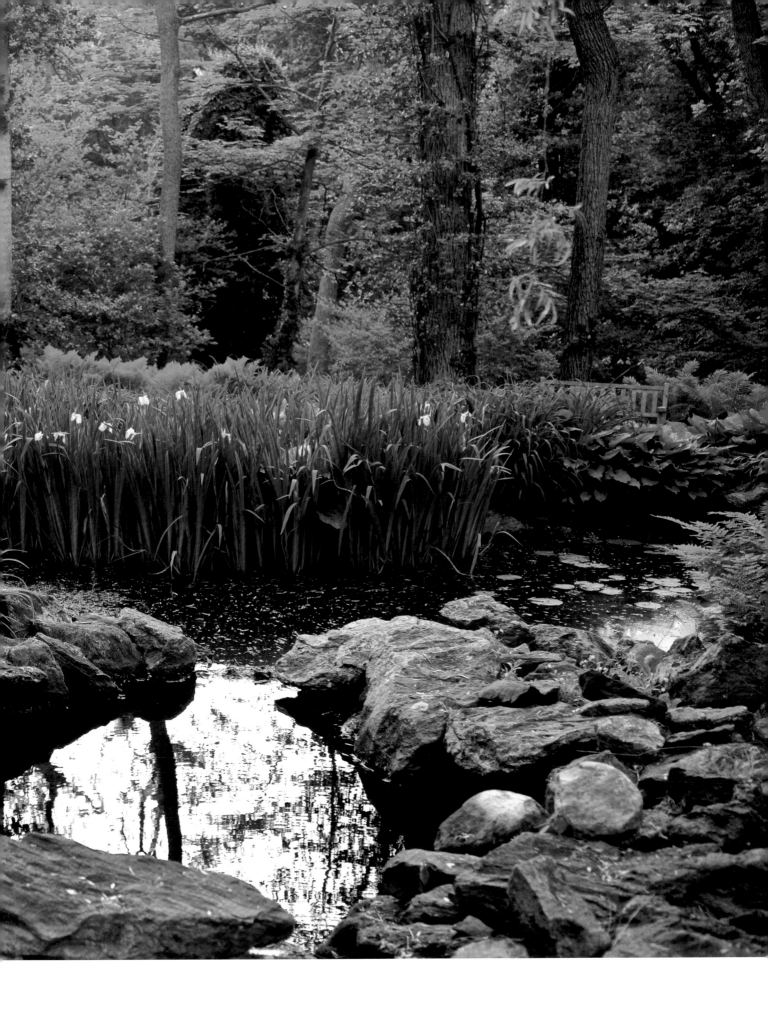

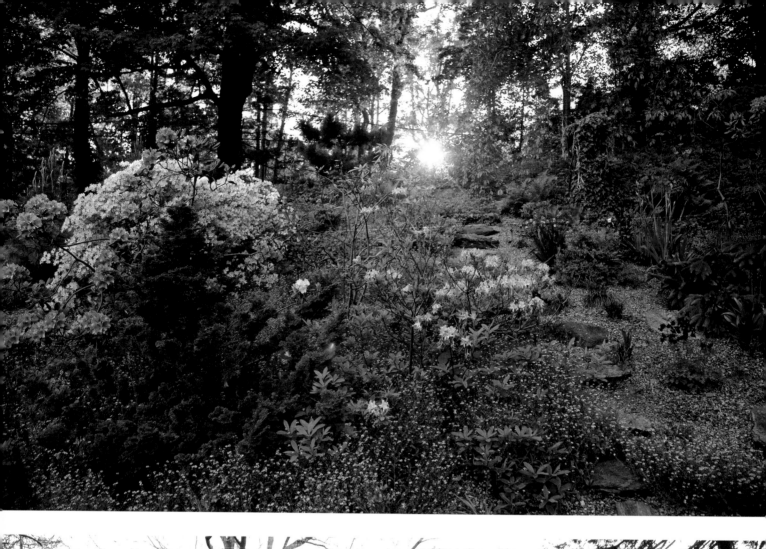

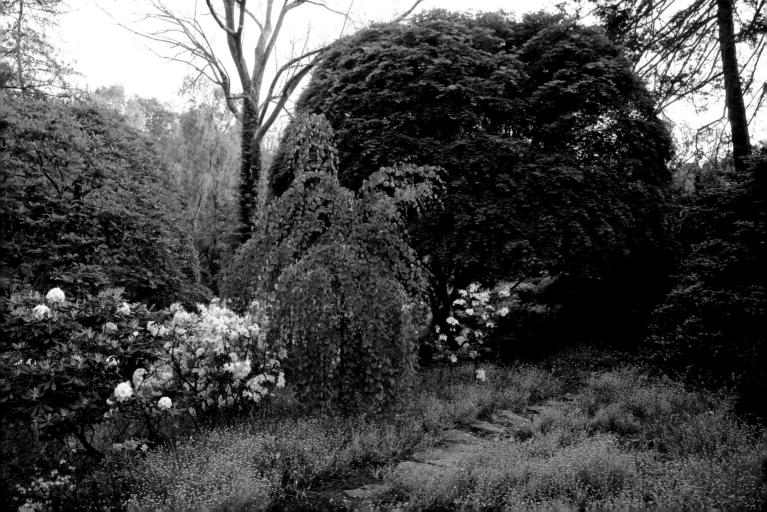

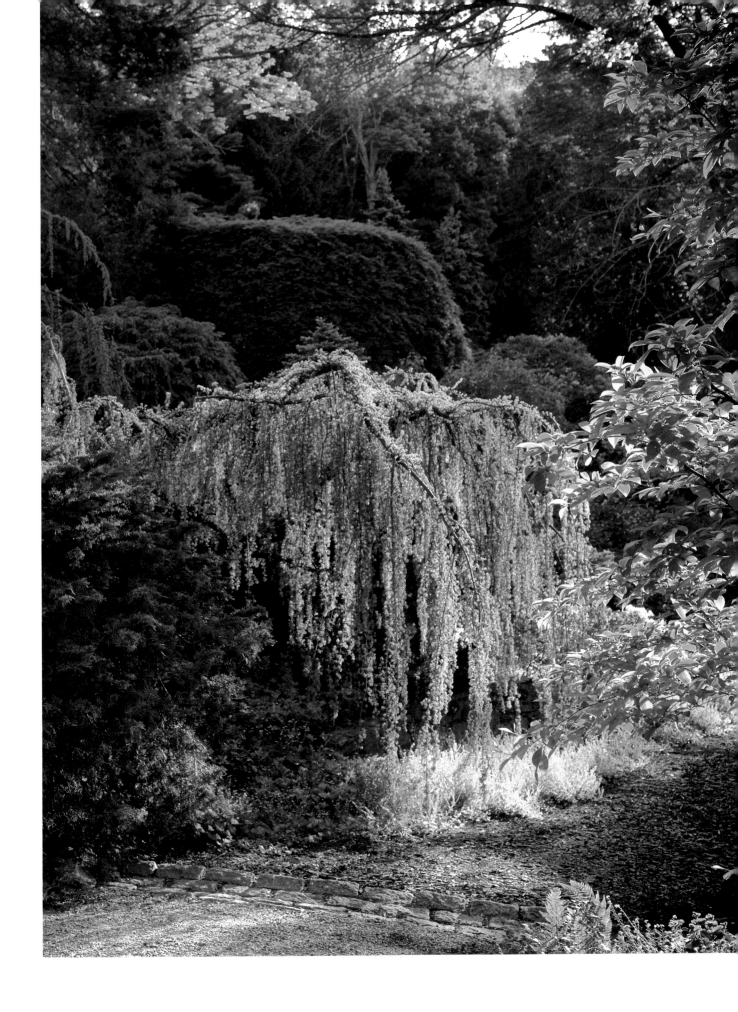

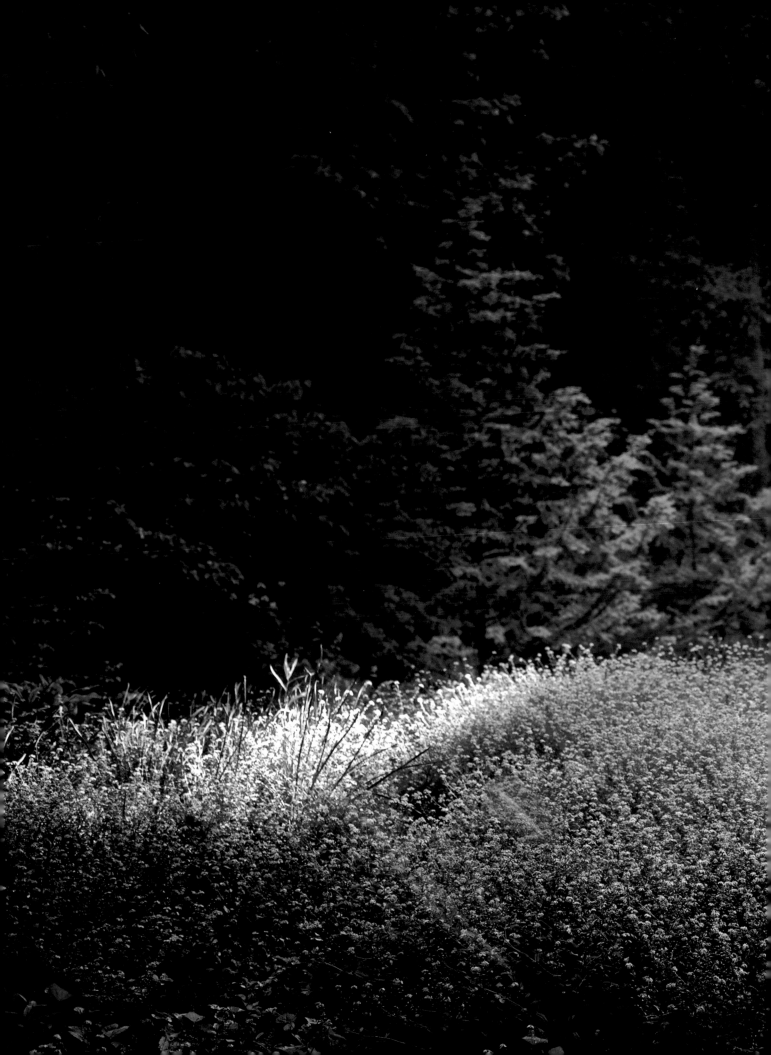

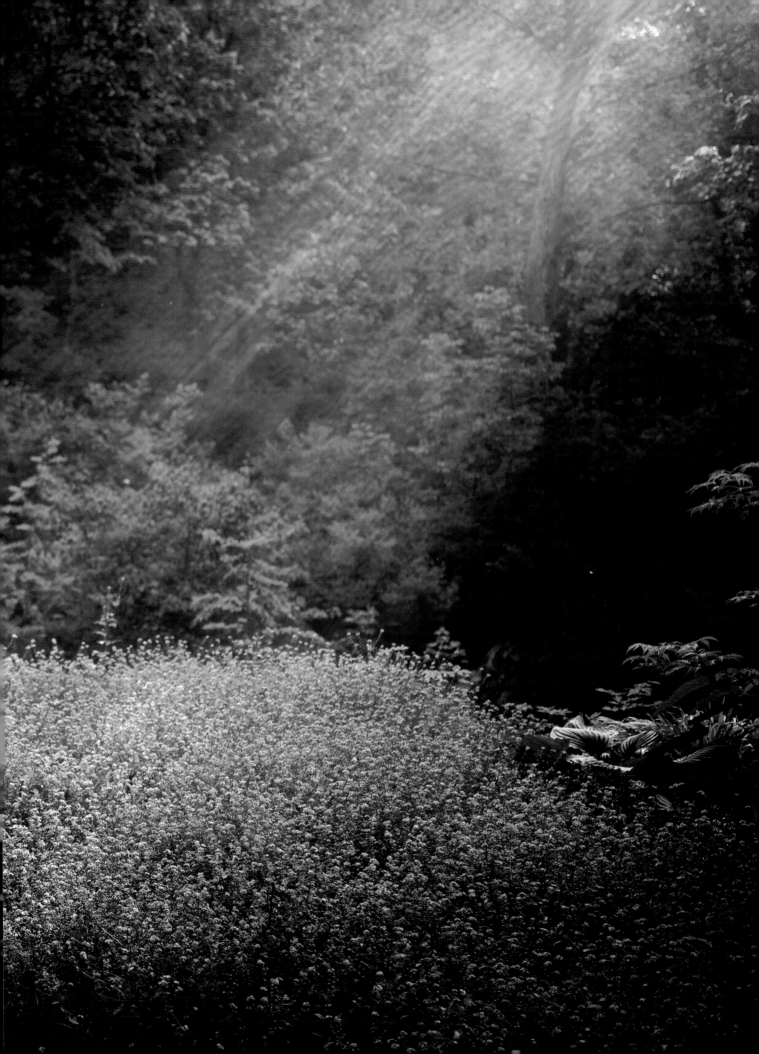

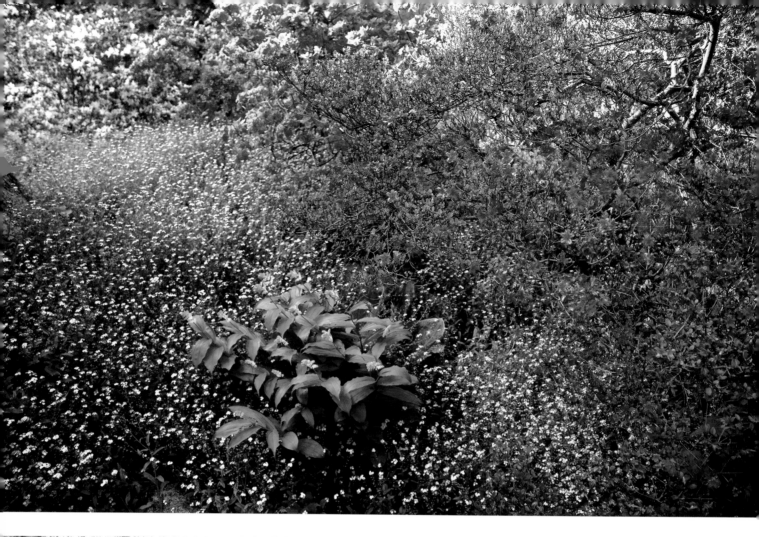

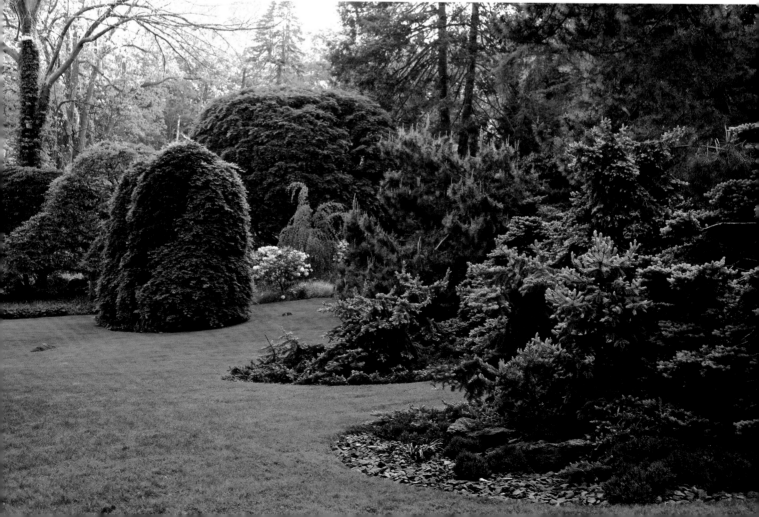

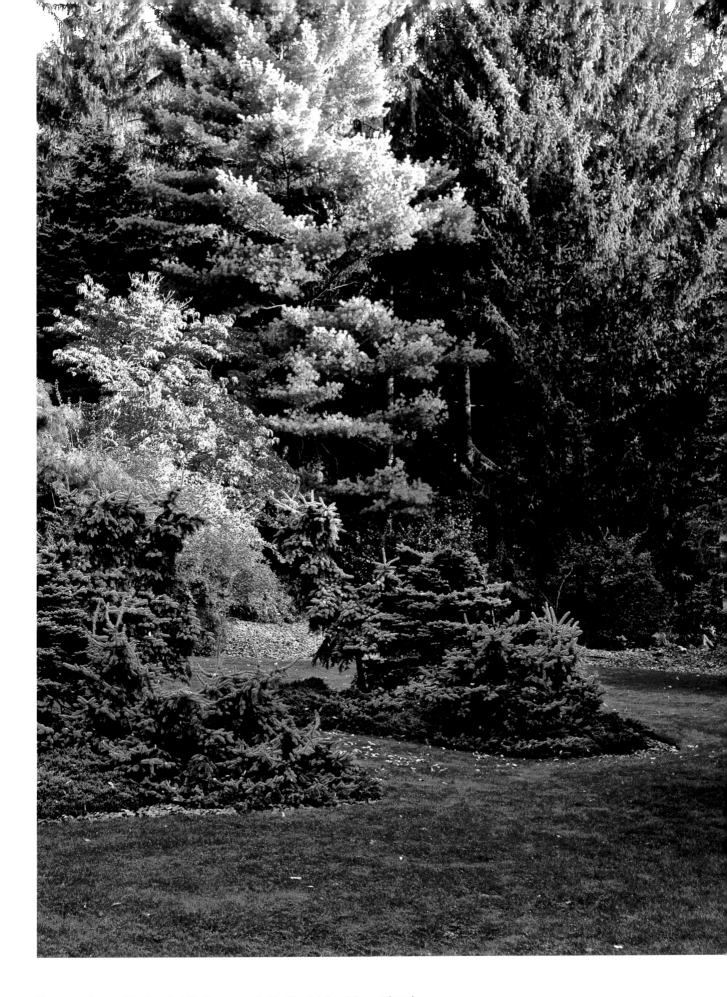

Mature specimens of black walnut (*Juglans nigra*) and ash (*Fraxinus*) are complemented by recent additions of weeping beech (*Fagus sylvatica* 'Pendula') and dawn redwood (*Metasequoia*) among an impressive collection of magnolias and conifers.

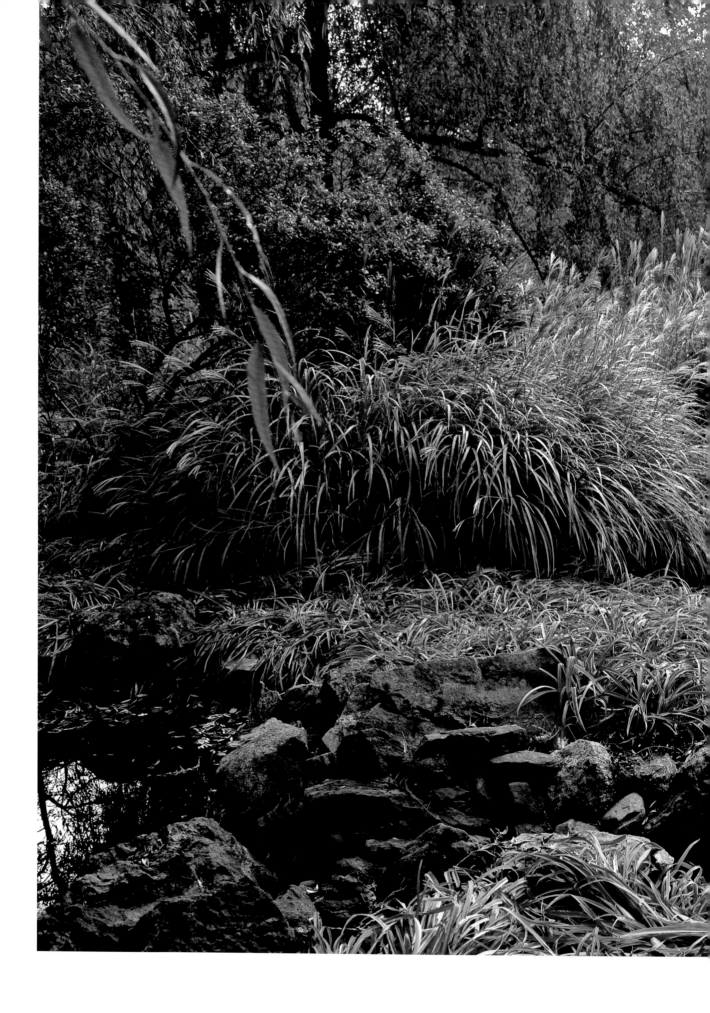

Ornamental grasses edging a pond.

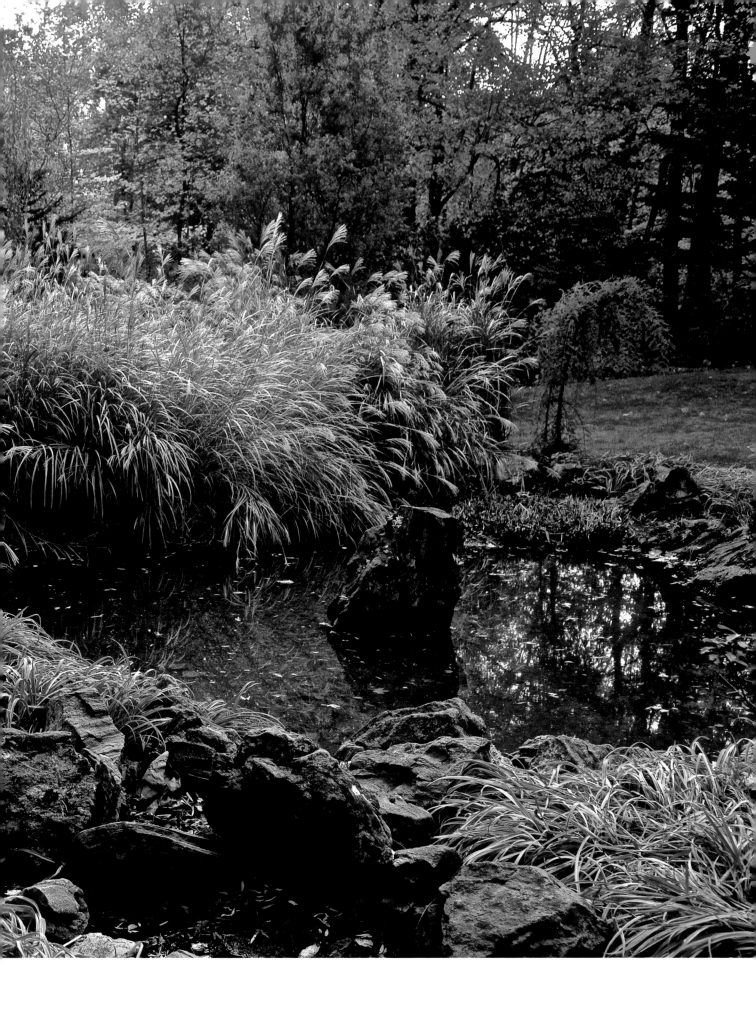

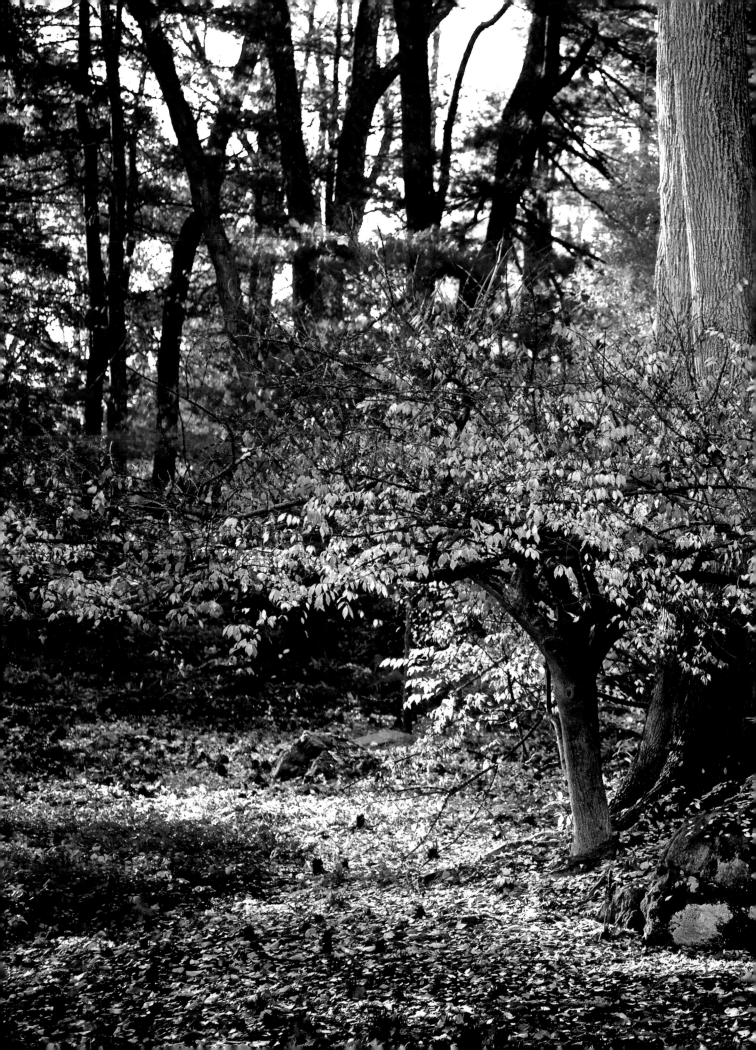

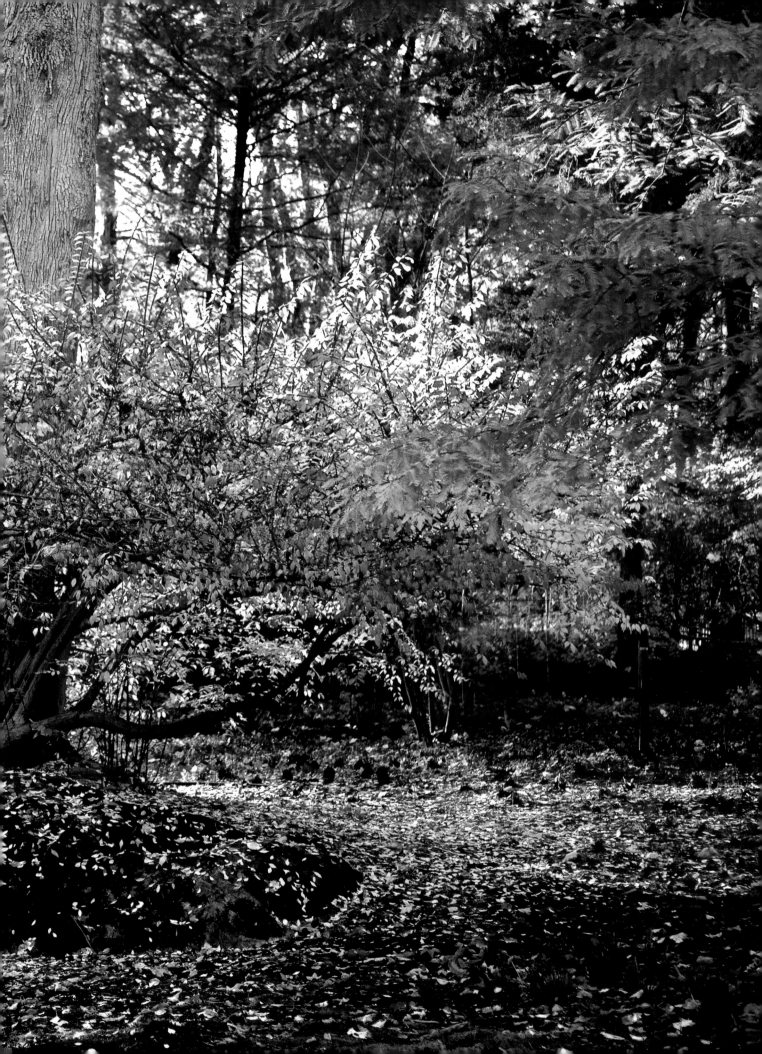

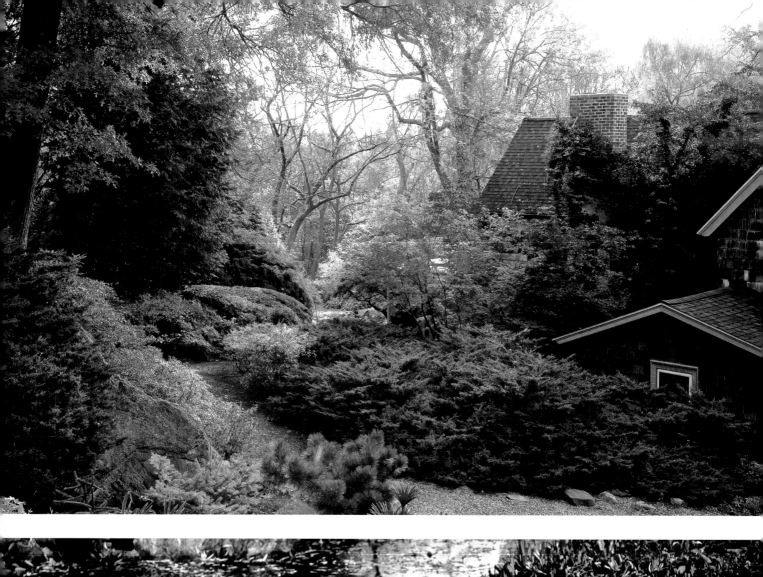

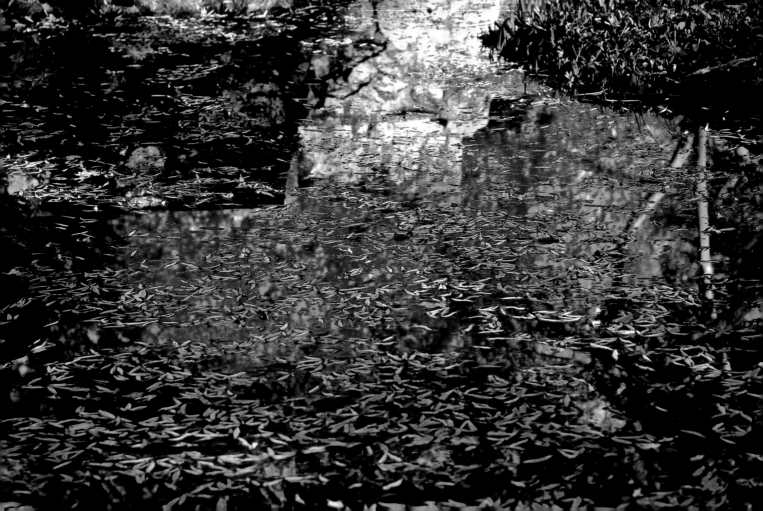

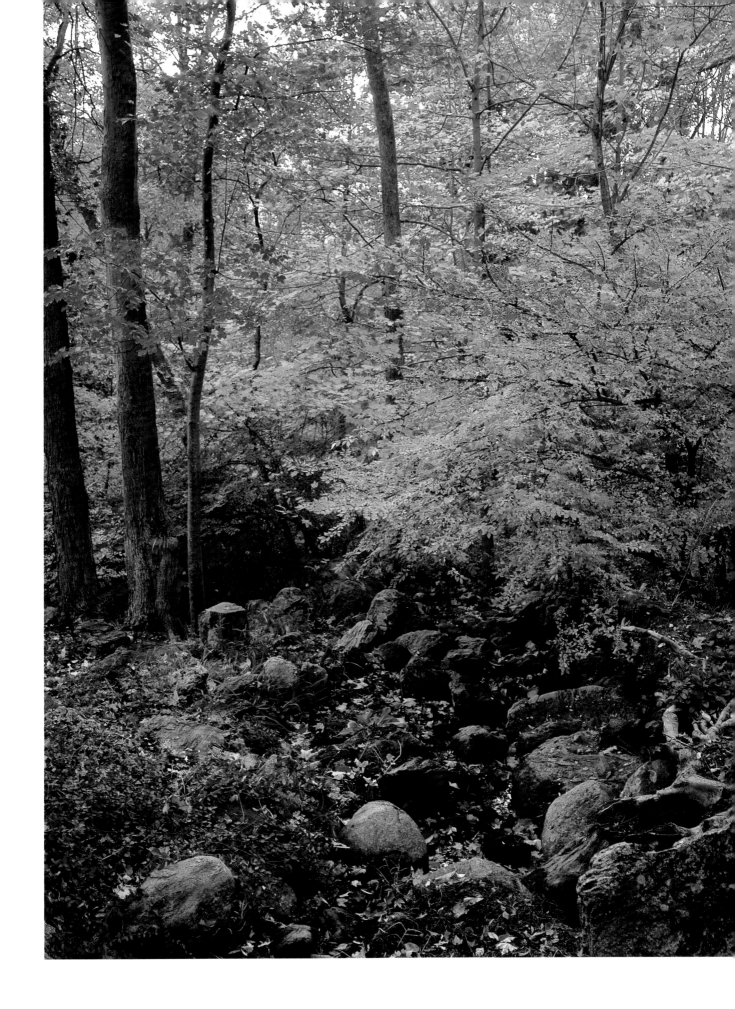

A never ending symphony for the senses
measures the passing of the seasons.

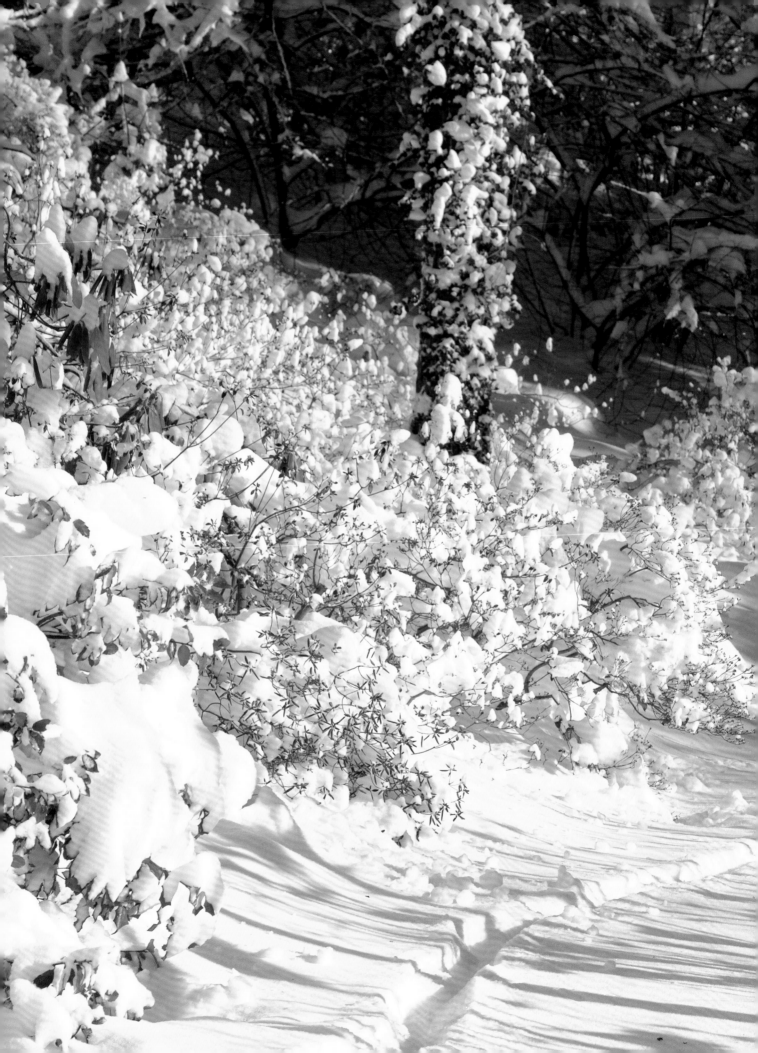

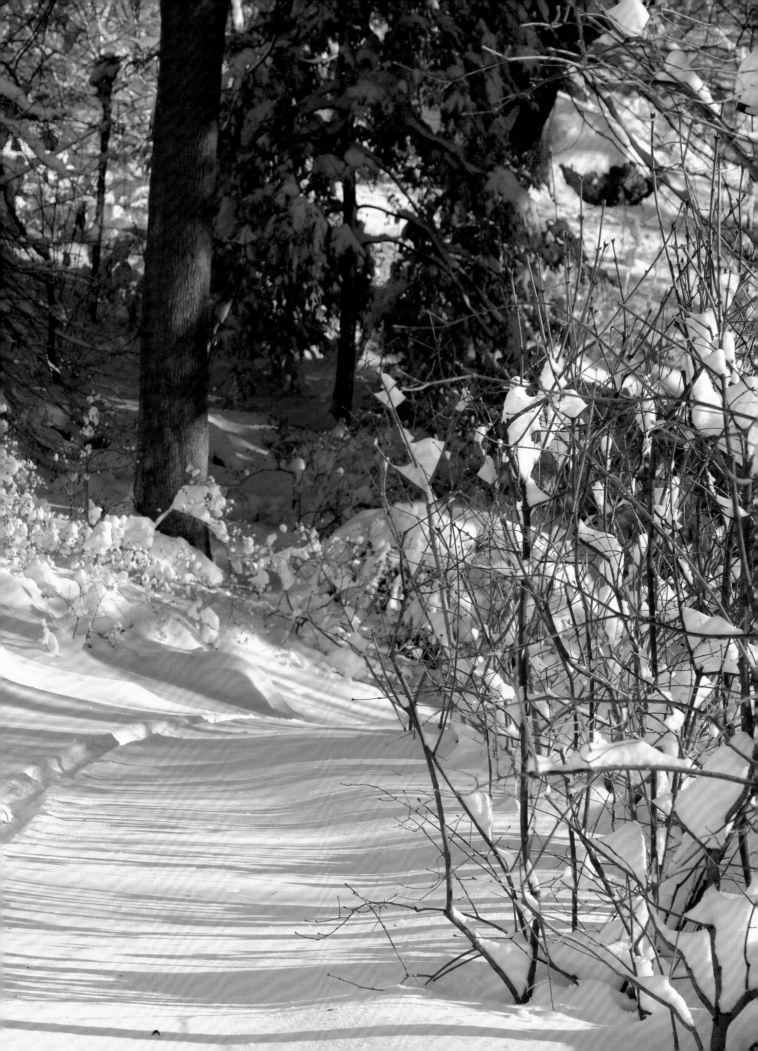

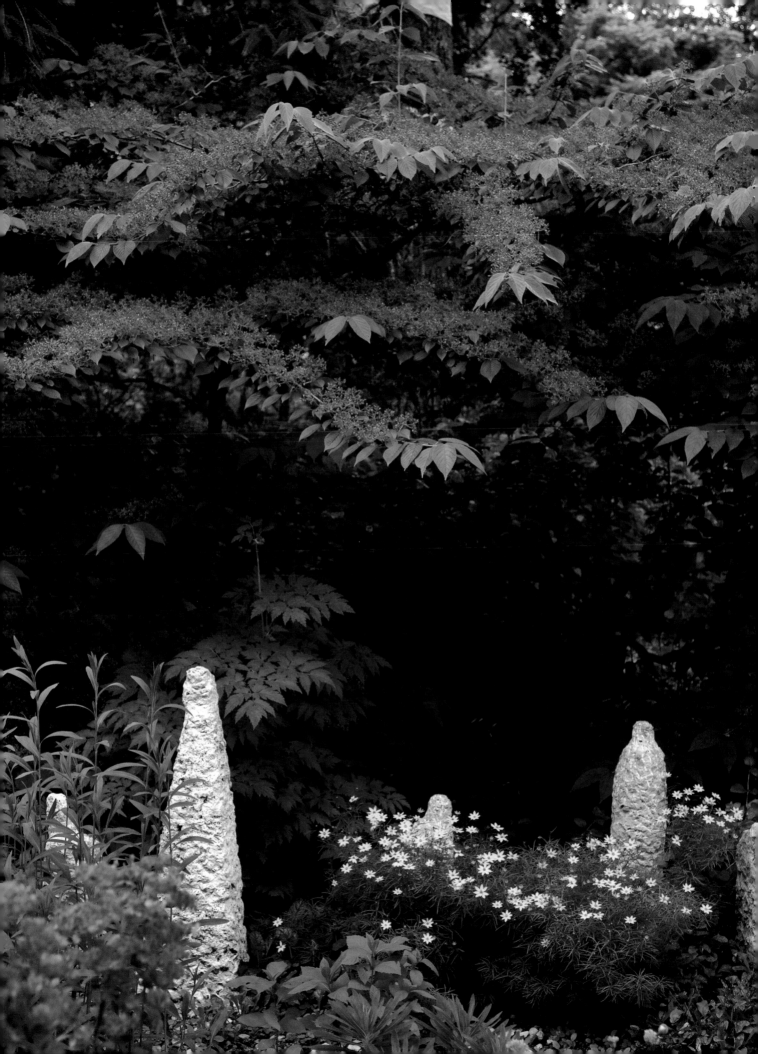

Inspired Nonconformity

EAST HAMPTON, NEW YORK

In 1975, renowned textile designer Jack Lenor Larsen acquired sixteen acres of old wooded farmland near the eastern tip of Long Island. The original motivation was to stave off encroaching development, but Jack, a lifelong gardener who from a young age liked to collect wildings and garden for his neighbors, couldn't resist the blank canvas of the property. In the ensuing years, the sculpture gardens of LongHouse Reserve have come to fully reflect his colorful, joyful, and ever-creative approach to life. As he stated in a *New York Times* interview, "I wanted LongHouse to introduce people to an alternative lifestyle, to encourage them to be inventive and nonconformist."

Inspired noncomformity is just what visitors to the gardens will find: a quirky and fanciful integration of nature, art, and design. Jack freely admits he doesn't know the scientific names of any plants, but it's the landscape that is his medium, the landscape where he wields his artistry with such panache. Visitors are delighted not only by the various permanent and temporary sculptures on display by the likes of Dale Chihuly, Willem de Kooning, Buckminster Fuller, Kiki Smith, and Yoko Ono, but also by the great lawns and allées, the walking paths and sandy dunes, the wooded glens and a lily pond. The grounds also boast an amphitheater and a croquet court. Jack's favorite seasons in the gardens are spring and fall, when what seems like millions of daffodils (*Narcissus*) color the views. Throughout, visitors find vibrant collections of conifers, hundreds of flowering trees, ornamental grasses, and other perennials that represent the flora of the region.

The sixteen-room LongHouse building, its design inspired by Japanese Shinto temples, displays traveling art exhibitions and the best of Jack's collected ephemera from over many decades. It also archives hundreds of his original textile designs as well as 2,500 ethnographic fabrics. Set up as a nonprofit from the start, LongHouse Reserve is a place where, in Jack's words, "visitors experiencing art in living spaces have a unique learning experience—more meaningful than the best media."

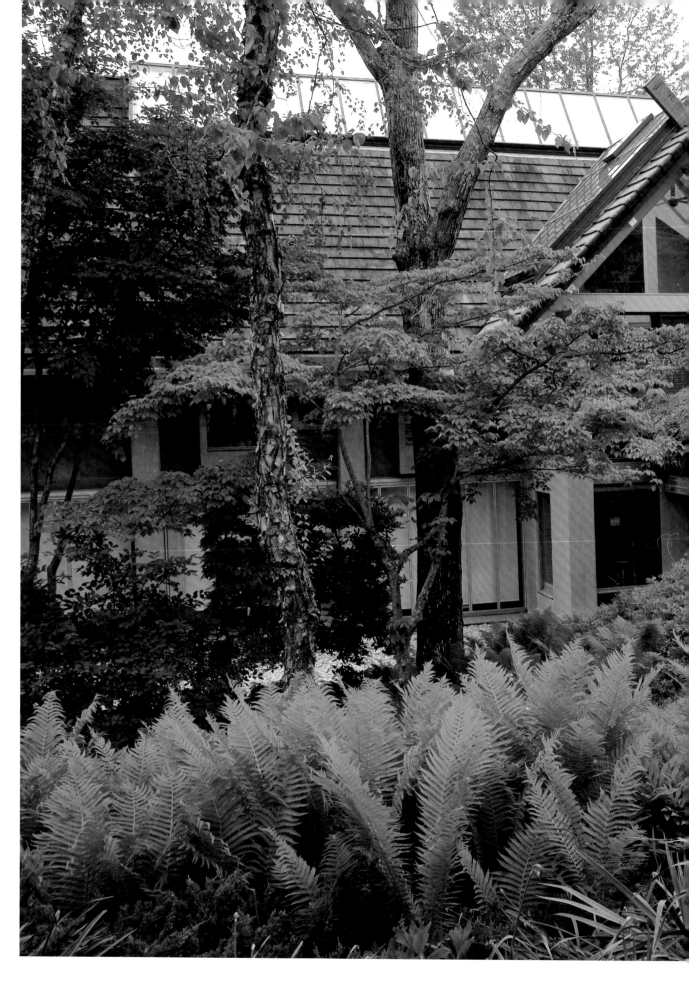

Previous spread: Artwork by Atsuya
Tominaga, *Ninguen*, 2008, marble. This
spread: A view of the LongHouse building
with its Shinto-inspired architecture.

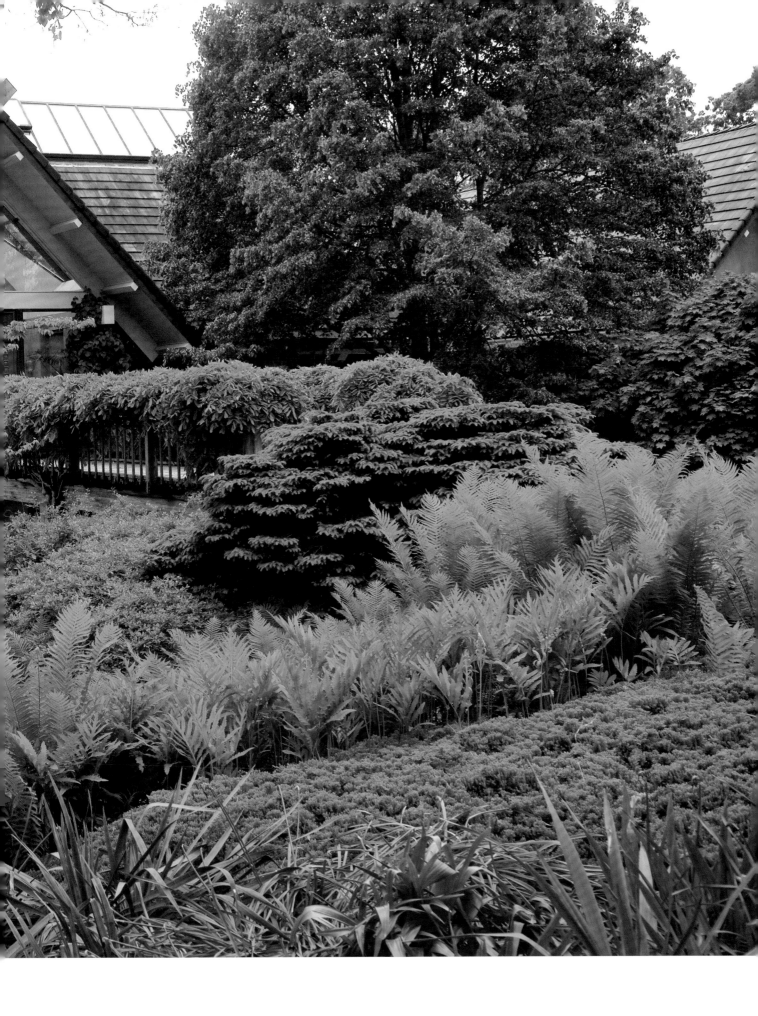

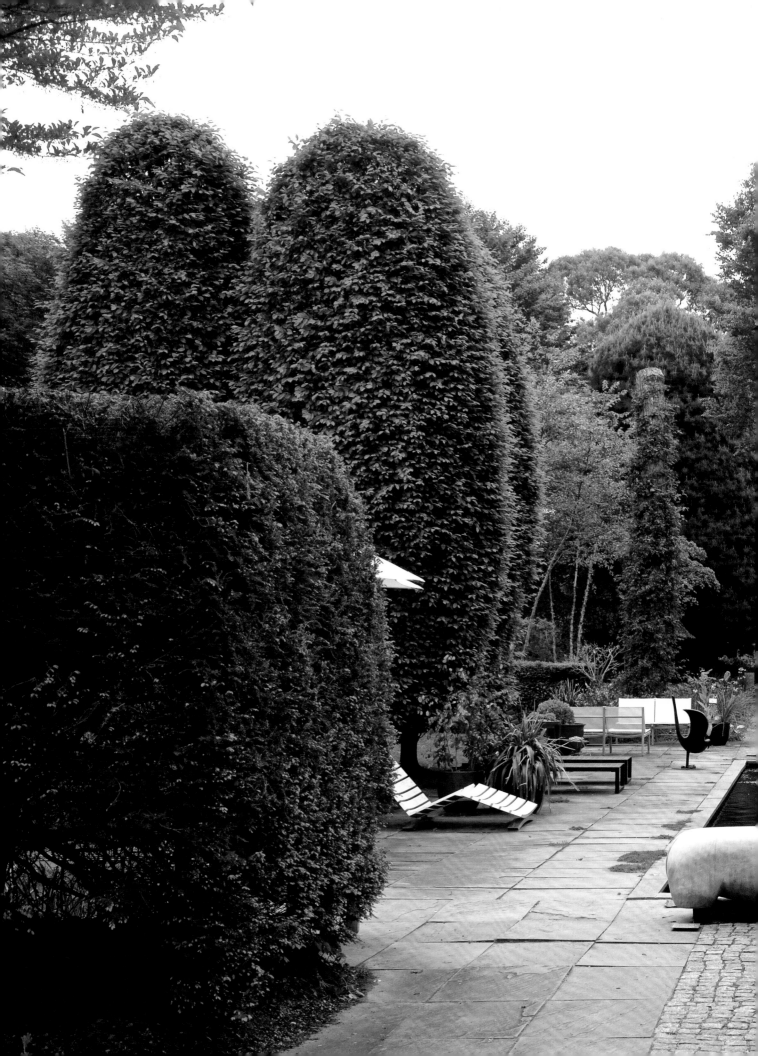

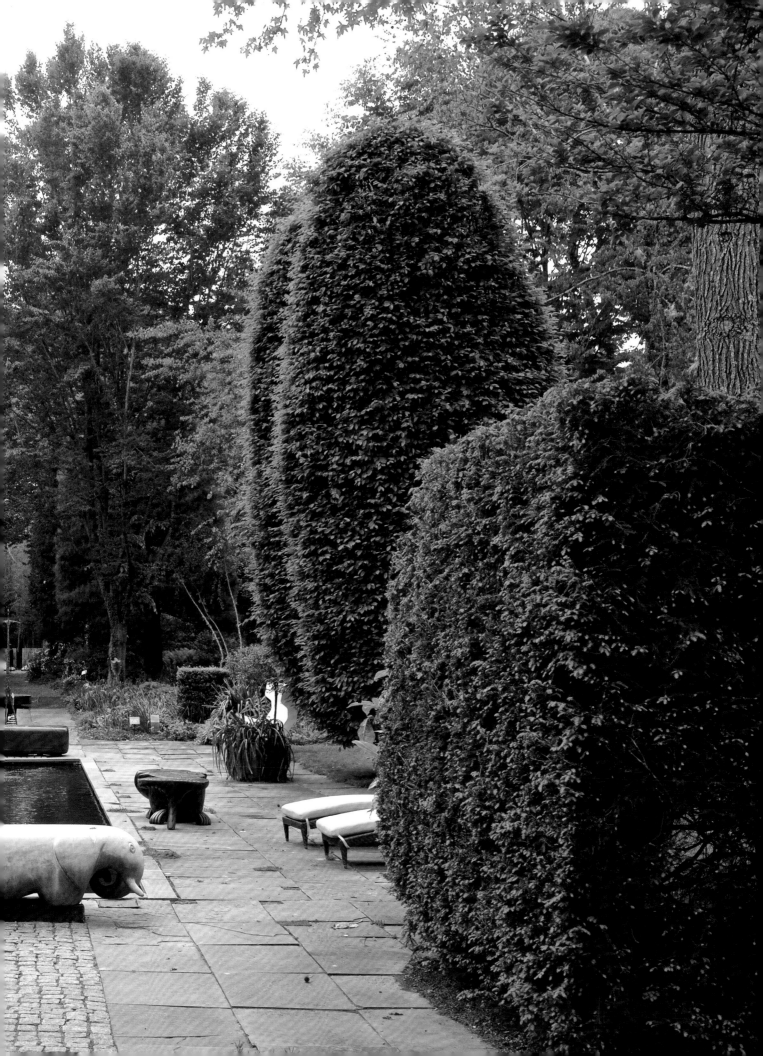

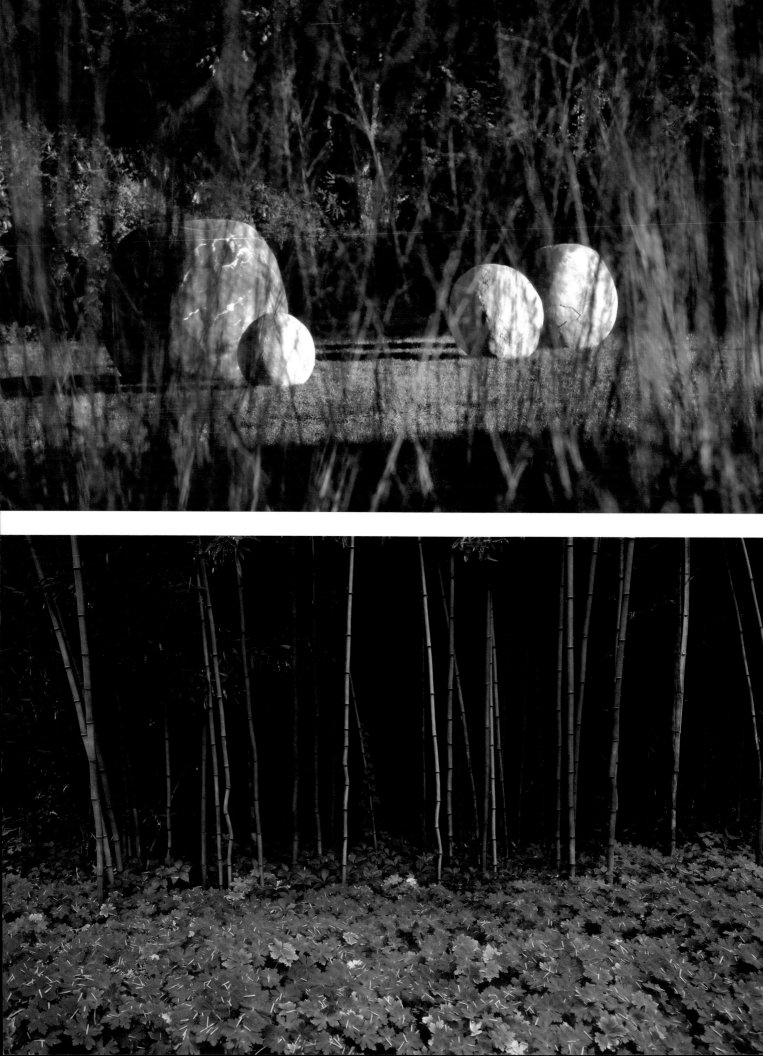

Visitors can appreciate man-made
sculptures like Grace Knowlton's
Untitled (5 Round Forms) (1985)
nestled among nature's own arresting
creations. Previous spread: Artworks
by Judy Kensley McKie: *Elephant
Bench* (2008), *Fish Bench* (1999),
and *Seagull Chair* (date unknown).

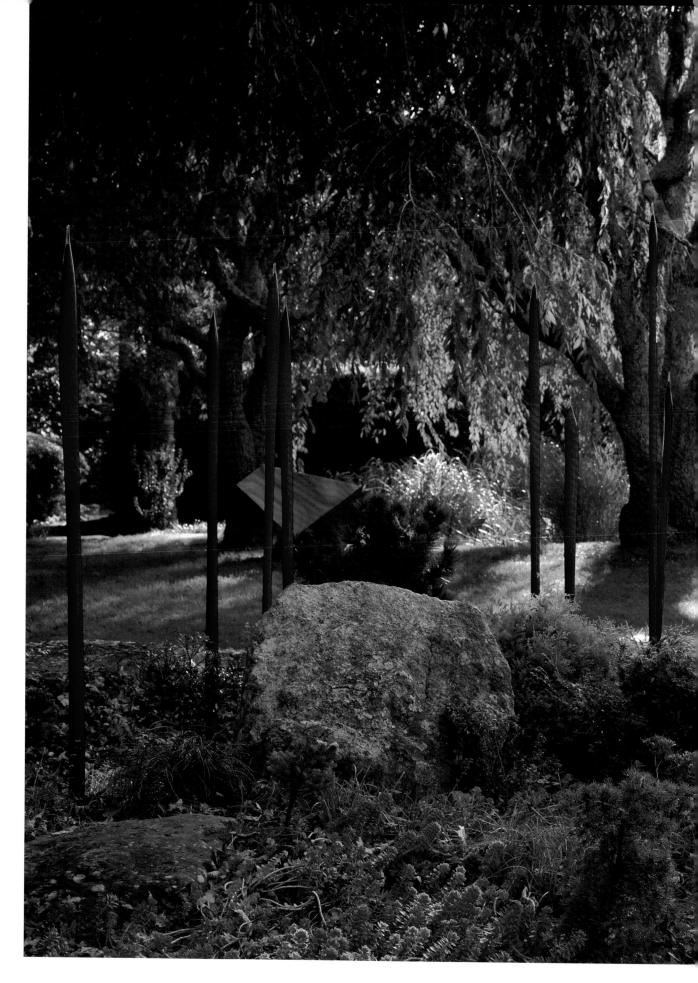

Glass-blown *Cobalt Reeds* (2000) by Dale
Chihuly stand like alien cacti in a cozy bower.
Following spread: Artwork by John
Chamberlain, *Pineapple Surprise* (2010).

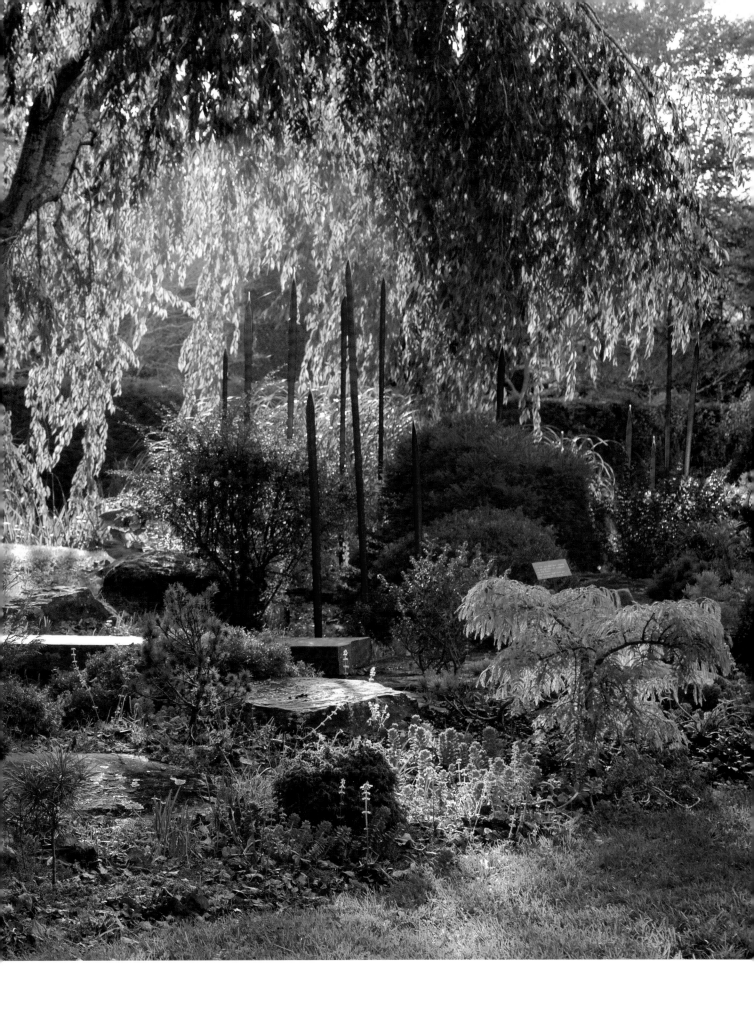

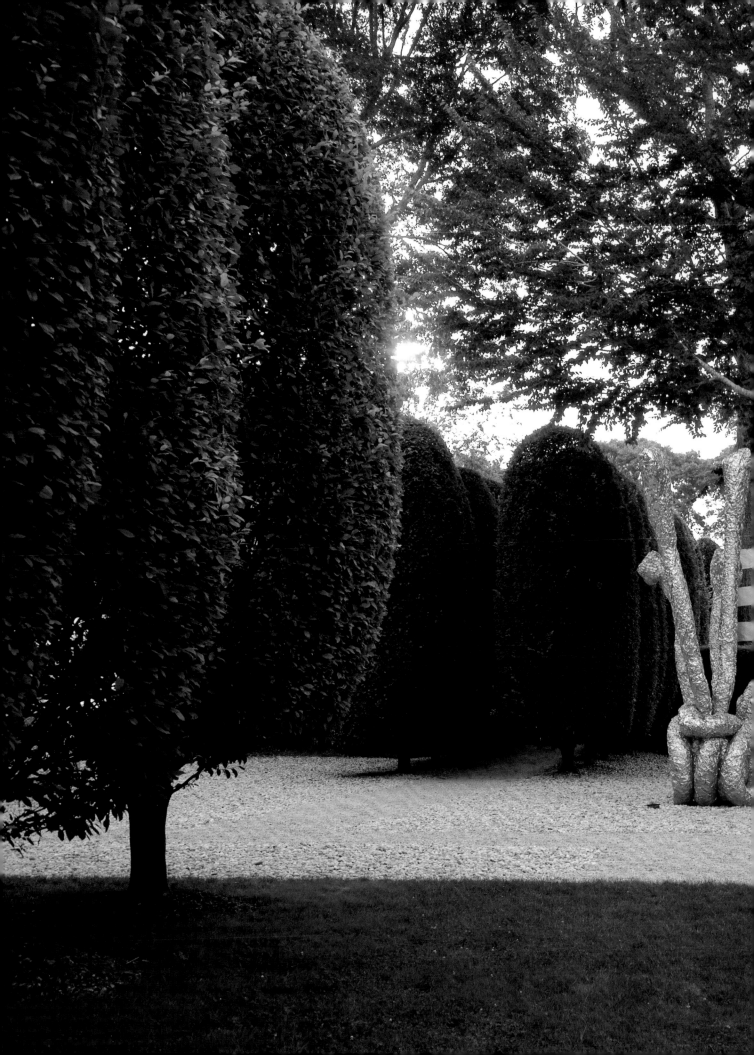

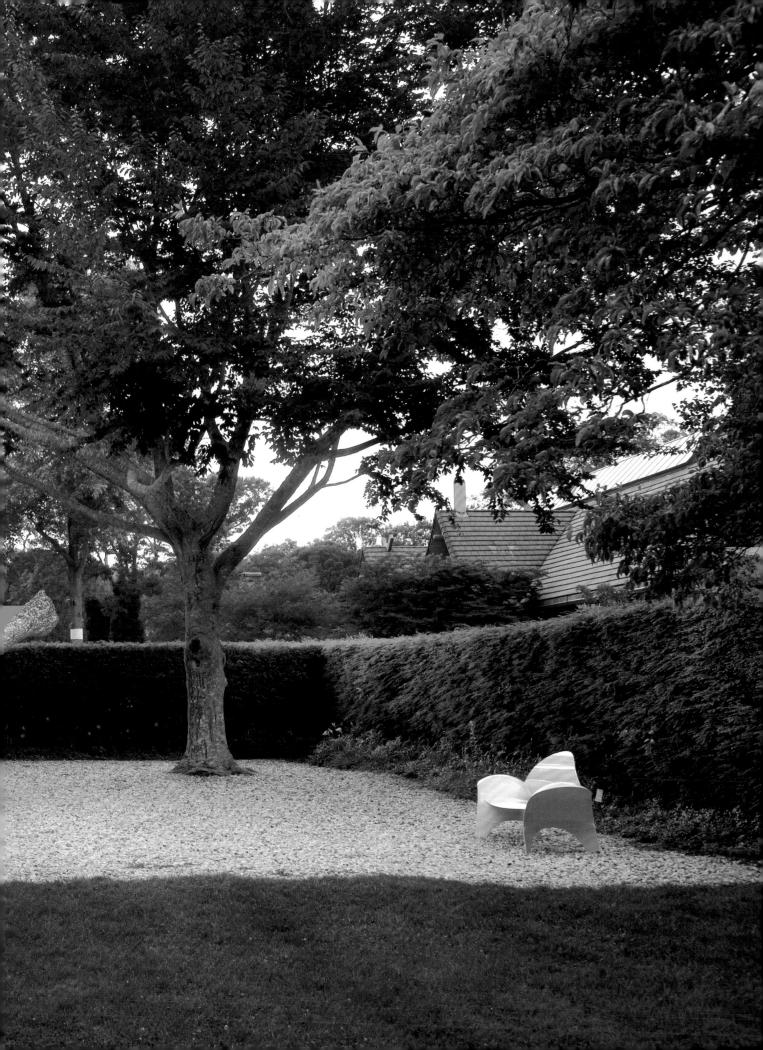

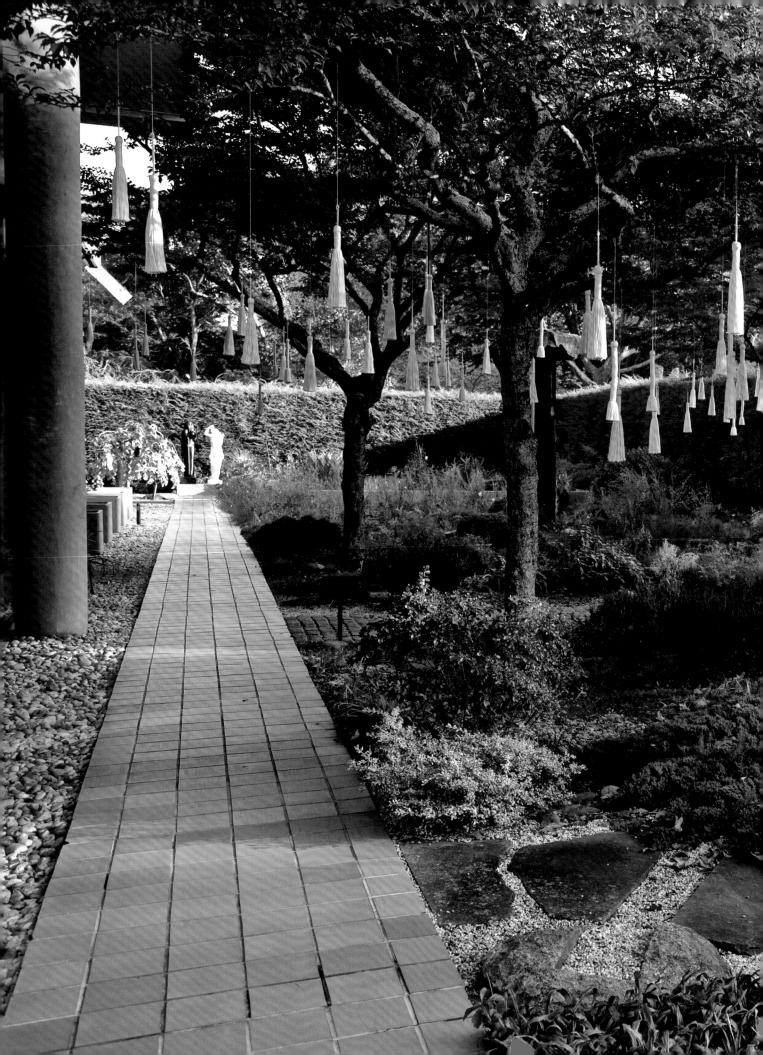

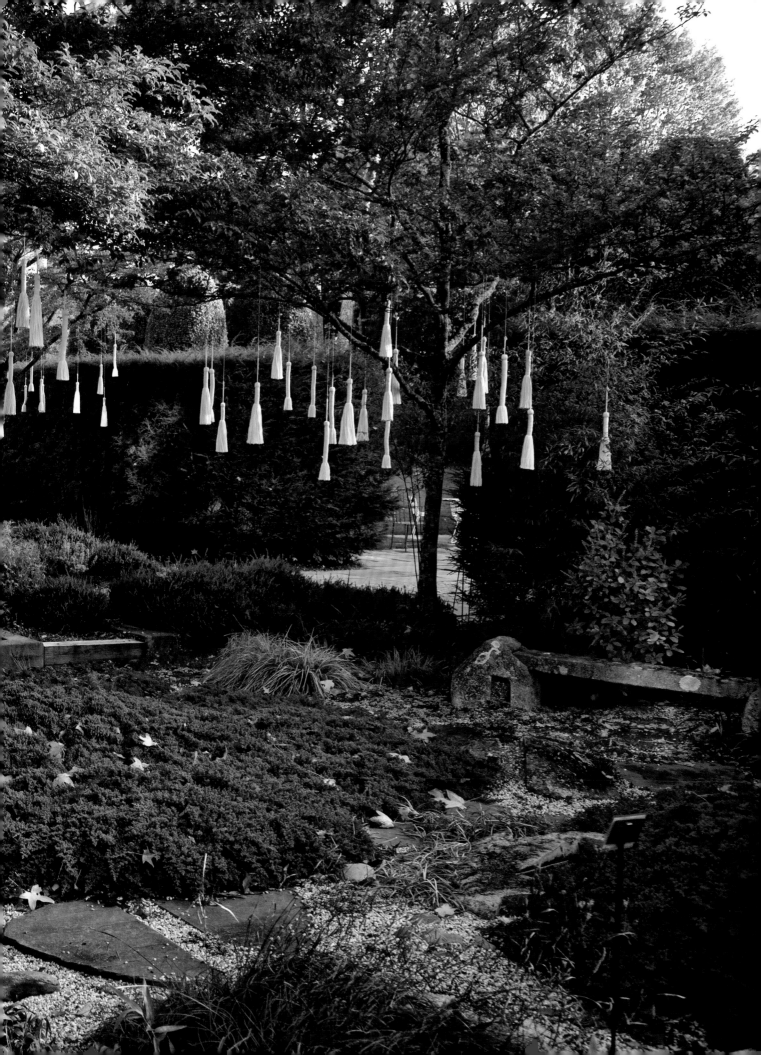

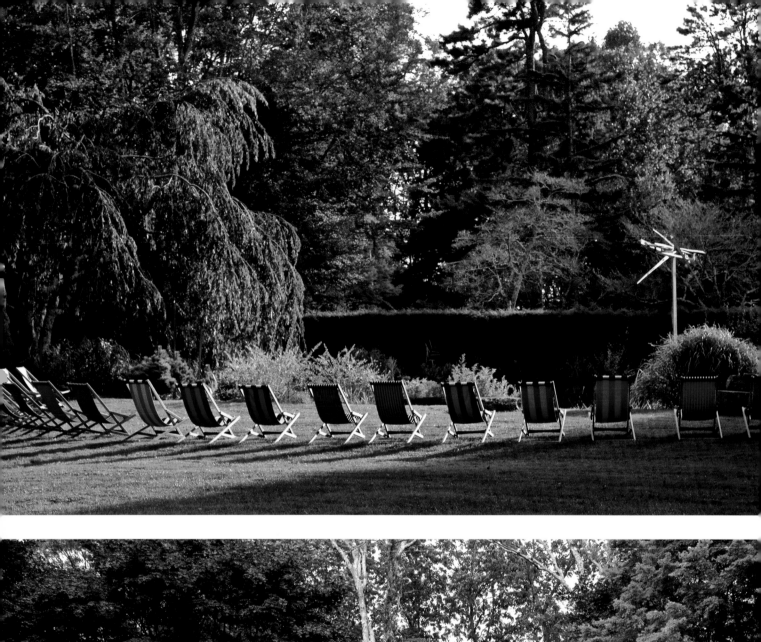

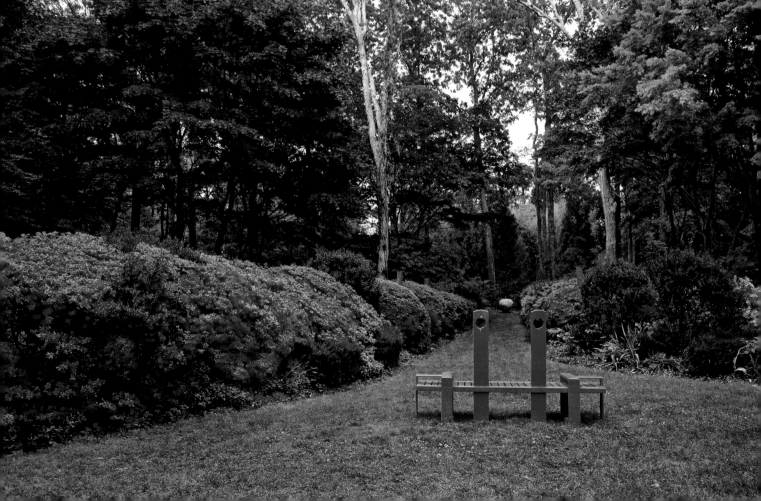

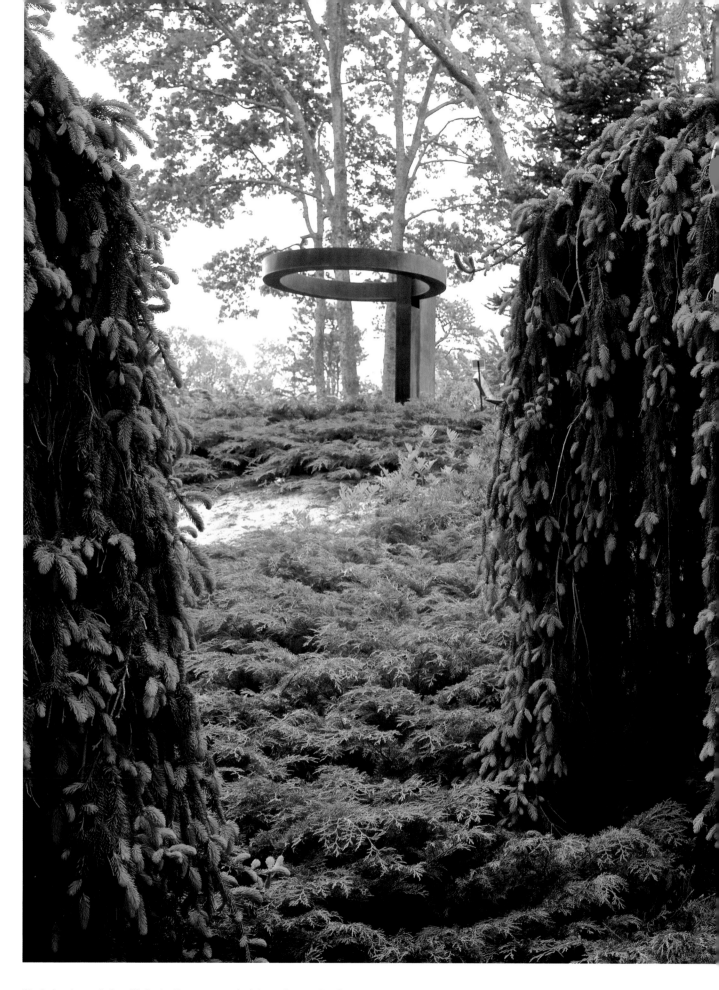

Clockwise: Lawn chairs with Sunbrella
fabric; *Eye of the Ring* (2007) by
Takashi Soga; and *Study in Heightened
Perspective* in the Red Garden by

Jack Lenor Larsen. Previous spread:
White tassels by Sunbrella. Sculpture
at the end of the path by Fred Wilson,
Mete of the Muse (2006).

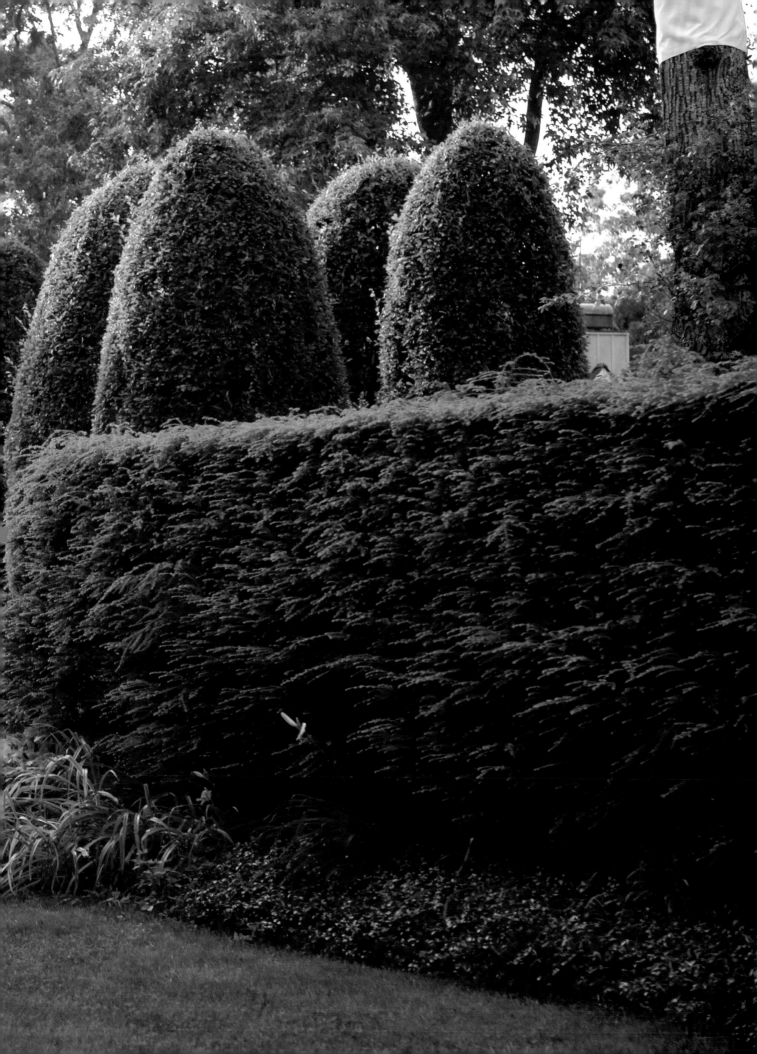

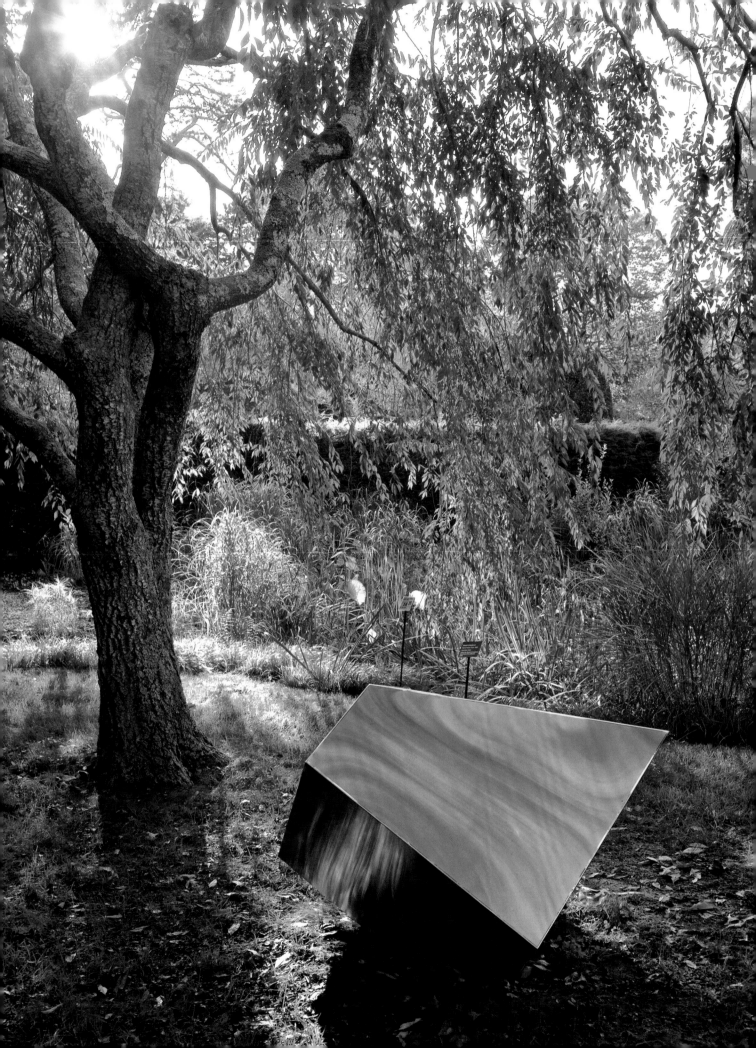

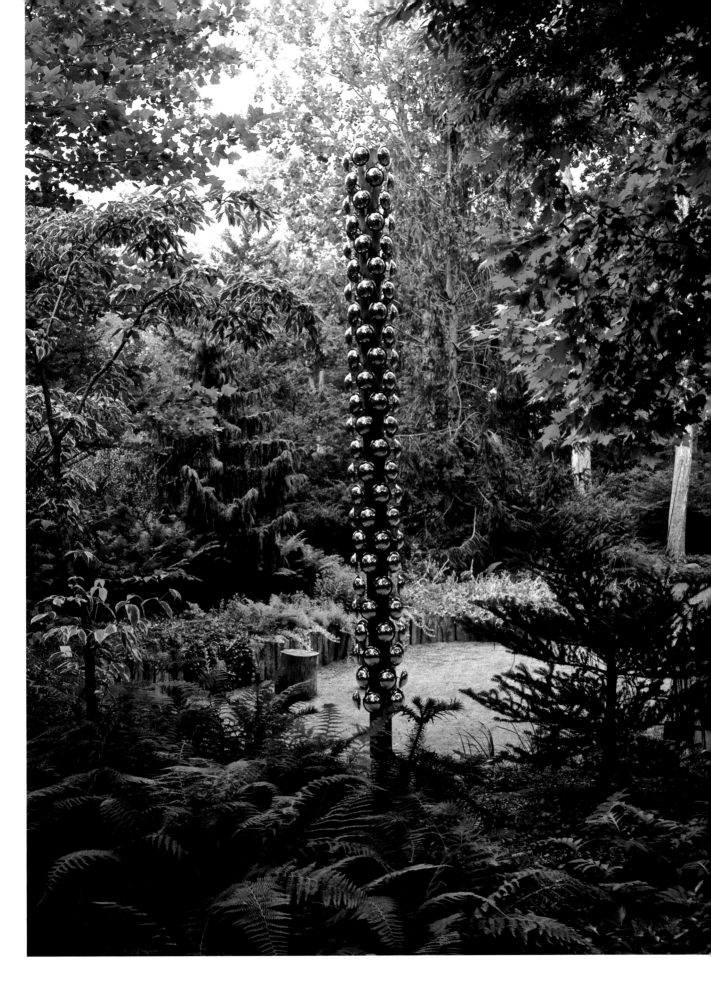

Left: *Spirit House Chair* (2006) by Daniel Libeskind. Above: *Would That I Wish For (Tall Totem)* by Marko Remec. Following spread: *6 Lines in a T II* (1966–1979) by George Rickey.

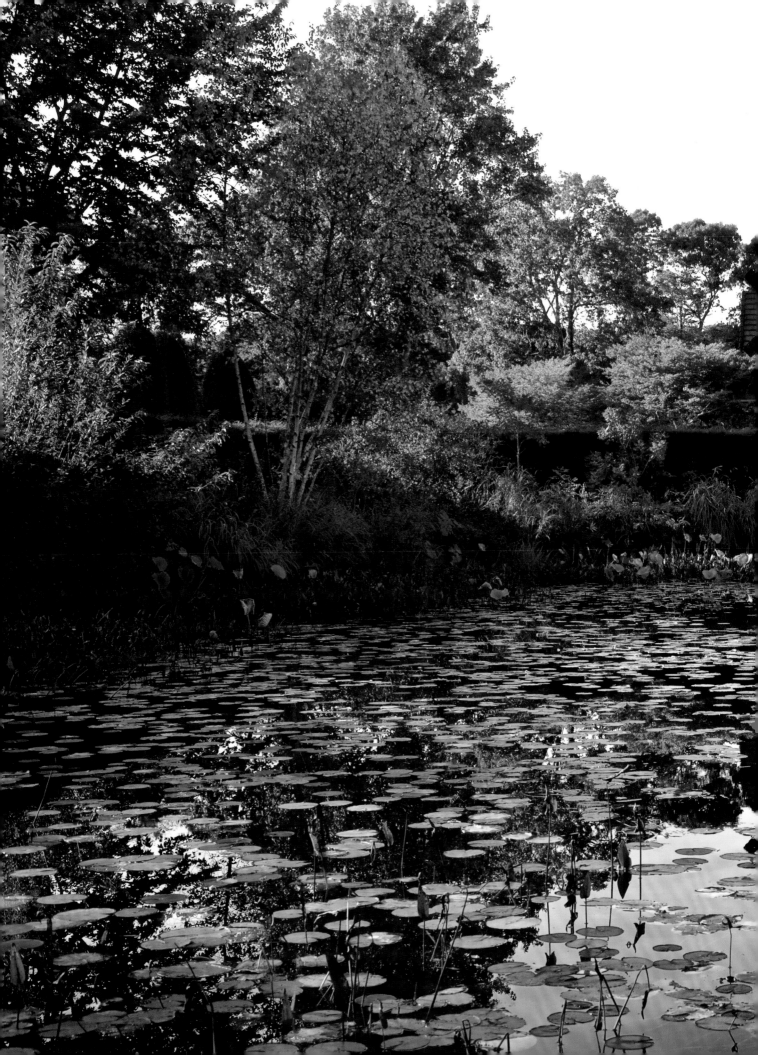

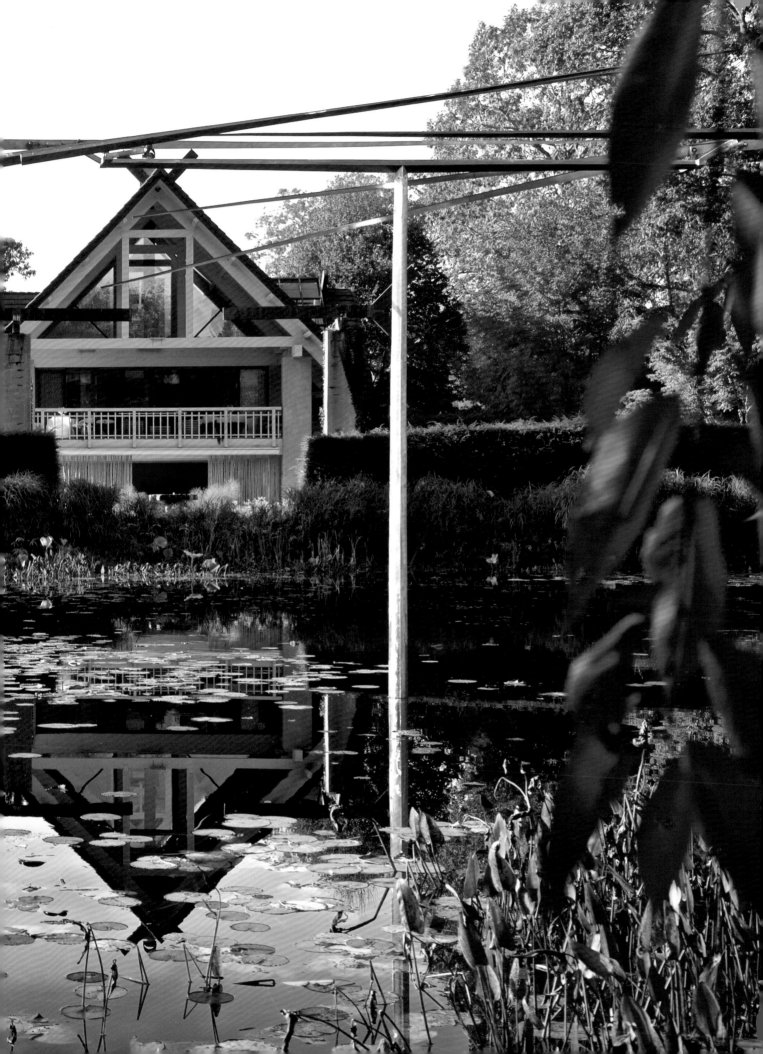

A Journey of Discovery

SCARSDALE, NEW YORK

When Florida-based landscaper Jorge Sánchez was presented with an overview of Southlawn's nine-acre property in New York's Westchester County, he was struck by a vision that his client, an active, outdoor-loving family, quickly championed. Thinking outside the box—specifically, outside the property's original setup as a subdivision—Jorge envisioned a garden as a journey of discovery, a living dream of wildflower meadow, woodland walks, and even bubbling stream, among other features. The mission was to realize this dream without straining the local environment and at the same time minimizing the cost of maintenance.

To hew to their design goals, the general plan was to establish large areas "with a natural, wild appearance." (Large areas in a garden provide a stability while limiting environmental stress.) And in deference to the original house, designed by prominent American architect Charles A. Platt in 1917, they wanted to give the site "an appearance of an estate that had been there for a nearly a century," even though the garden would be new. The play of light and shade would also be imperative. "Our intellect and emotions," Jorge says, "react well to this pleasant change: nature is a good medicine, and a walk in a beautiful garden will calm one's feelings."

The cycles of nature are continually reflected in the garden's many pleasures. As one wanders, each change in direction or elevation promises a welcome surprise, like an unsightly marsh improved into a breathtaking wetland, a sea of forget-me-nots (*Myosotis*) dancing in green, horses grazing, and fallen trees arranged into natural sculptures. "It's all part of an initiative to honor what came before as well as an investment in the land's future," says Jorge. To that end, annuals are minimized, owing to their high cost, and also to cut down on waste.

Of many highlights, the Garden Walk stands out. There are various entry points, but Jorge's favorite is by way of the large boulder stairs that lead from the Summer Garden. Mossy floors create lush outdoor rooms while azaleas make bold statements along the walk. At the end of the walk, the fortunate wanderer will encounter the Stumpery. Finding the right stumps for this garden presented an unexpected challenge, until Jorge transplanted the dead stumps of slash pines (*Pinus elliottii*) all the way from Florida. Once installed, the pine stumps were carefully interlaced and sheets of moss were added to create a graceful hideaway glen.

Southlawn is a garden best appreciated throughout the year, artfully presenting a completely different canvas in each season. As Jorge humbly acknowledges, "Nature is an amazing designer."

A series of sweeping blue stone terraces accommodate the knoll on which the property is set.

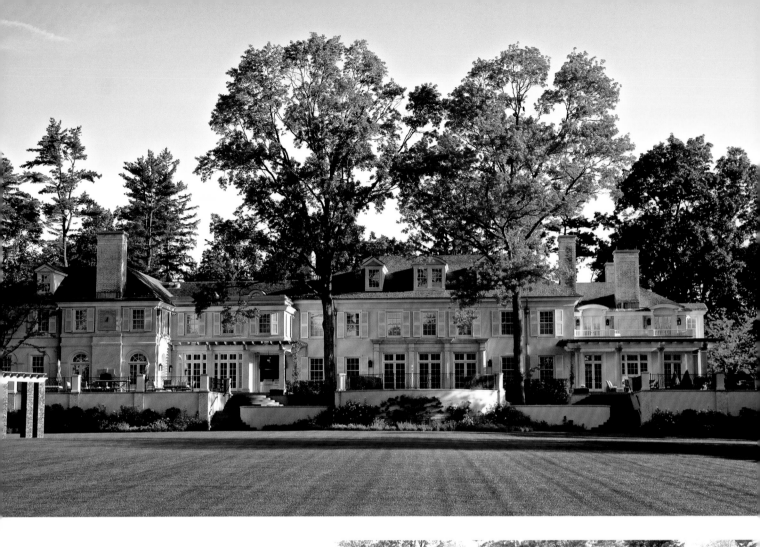

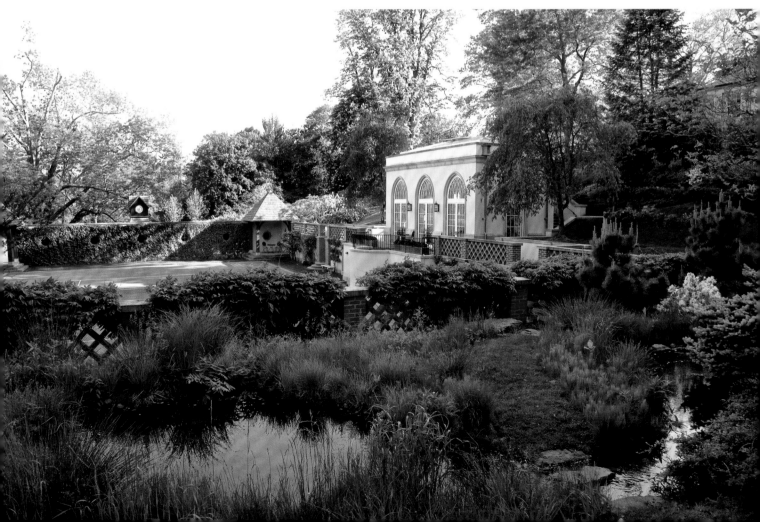

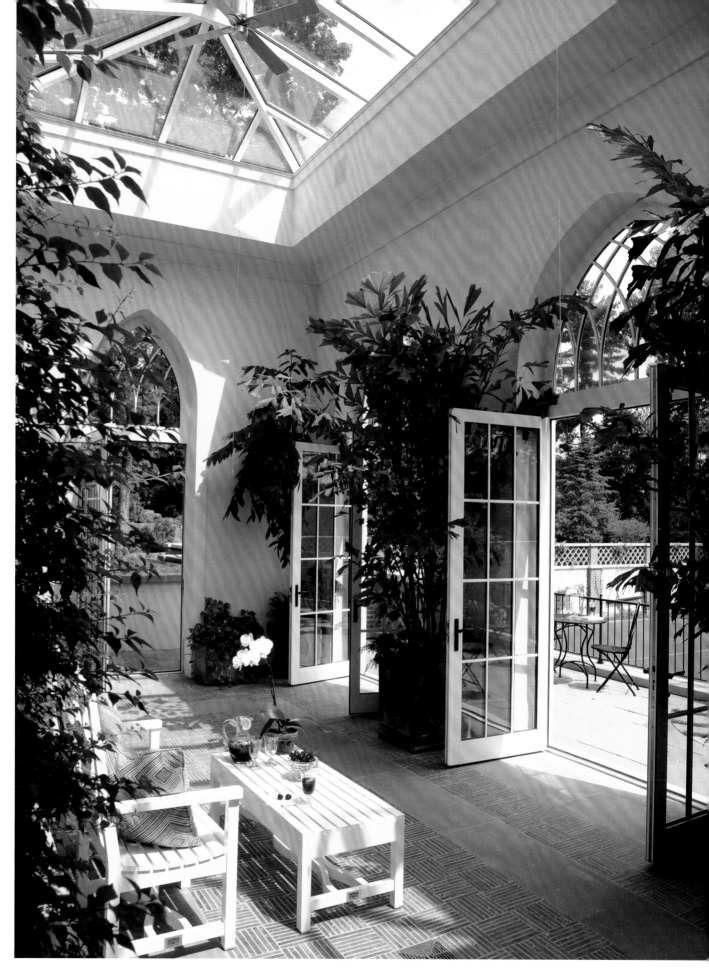

Views of the Main House with a great lawn, an orangerie flanked by a pair of weeping cherry trees (*Prunus pendula* 'Pendula Rosea'), which serves a walled-in tennis court, and a rill with a pleasing series of ponds and falls.

Following spread: Coreopsis fills the wildflower meadow that becomes a tobogganing slope in winter. A mowed grass path serves as a pedestrian passage to the paddock beyond.

159

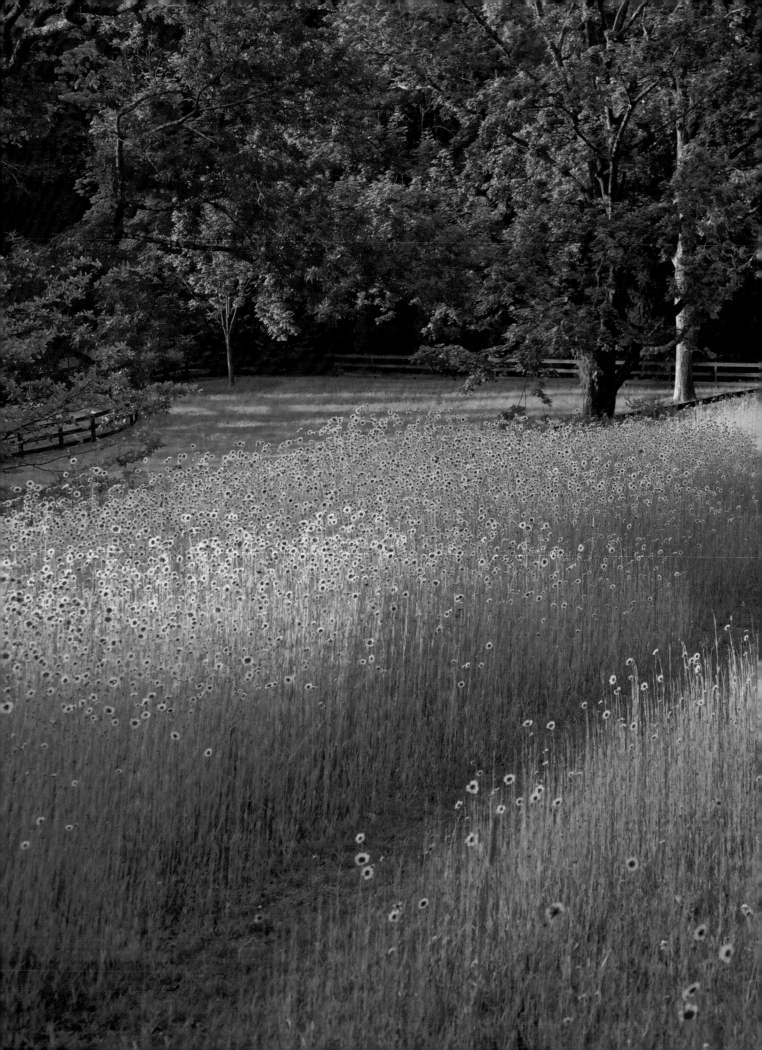

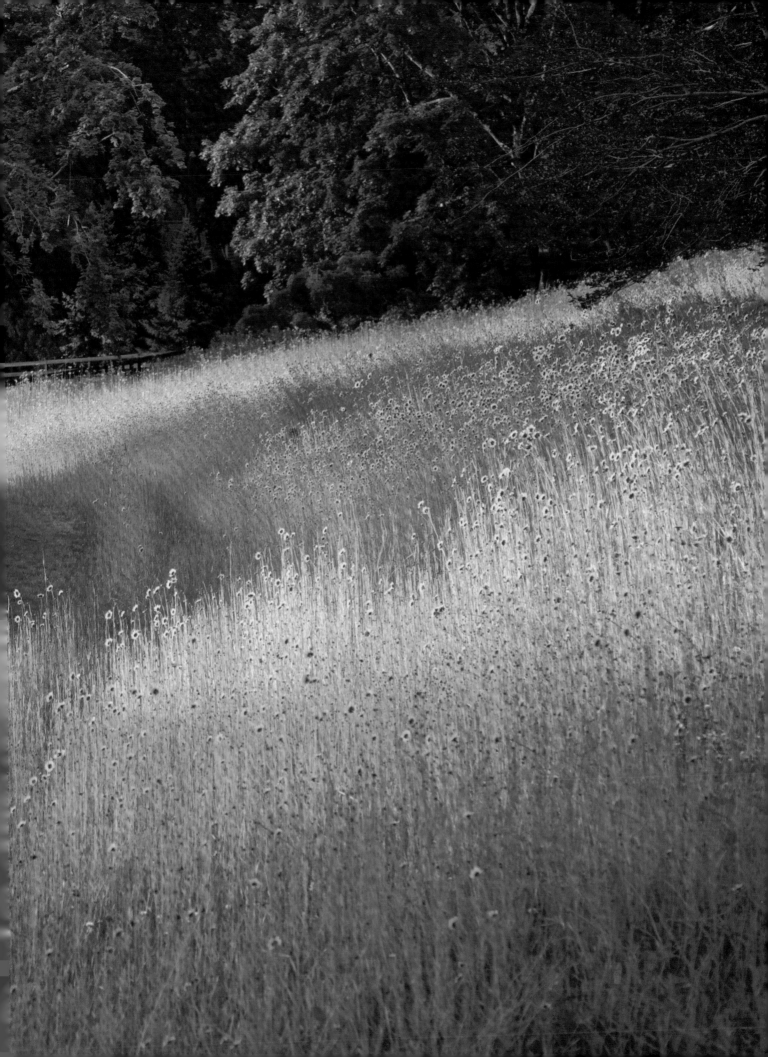

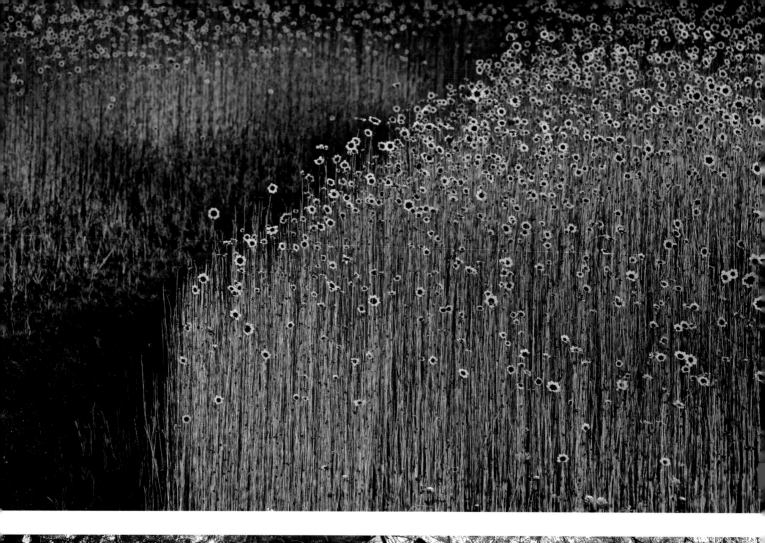
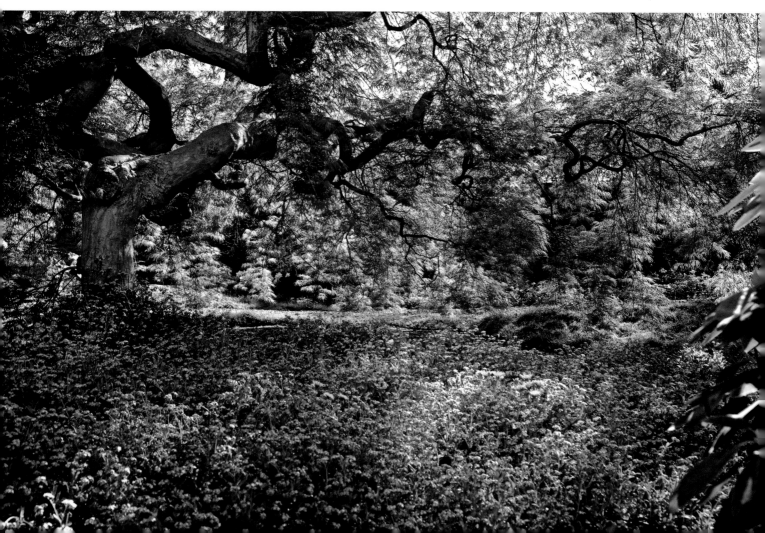

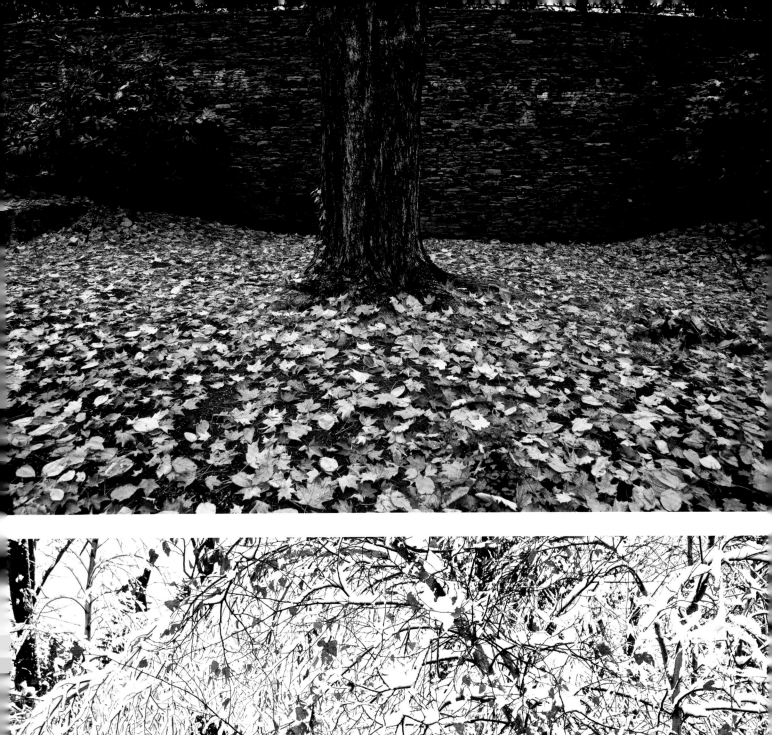
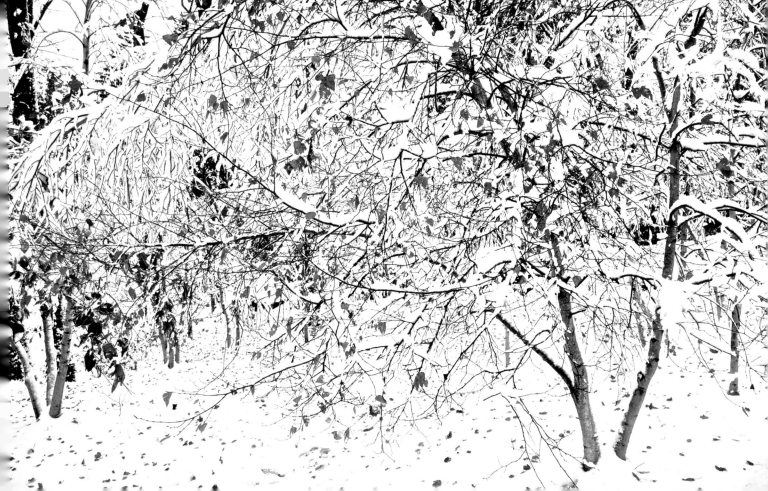

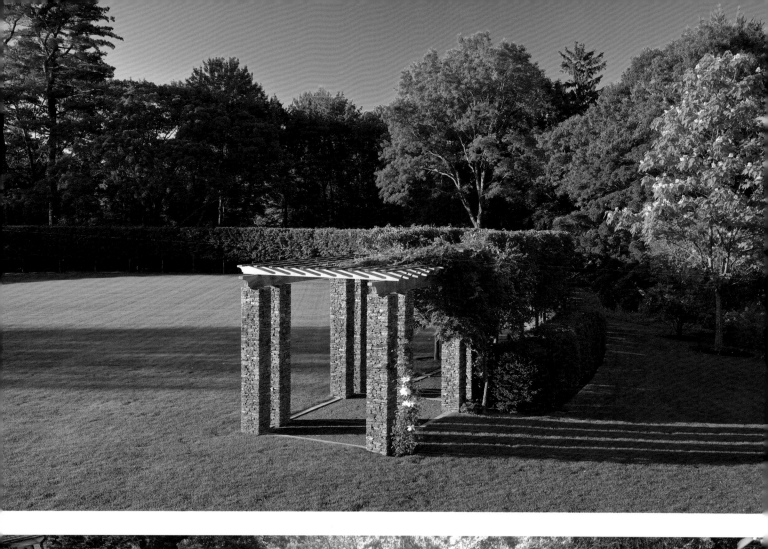

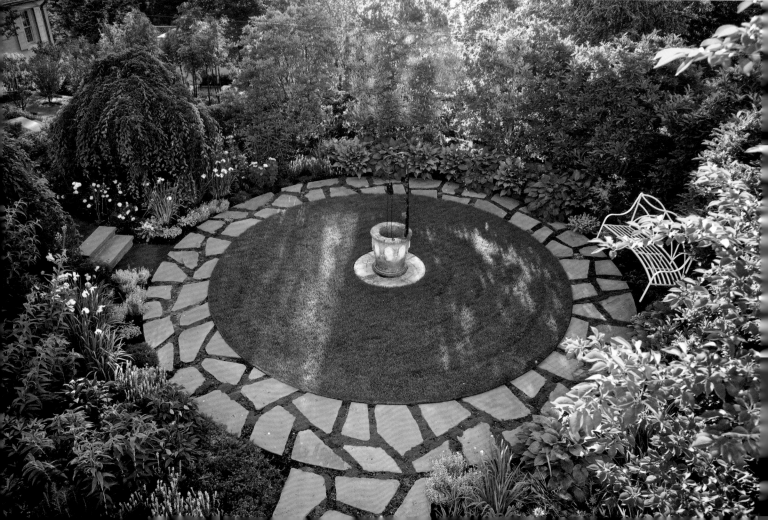

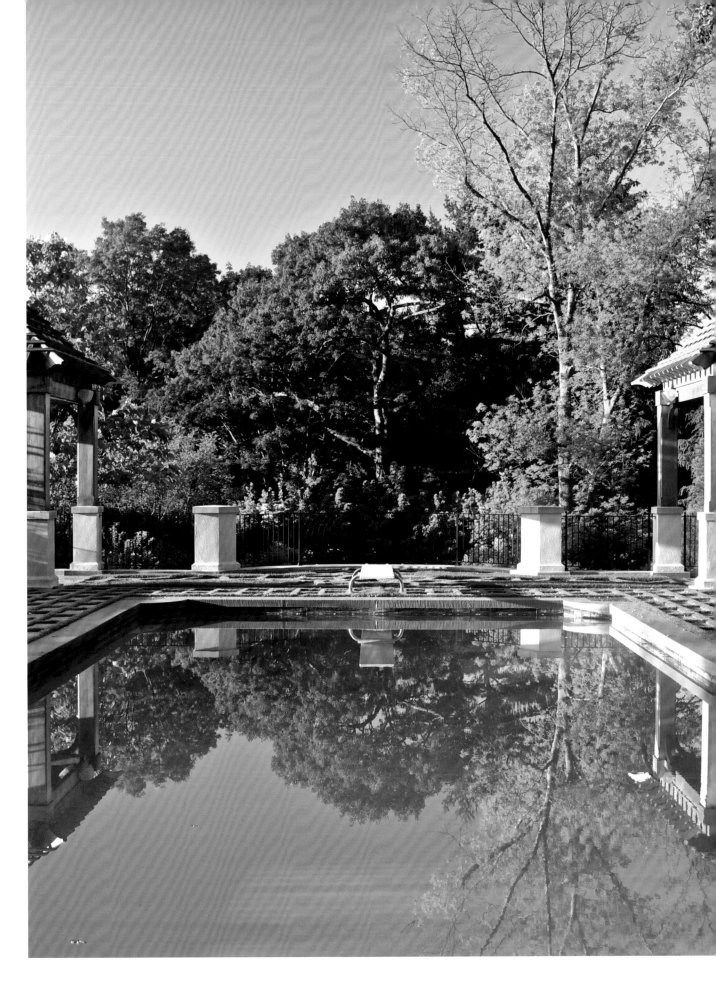

Clockwise: A Bloodgood Japanese maple (*Acer palmatum* var. *atropurpureum* 'Bloodgood') and northern catalpa (*Catalpa speciosa*) stand in the background of Tilia horseshoe allée; the swimming pool provides a dramatic view from the belvedere of the summer garden; view of the white garden surrounded by star magnolia trees (*Magnolia stellata*).

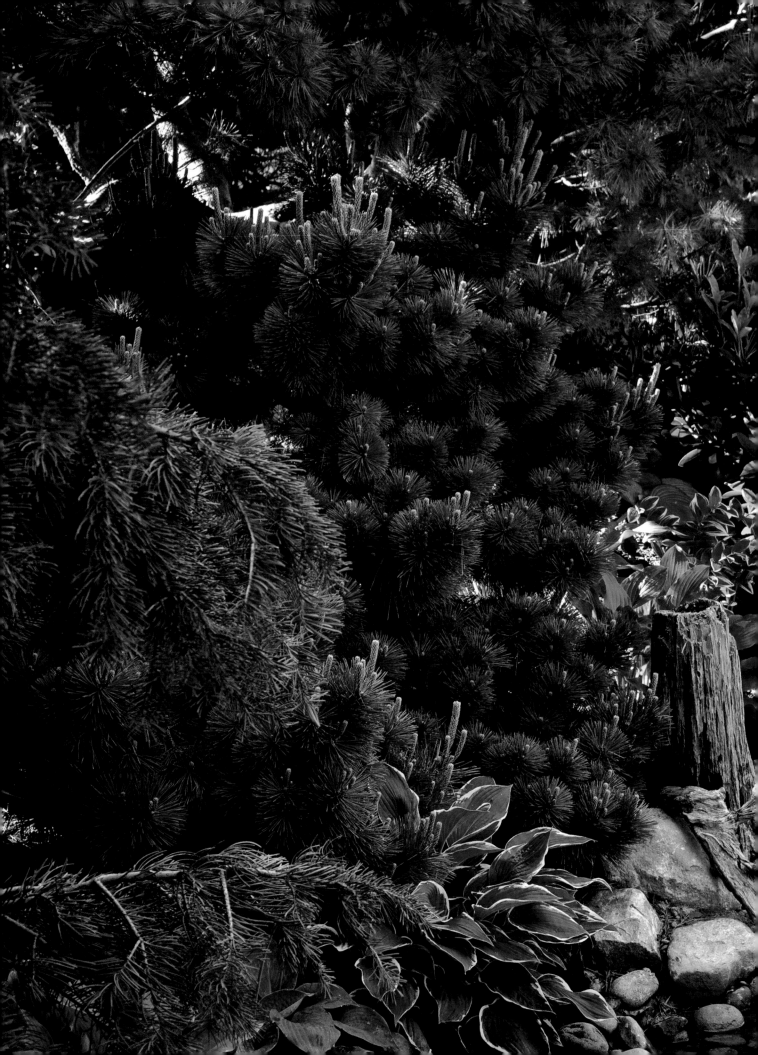

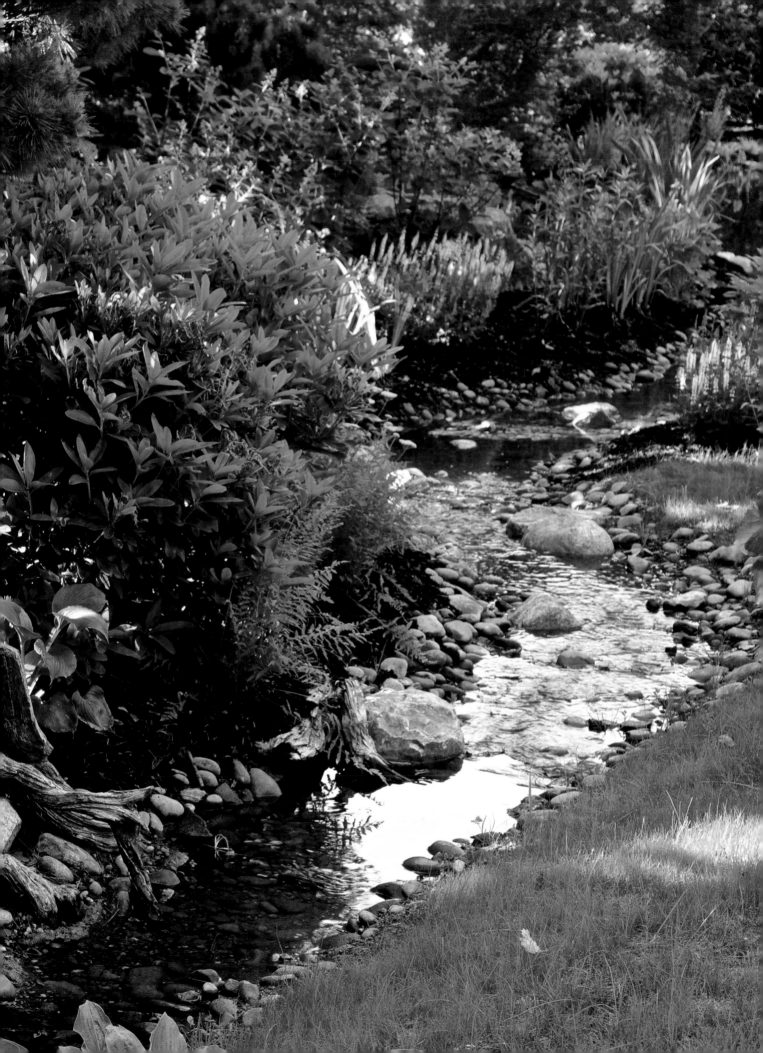

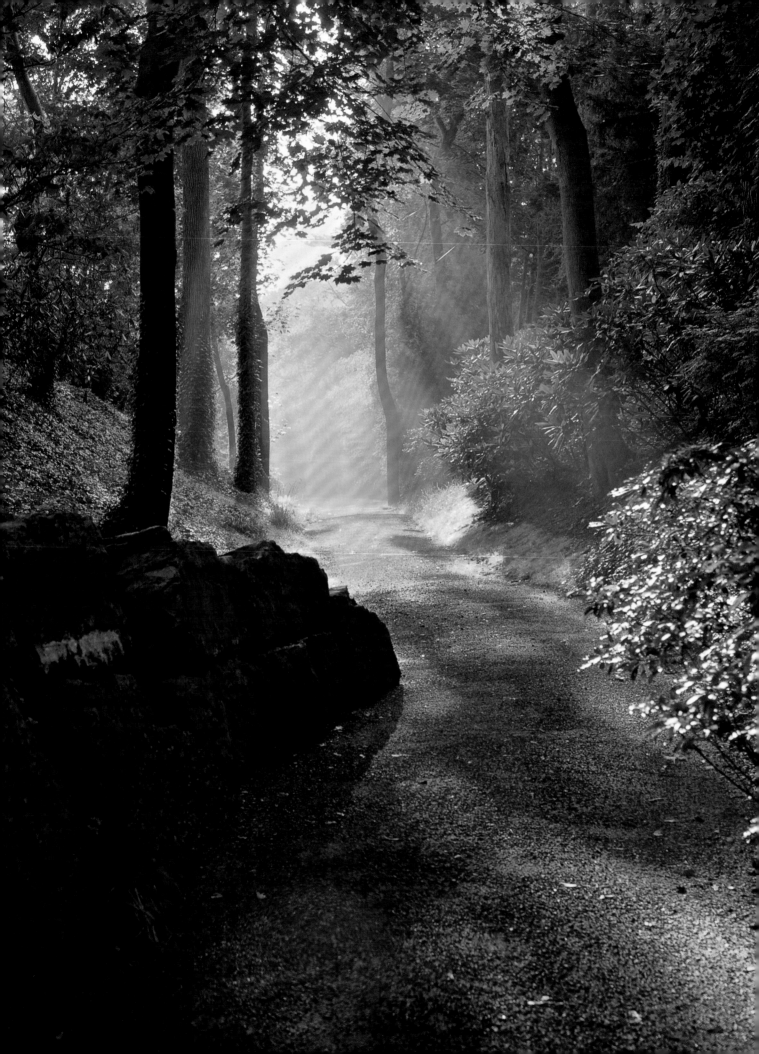

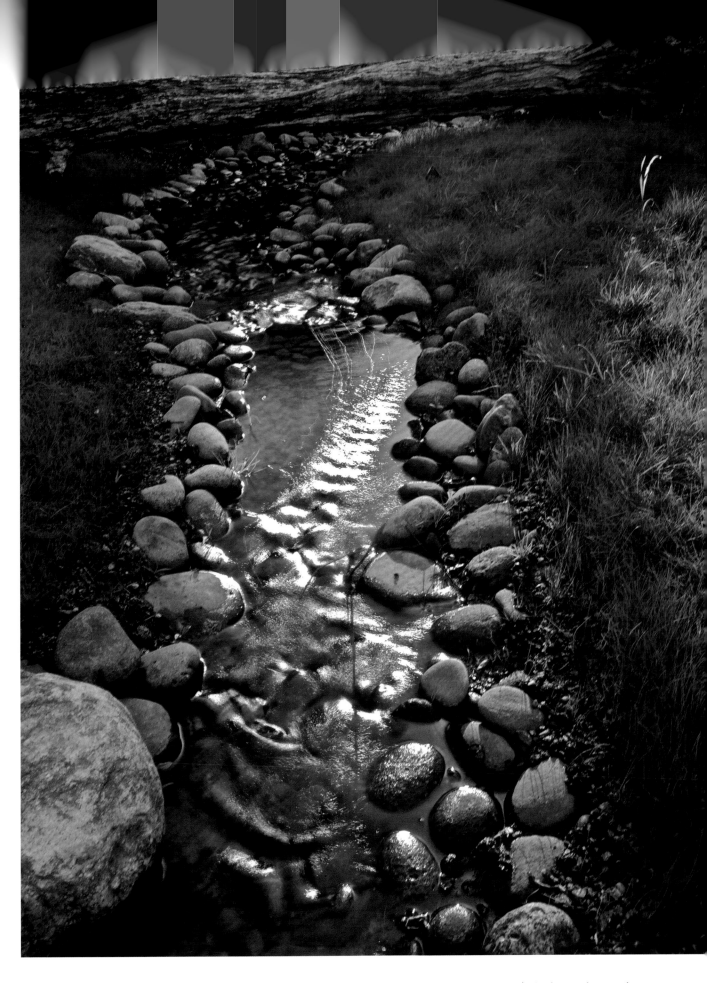

Riding trail through the ravine planted with
a small forest of large shade trees on its
slopes, underplanted with various types of
rhododendrons and mountain laurel (*Kalmia*
latifolia) and English ivy (*Hedera helix*)
as ground cover. Previous spread:
An unforgettable sea of forget-me-nots
(*Myosotis*). Following spread: Moss and
liverwort (*Marchantiophyta*) grace the ground
of the stumpery. Large English yew trees (*Taxus*
bacatta) and Japanese cedar (*Cryptomeria*
japonica) help to further privatize the space.

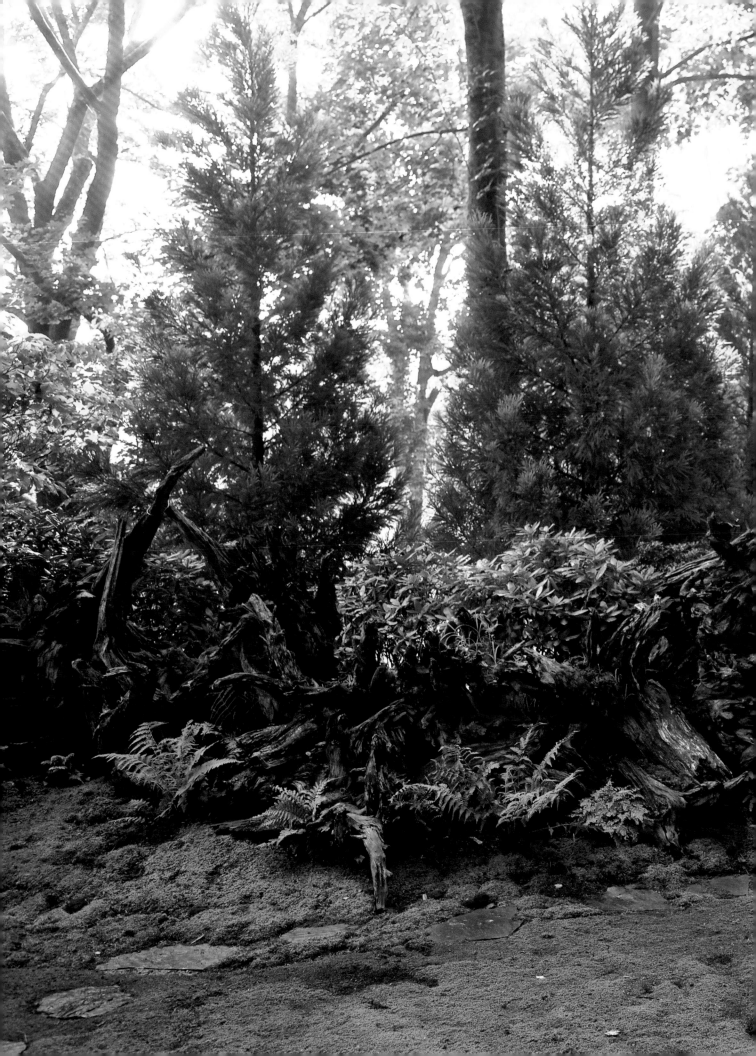

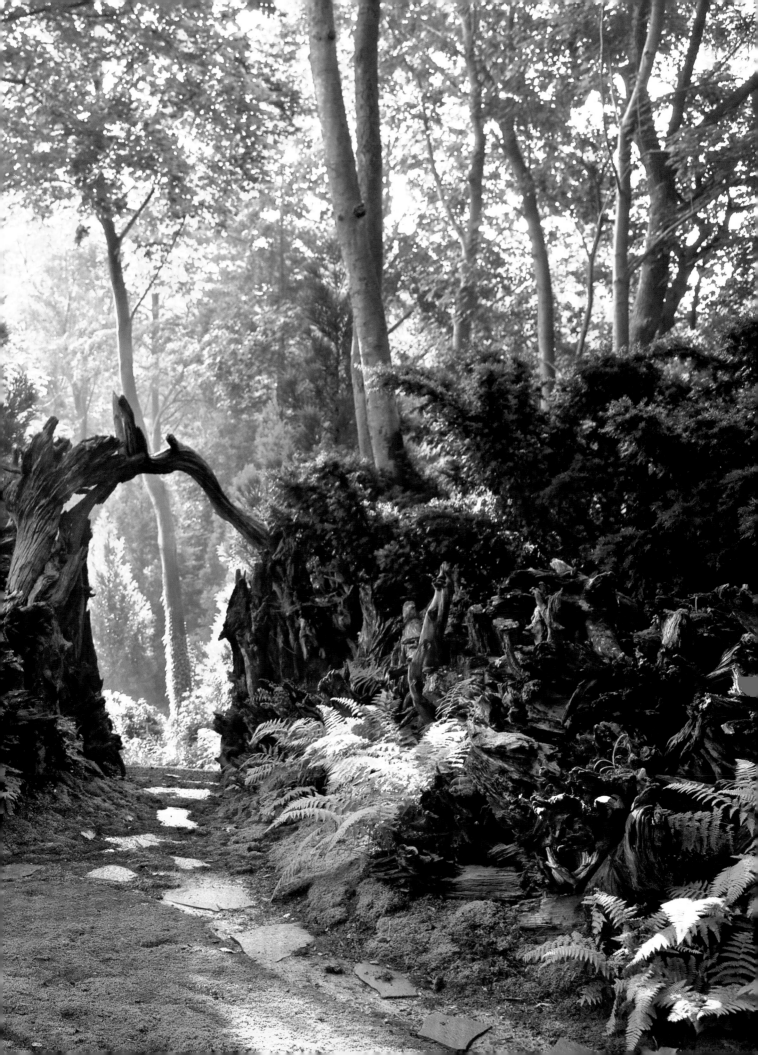

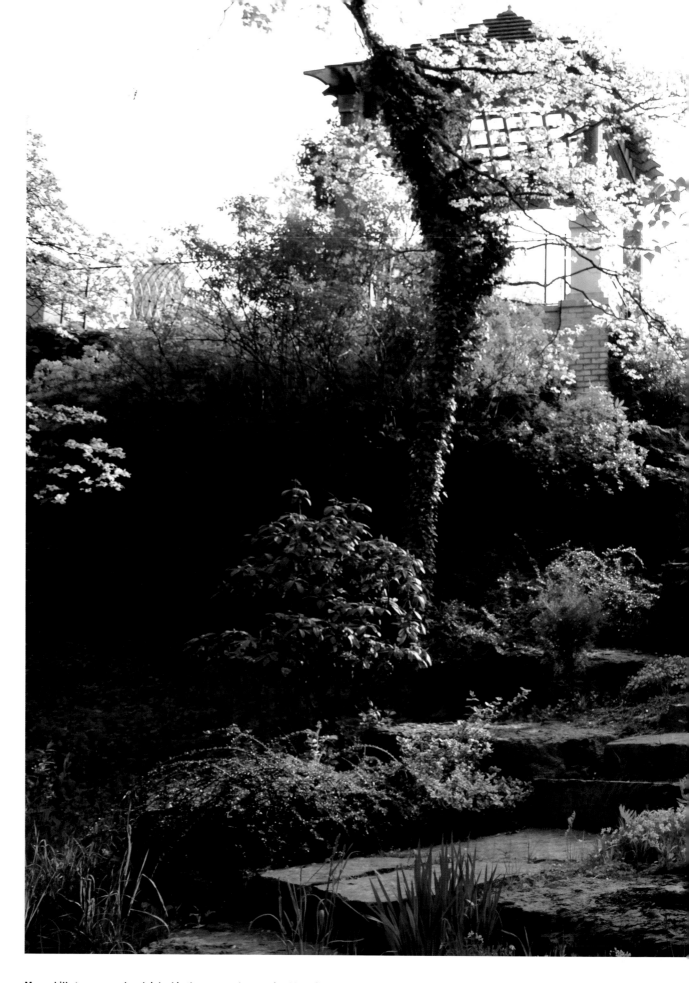

Mossy hill stones were handpicked in the Adirondacks for the garden stairs. They connect the lower riding trail with an upper summer garden and create natural terracing where spring blooming Karen azalea, white dogwood and whitespire birch tree are planted. Low growing blue Creeping Phlox (*Phlox Stolonifera*) is at bloom.

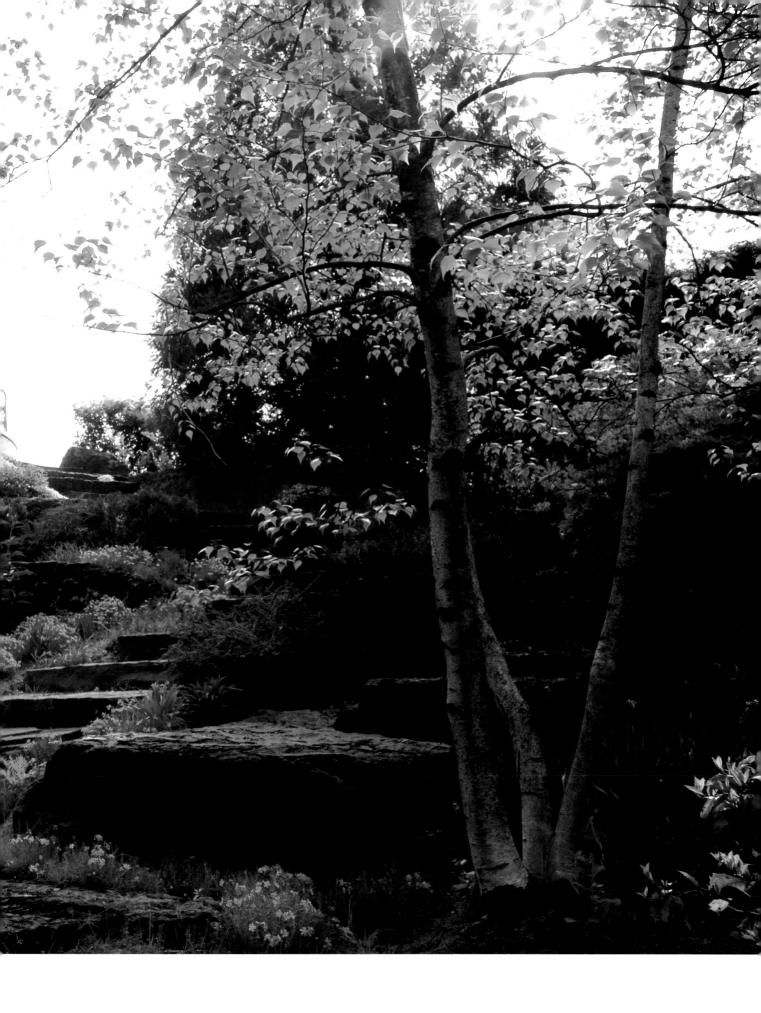

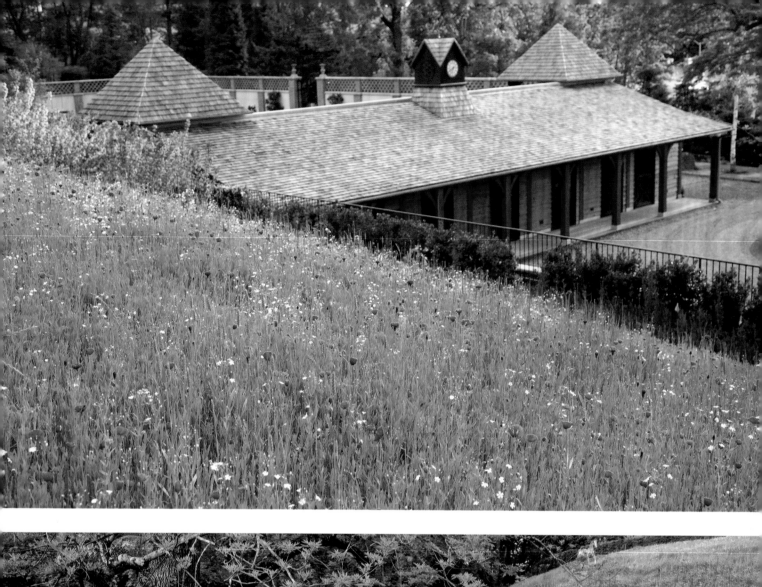
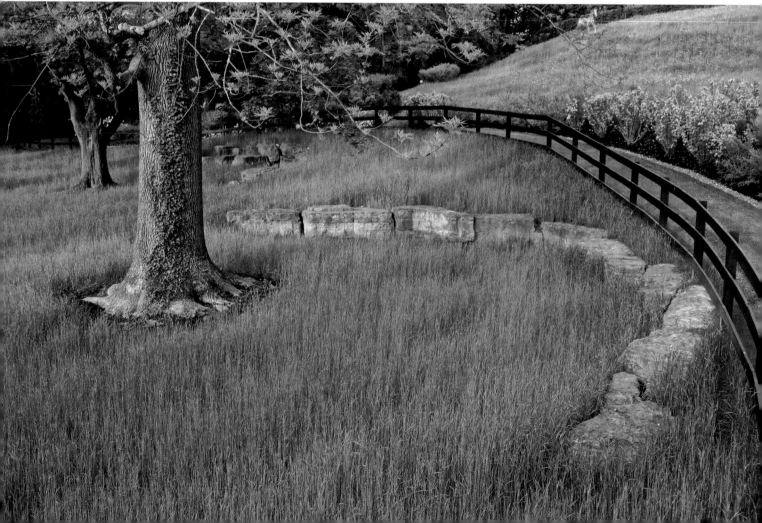

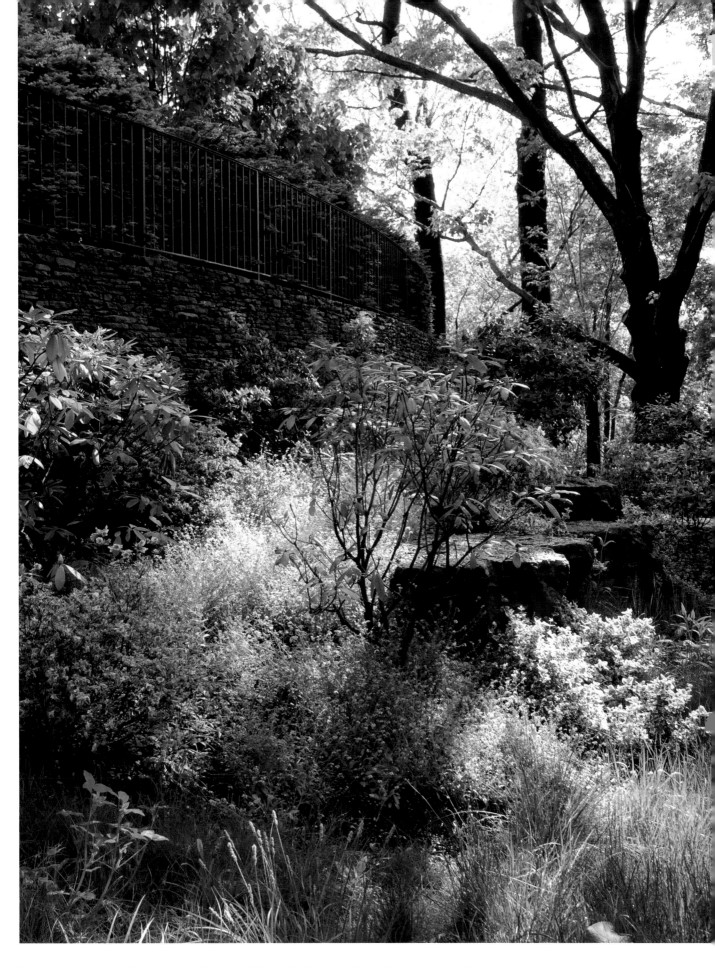

Clockwise: Cornflowers (*Centaurea cyanus*) and poppies (*Papever rhoeas*) brighten the wildflower meadow in front of the stables; rhododendrons, forget-me-nots (*Myosotis*), and viburnums add charm to the riding trail behind a retaining wall; paddock and riding trail with ash tree (*Fraxinus*) for shade. Previous spread: Hand-picked stones from the Adirondacks connect the lower riding trail with the upper Summer Garden and create natural terracing planted with spring-blooming azalea (*Rhododendron* 'Karens'), asian white birch (*Betula populifolia* 'Whitespire'), and creeping phlox (*Phlox stolonifera*).

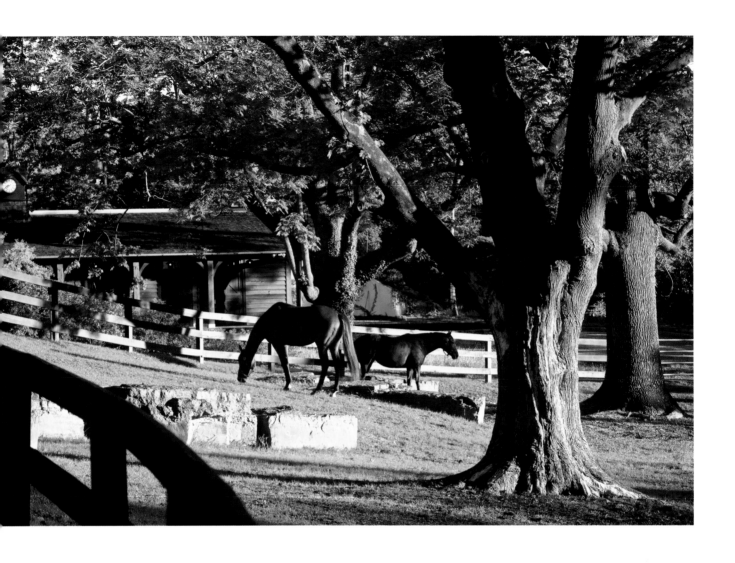

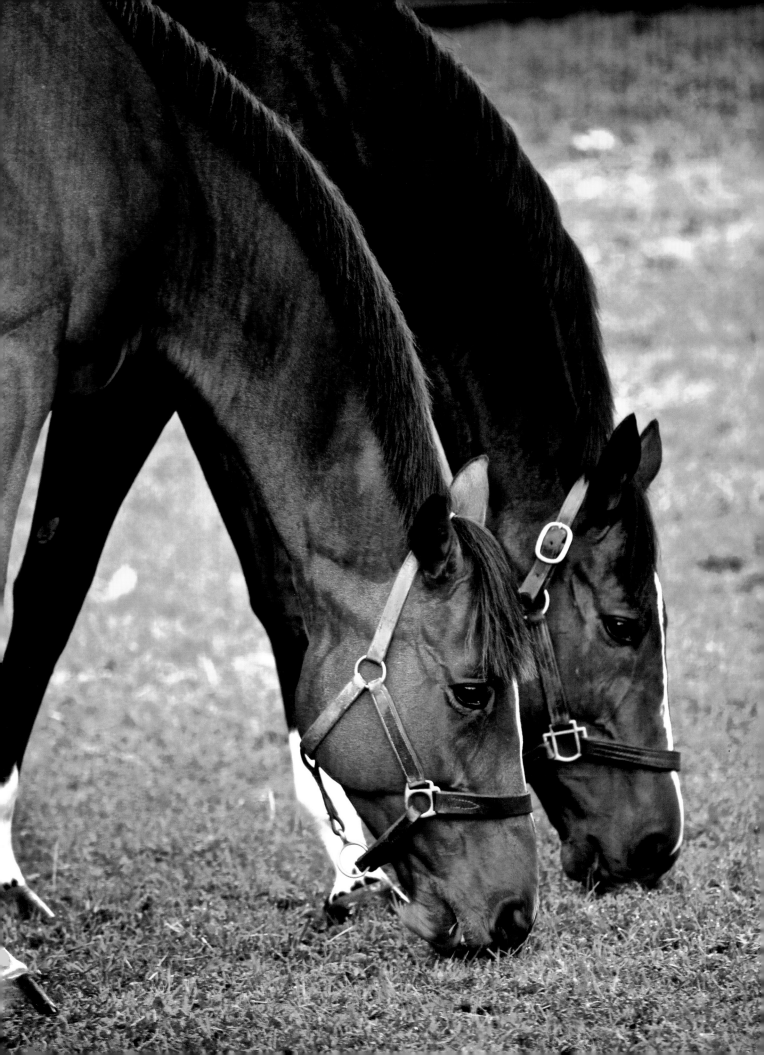

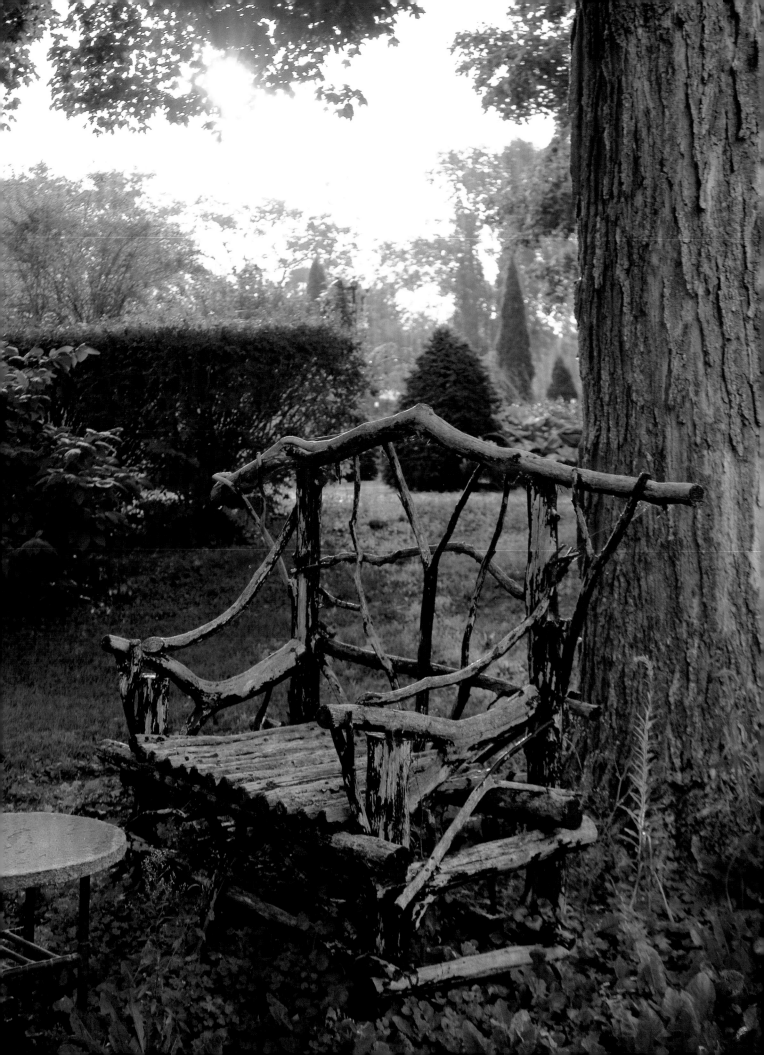

Failing Toward Beauty

ASHLEY FALLS, MASSACHUSETTS

In the lush, fertile flatlands straddling western Connecticut's storied Housatonic River, screenwriter and horse trainer Maria Nation has finally, after almost two decades and through much trial and tribulation, found her true garden. Maria describes her approach to garden design as creating a sense of place—more about following her intuition than hewing to a strict blueprint. A very hands-on gardener who from a young age heeded the call to "dig in the dirt," Maria buys and plants everything herself, nurturing what has become a rich green haven that invites the fortunate soul to ramble as much in thought and beauty as through the sculptural, painterly surround.

Sited on old farmland, flat and loamy without many rocks, Maria has inhabited her garden with a robust variety of boxwoods and evergreens. Very little bright color is in evidence, and then, subtly and artfully—a spray of red appears in sight that you might have missed while lost in revery. Unlike previous incarnations of her garden that roared with perennials, one of Maria's goals in her current garden was to "extend the months of beauty," so now perennials are pretty much banned. Strongly influenced by Nicole de Vesian's La Louve garden in Provence, Maria has created a similar tapestry of textured greens in a balanced play of volume and void, delighting the eye's proclivity for vertical rhythm while creating a sense of grounding through pathways paved with the occasional rocks that were dug up when planting.

To Maria, the garden daily inspires unspeakable joy. It is a twenty-year relationship between equals engaged in an ongoing dialogue, a place for wandering, eating, napping, reading, hanging out with friends, and remembering (the bones of beloved dogs are buried in the garden). What she has learned is "that the garden is a metaphor for life itself," that seasons are short, and that each day is a gift to savor. "Carve out time to do nothing," she says, "but to simply be and sense the miracle of existence."

Maria enjoys many other creative outlets—writing, cooking, and training horses—that reinforce the importance of patience in nurturing her garden. Other tips she offers for gardeners include: visiting as many gardens as possible in person and in books, and to garden for no one else but yourself. "Gardening," she says, "is a relationship that will last through the end of your days, and will give maximum pleasure only if you have spent the hours failing your way toward understanding what beauty is."

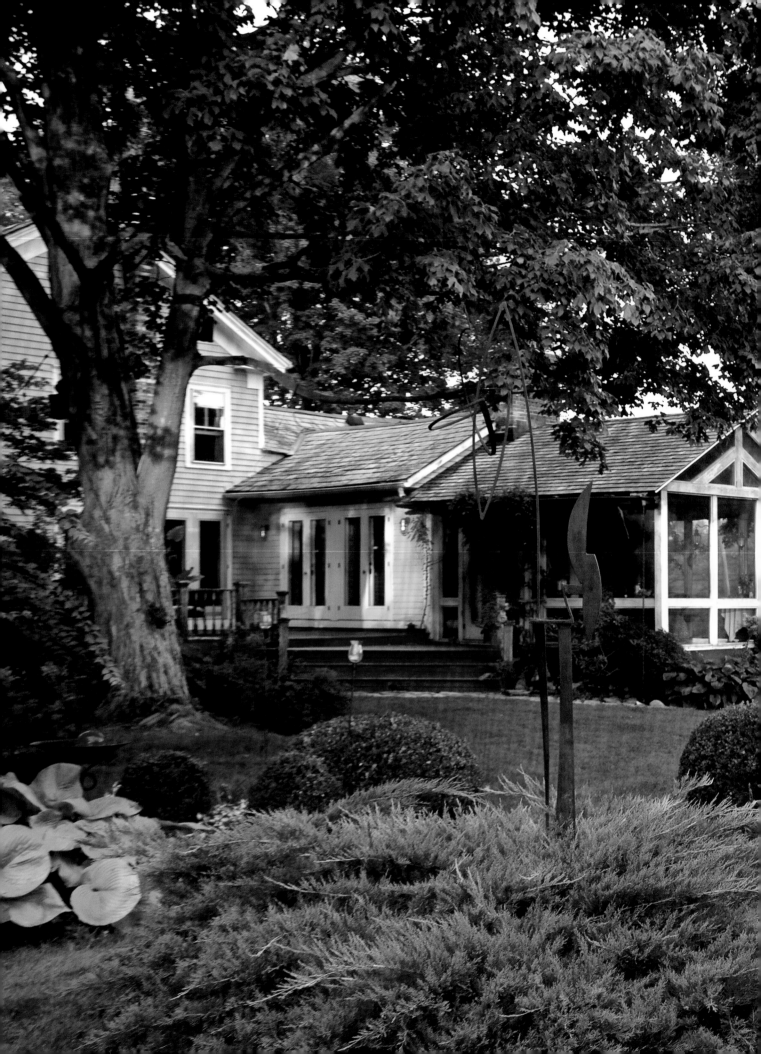

The towering great burnet (*Sanguisorba officinalis*) and the dark-hued bugbane (*Cimicifuga ramosa* 'Hillside Black Beauty') are two exceptions to the "no flowers" rule.

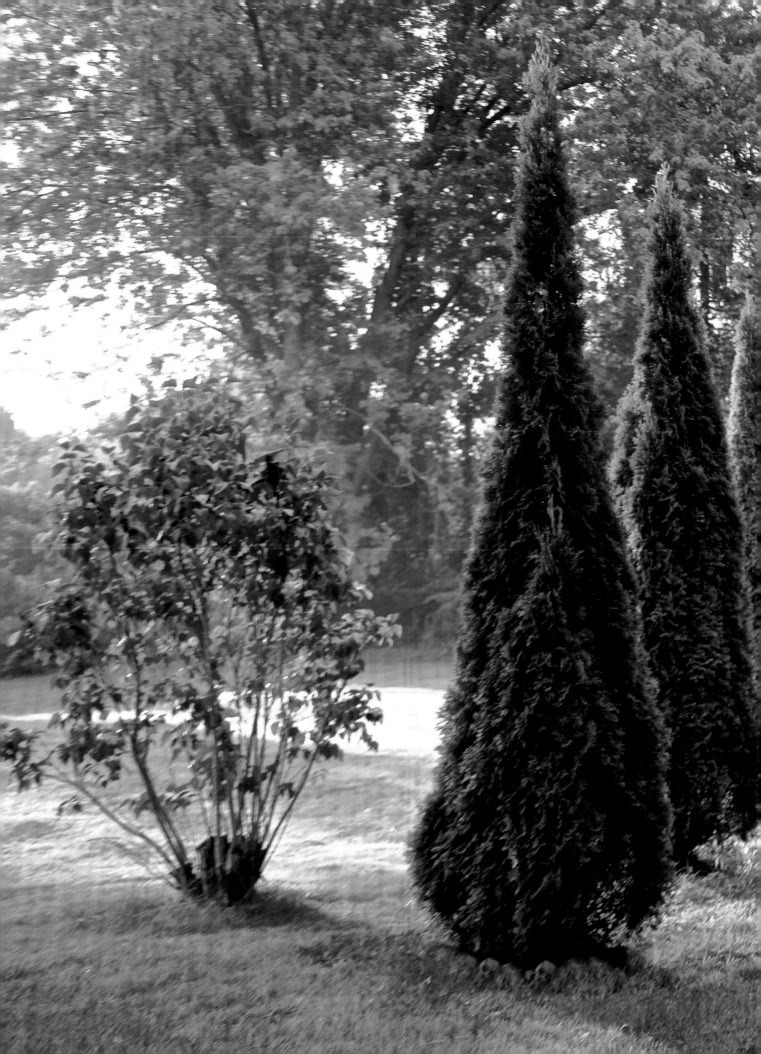

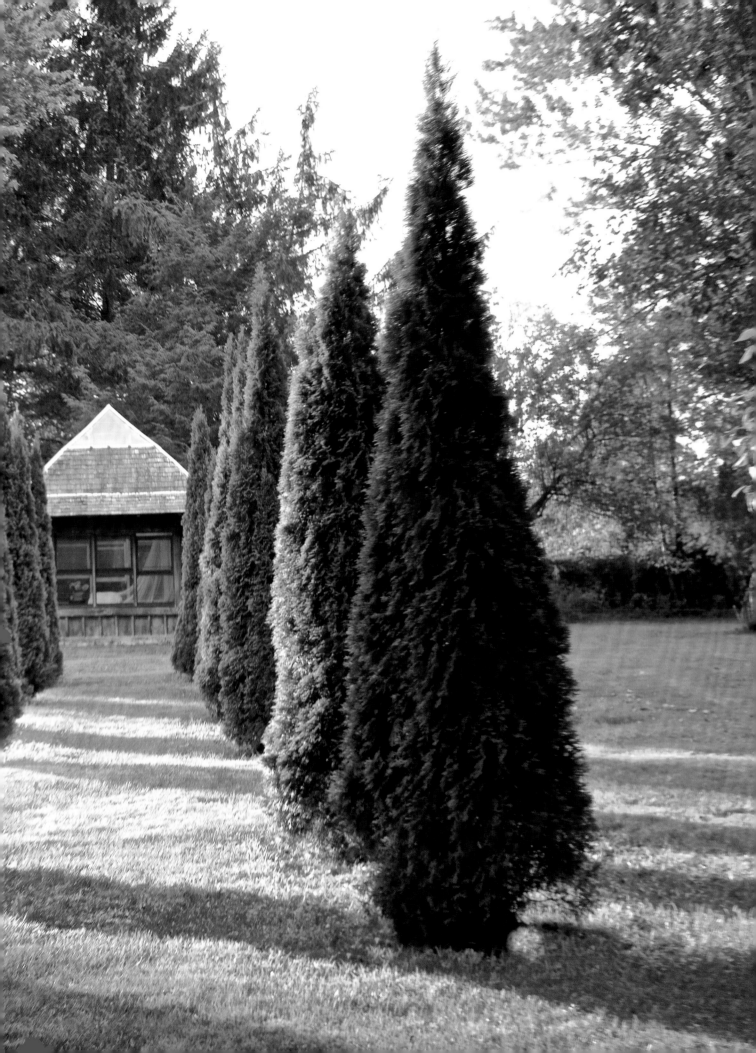

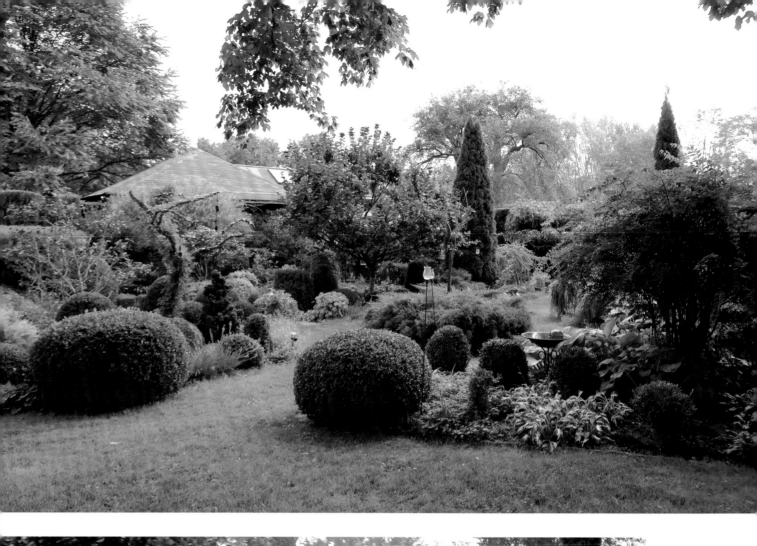

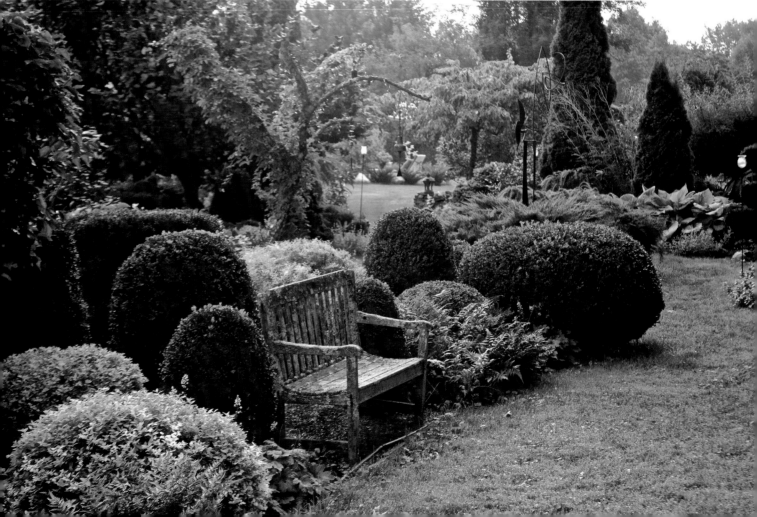

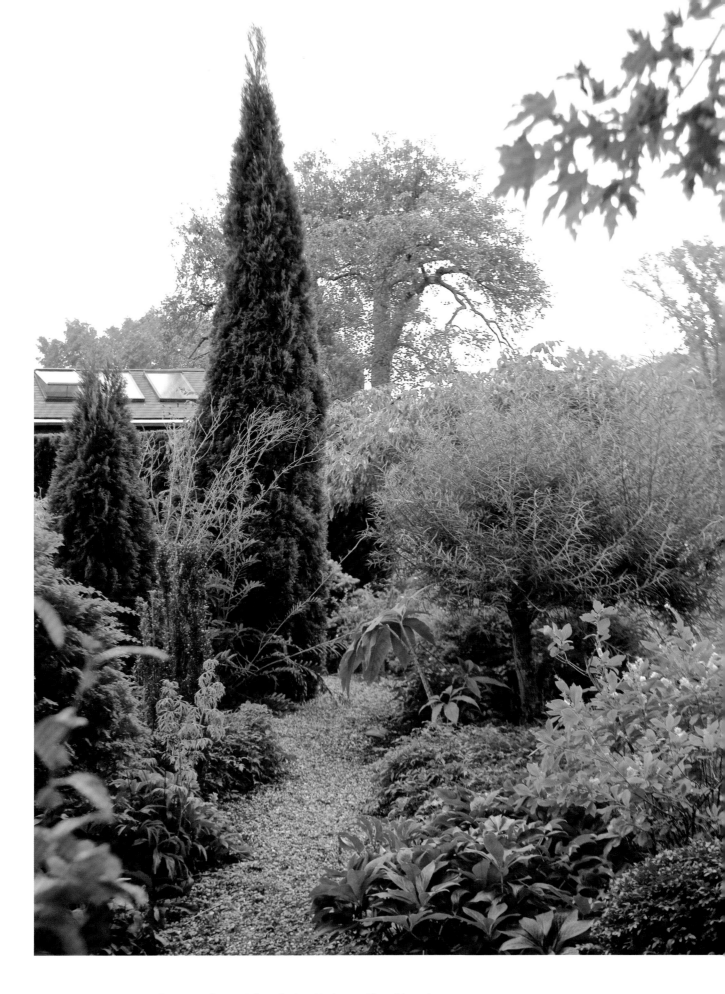

Paths create structure and logic but also hide parts of the garden until you reach a well-designed turn, encountering plantings like Chinese juniper (*Juniperus chinensis*), voodoo lily (*Amorphophallus konjac*), and rosemary willow (*Salix eleagnos*) along the way.

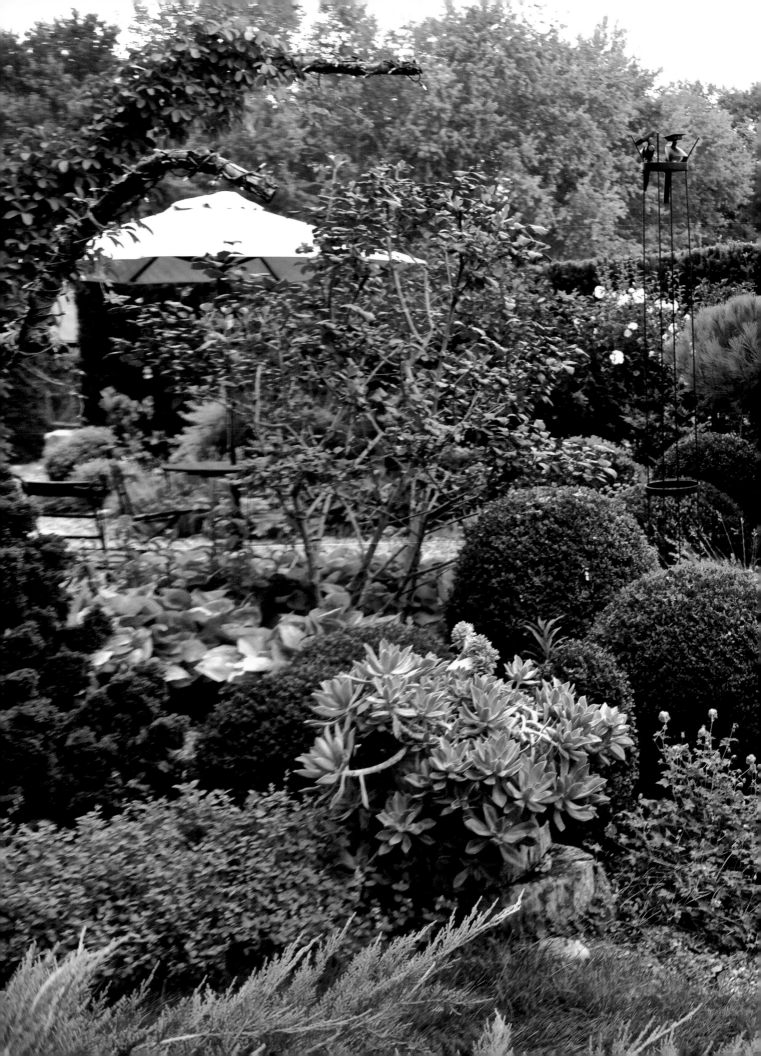

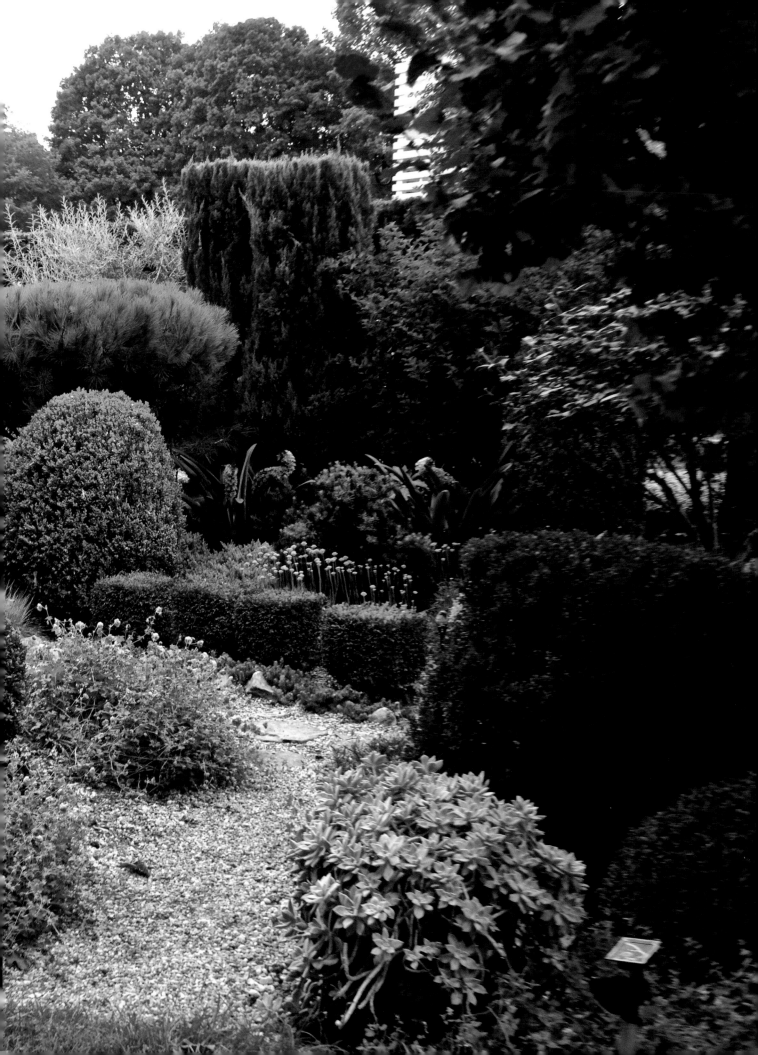

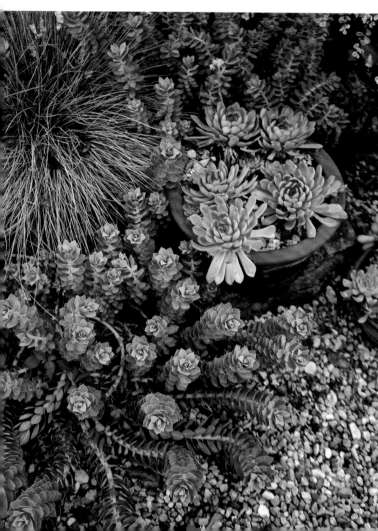

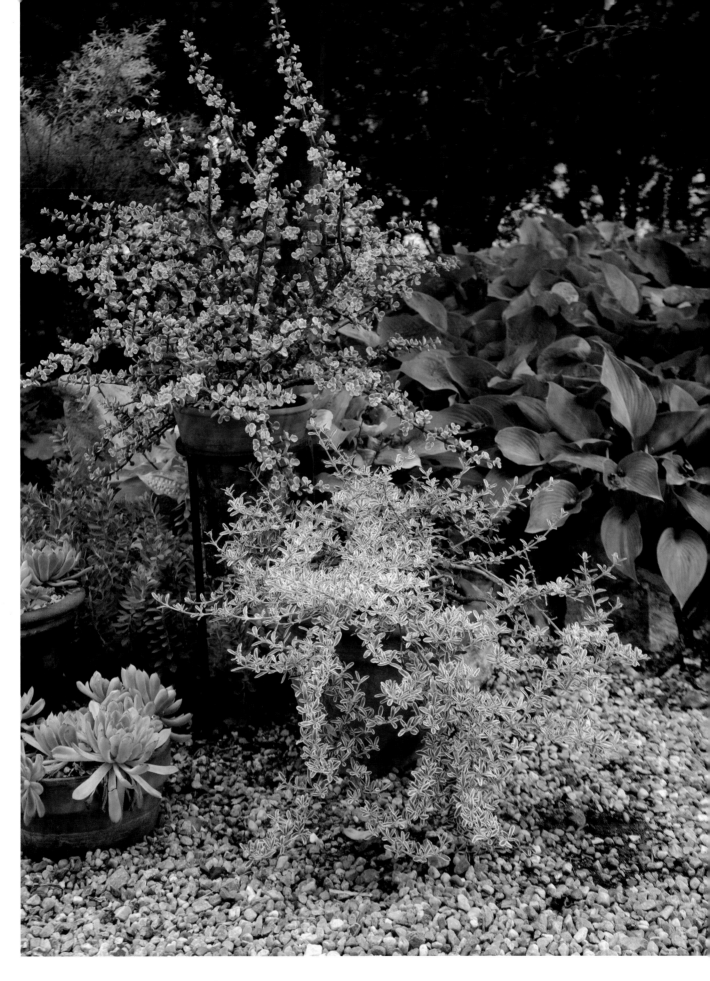

An intentionally minimal color scheme creates a great backdrop for more intimate details, such as these pots of succulents received from friends. The blue whorls of myrtle spurge (*Euphorbia myrsinites*) and the clumps of bloody geranium (*Geranium sanguineum*) are self-seeders that tend to have the run of the garden.

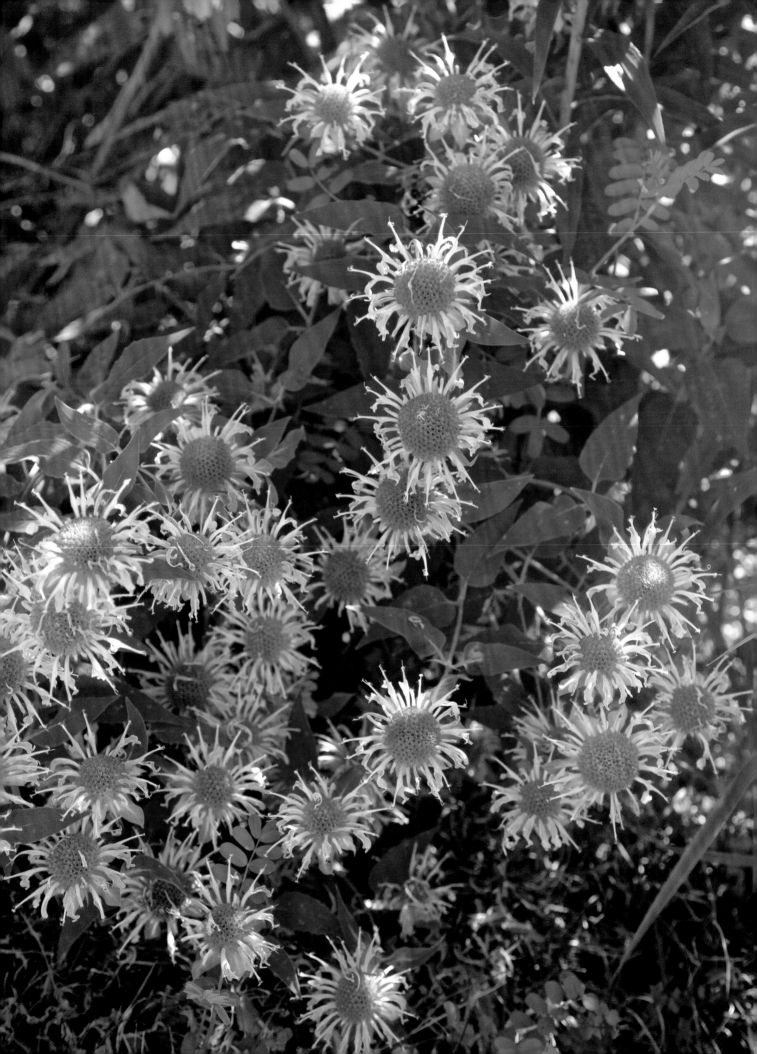

Art in Nature

WILTON, CONNECTICUT

Completed in 1968, architect Richard T. Foster's Round House sprouts like a mushroom out of a rural southwestern Connecticut hillside. In addition to its unusual shape, the house can rotate 360 degrees with a push of a button, providing its residents an ever-changing view of the surrounding landscape. Foster lived in the house with his family until his death in 2002. In 2010, a family from Manhattan purchased the property as their weekend getaway. They soon discovered that in spite of the home's all-around views, its pie-slice floor plan actually prohibited ample access to daylight. After Atlanta-based architects Merrill Elam and Mack Scogin opened up the interior to bring in more nature, upgrades to the surrounding landscape became imperative as well.

When renowned landscape designer and educator Darrel Morrison first visited the grounds, he found a typical suburban landscape, i.e., lots of lawn with little "wild growing." But he was impressed by the site's topography and its potential for having big outdoor rooms. There was upland, lowland, a pond, and steep slopes—what he called a "big bowl-like space." An ardent proponent of "where ecological processes inform the design," Darrel had to undo forty years of generic grass and minimal diversity to restore a sense of balance and dynamism by planting native species such gray dogwood (*Cornus racemosa*), American hazelnut (*Corylus americana*), quaking aspen (*Populus tremuloides*), American plum (*Prunus americana*), staghorn sumac (*Rhus typhina*), ragwort (*Packera aurea*), Jacob's ladder (*Polemonium reptans*), and wild blue phlox (*Phlox divaricata*).

As a big fan of drift, or fluid movement that can lead to intermingling of species, Darrel started his redevelopment with the naturally occurring fern drifts that were already present, which he built on with clusters of prairie-like sweeps throughout the property. He is also a firm believer of plant communities—a group of species that associate naturally. The result is a dynamic landscape that changes over time, not just through the four seasons but over many years, so that the landscape of 2017 will be very different from the landscape in fifty years.

Art has always inspired Darrel's landscaping. In particular, he is drawn to Kandinsky's energy and van Gogh's movement. Like a work of art in nature, the Round House landscape is enlivened by complexity via species diversity, mystery from not being able to see everything at once, coherence through patterns, and legibility, or the ability to read how to move through the place without feeling confused or claustrophobic. At Round House, stepping into a work of art is a dream that one never has to defer.

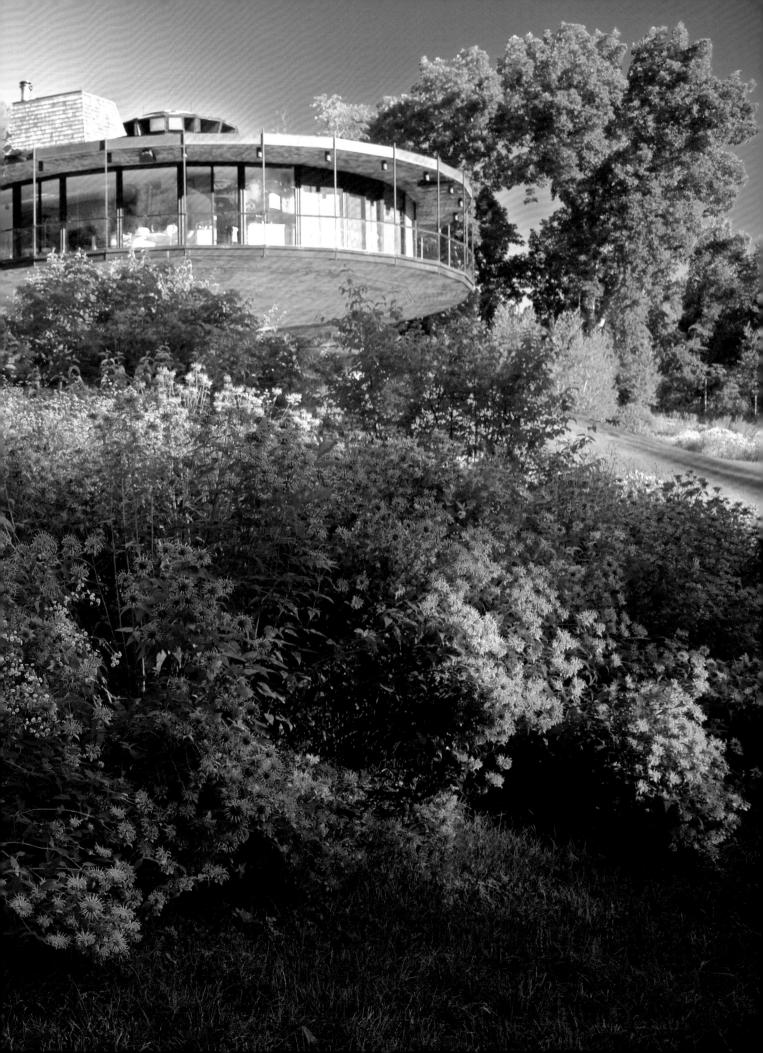

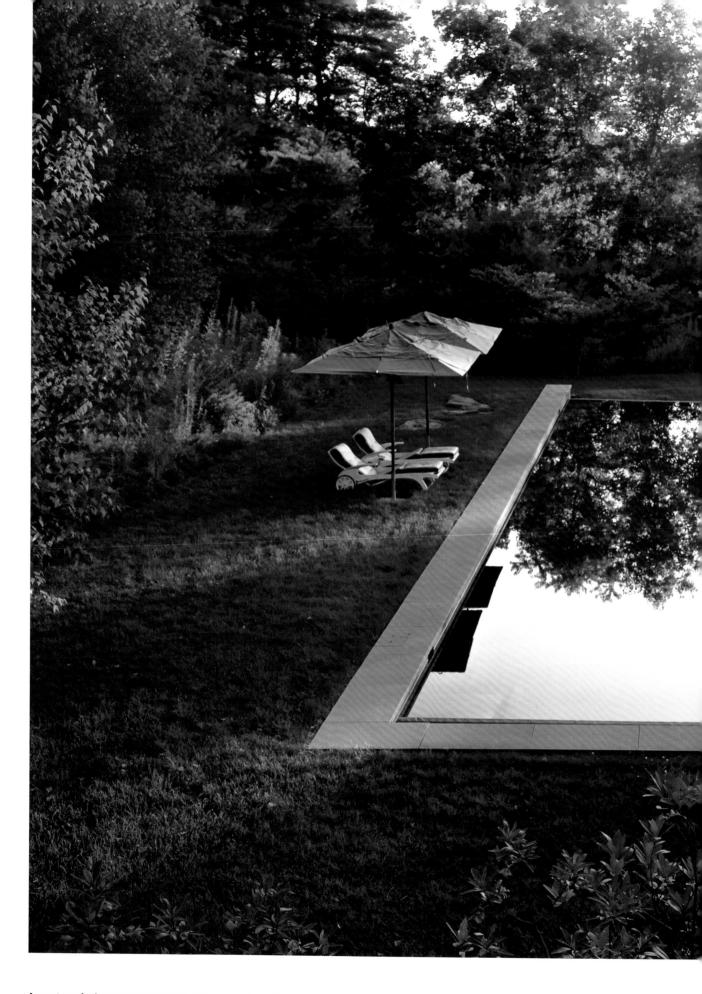

A sanctuary for humans as well as the various species of birds and insects that support it. All plants were chosen as straight species and provide an ever-evolving food source for birds, butterflies, bees, and other insects. No chemicals are used to maintain the garden.

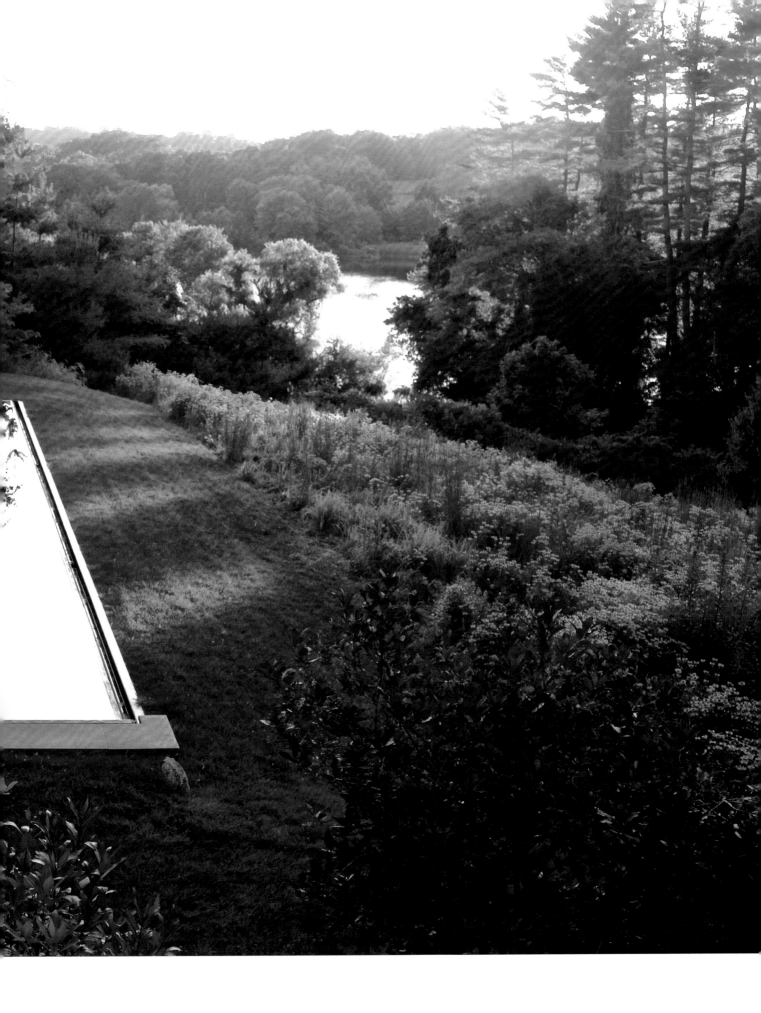

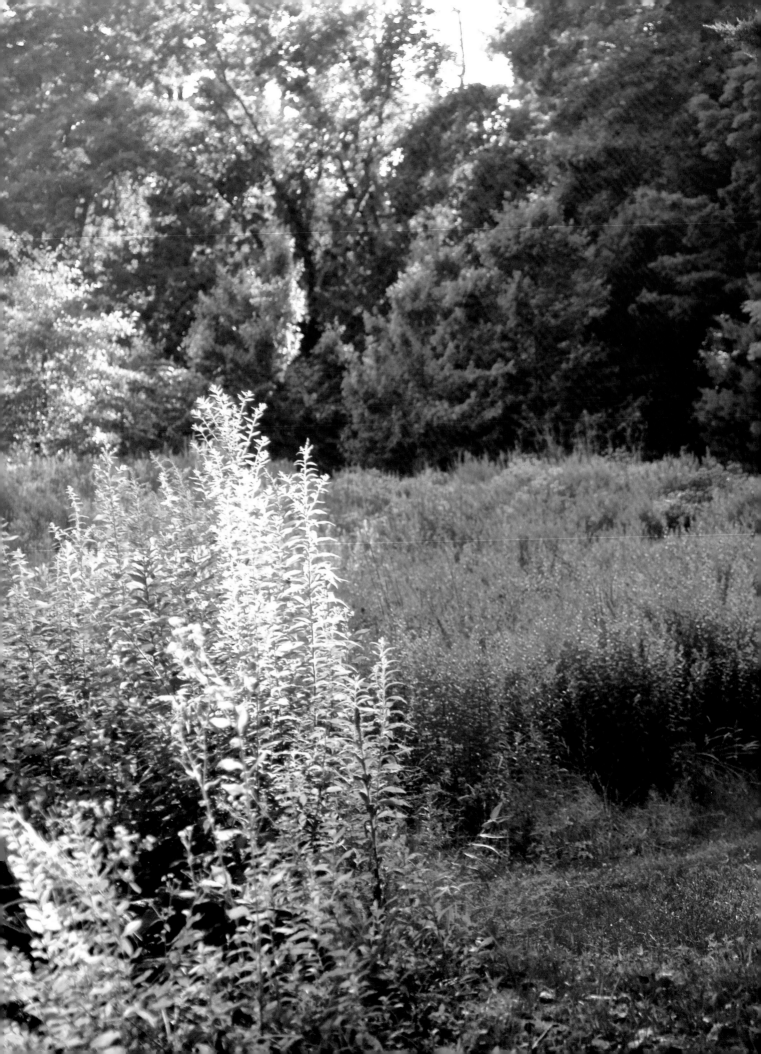

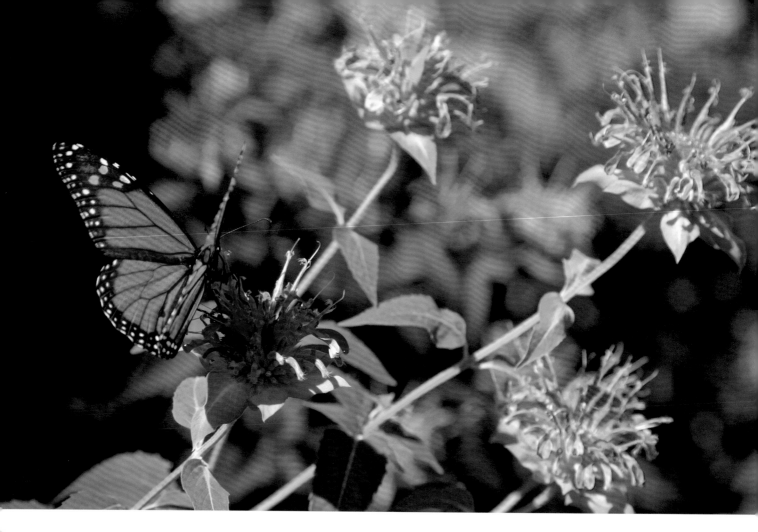
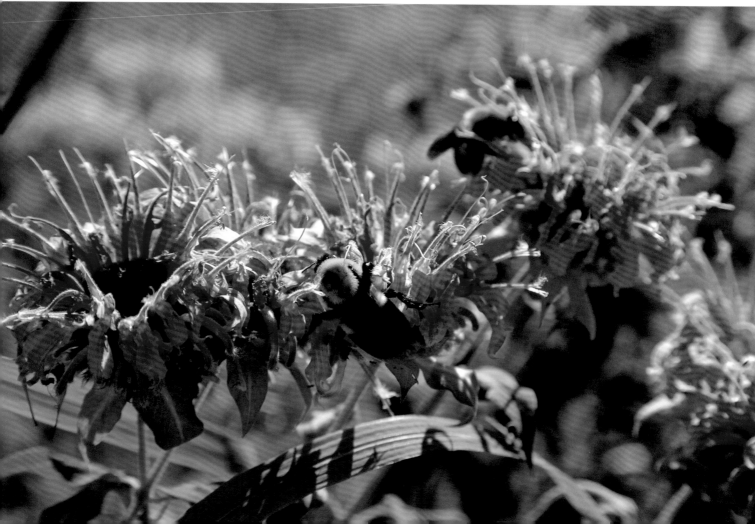

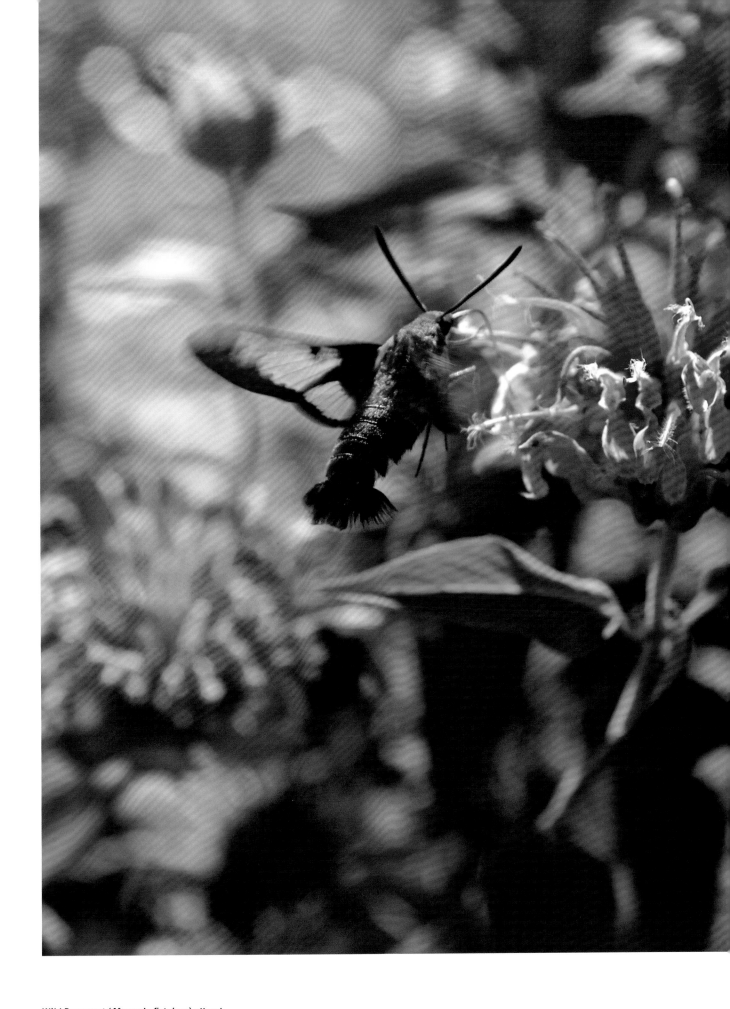

Wild Bergamot (*Monarda fistulosa*) attract
butterflies, bees, and hummingbirds.

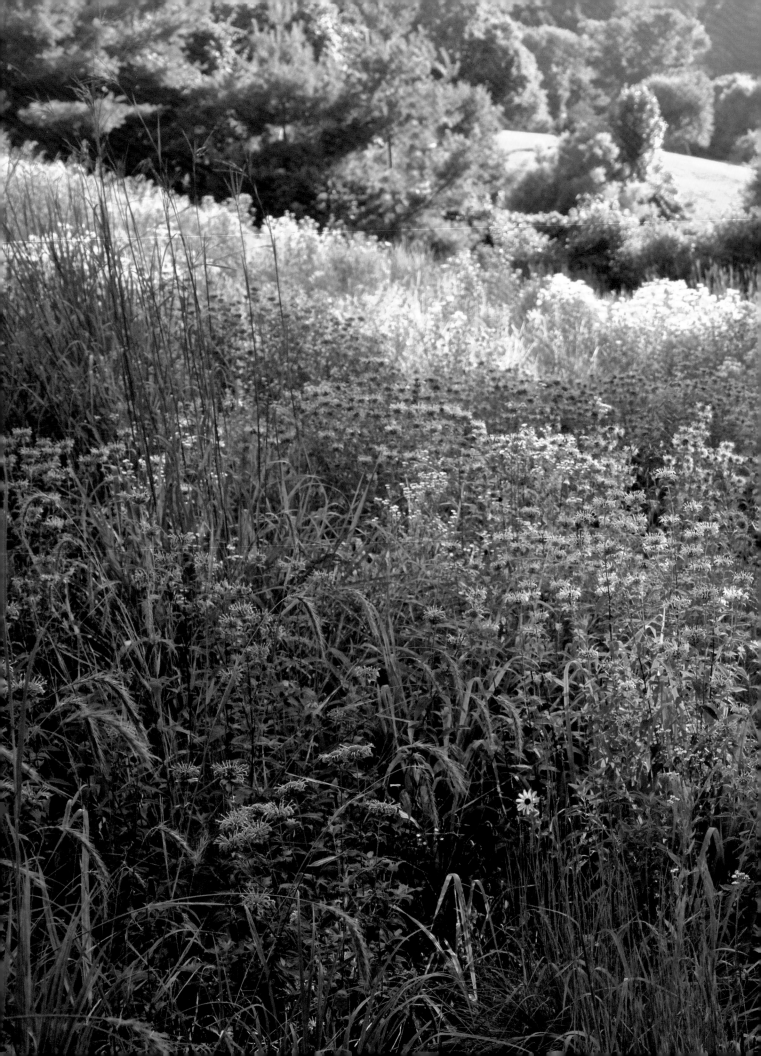

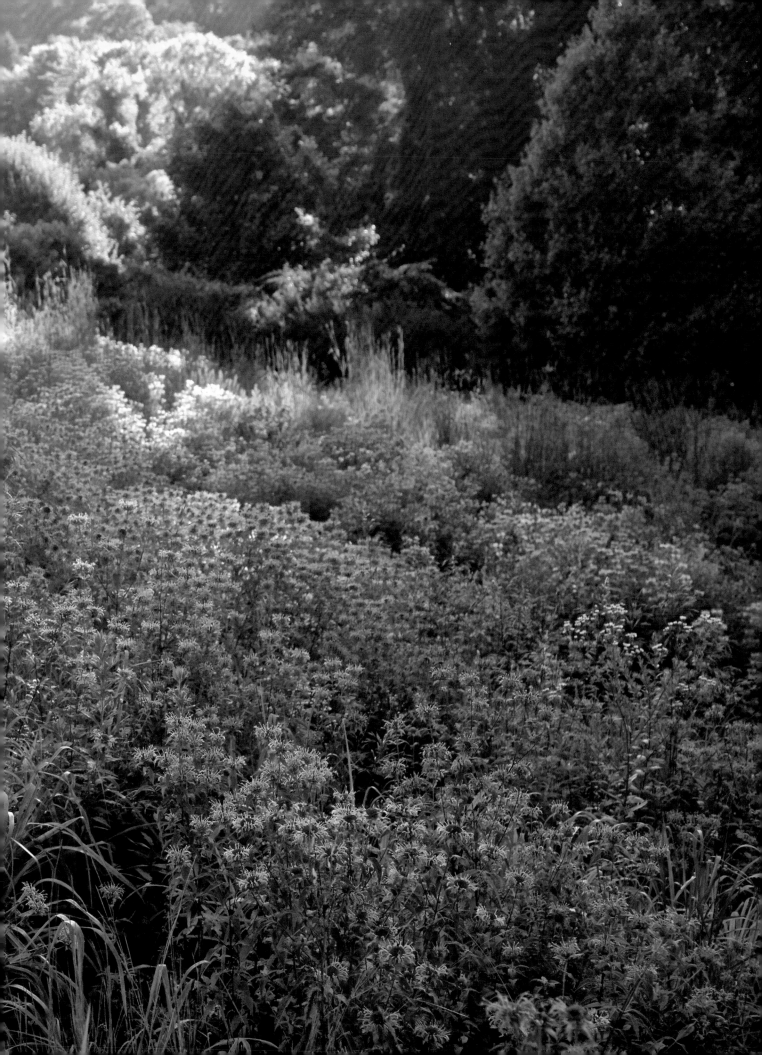

Previous spread: A variety of grasses are planted throughout the grounds, including switchgrass (*Panicum virgatum*) and bottlebrush grass (*Elymus hystrix*), purpletop tridens (*Tridens flavus*), beard grass (*Schizachyrium scoparium*), and big bluestem (*Andropogon gerardi*).

A Miracle Above

NEW YORK, NEW YORK

In 1999, almost two decades after the last train ran on the High Line elevated tracks on Manhattan's west side, the Friends of the High Line was founded by Joshua David and Robert Hammond, residents of the High Line neighborhood, to advocate for the High Line's preservation and reuse as a public open space. Ten years later, the first section of the High Line opened to the public. The final section of the 1.45-mile-long greenway was completed in 2014. To say the elevated public park has been a smashing success barely encompasses the wide-ranging impact it has had not just in New York City, but in urban centers worldwide.

Designed by New York firm Diller Scofidio + Renfro in collaboration with landscape architects James Corner Field Operations and Piet Oudolf, the walking surface of the High Line was digitized into discrete units of paving and planting to work with the wild-seeded landscape that had developed in disuse. That original, self-seeded landscape had evolved into a variety of microclimates: narrow sections that were sheltered by buildings retained water and developed deeper areas of soil, allowing groves of trees and tall shrubs to grow above the city's unsuspecting pedestrians; sections that were more exposed developed drought-resistant grasses and wildflowers that could withstand exposure to the harsh northeastern elements. The design conscientiously worked with this existing landscape to minimize the resources needed for maintenance, while sheltering and nurturing native pollinators. As Andi Pettis, director of horitculture at Friends of the High Line explains, "The High Line gardens are truly four season. The look of the gardens changes weekly, sometimes daily, in subtle and not-so subtle ways. The bleached out grasses and dark, skeletal seedheads of the dormant winter garden are haunting and rich with color and texture. To me, the winter High Line is just as beautiful as the midsummer garden."

Architecturally, Elizabeth Diller felt "our biggest work was not screwing it up—because it was already there." From a landscaping and gardening standpoint, perennials, grasses, shrubs, and trees were chosen for their hardiness and sustainability. Also considered were the texture and color of the plantings, and a focus on native species (half of the plantings on the High Line are native). A drip irrigation system allows the planting beds to retain as much water as possible. Any supplemental watering is supplied by hand to prevent overwatering. There is also a strong commitment to avoiding the use of pesticides and chemical fertilizers.

A marvel above the gritty streets of New York City, the High Line has much to celebrate, and it does so every day by welcoming the millions of visitors who come to appreciate its many charms.

The fading flowers, seed heads, and dried,
brown stalks of fall and winter are just as
visually important as the fresh new growth
of spring or the abundant flowers of summer.

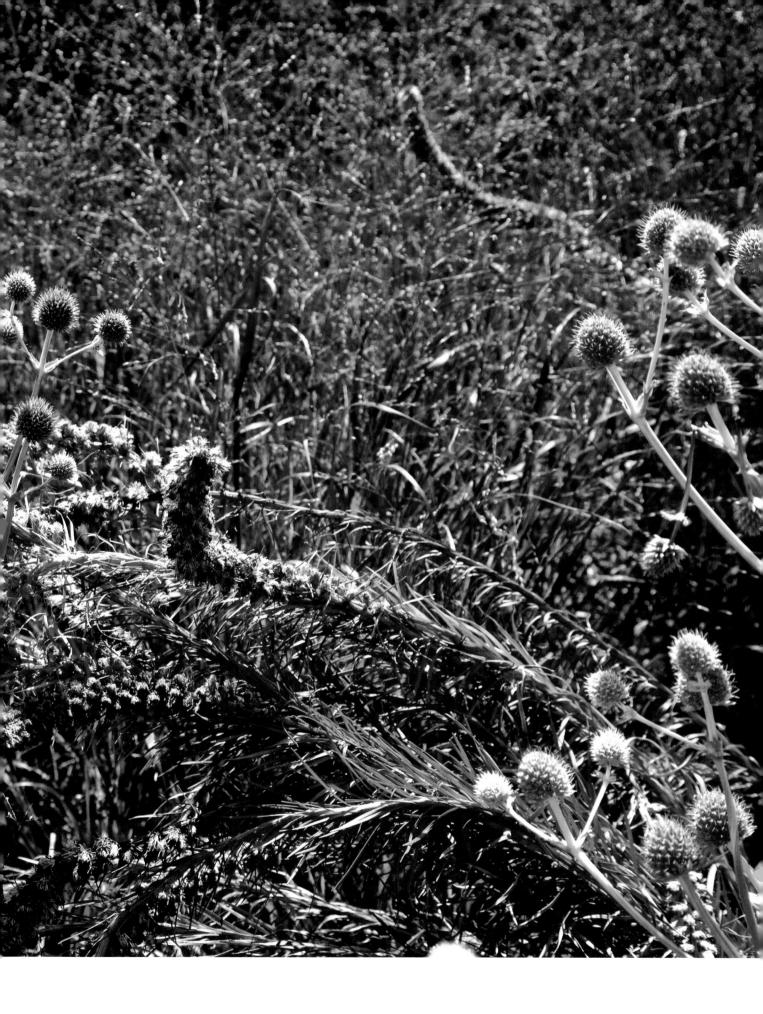

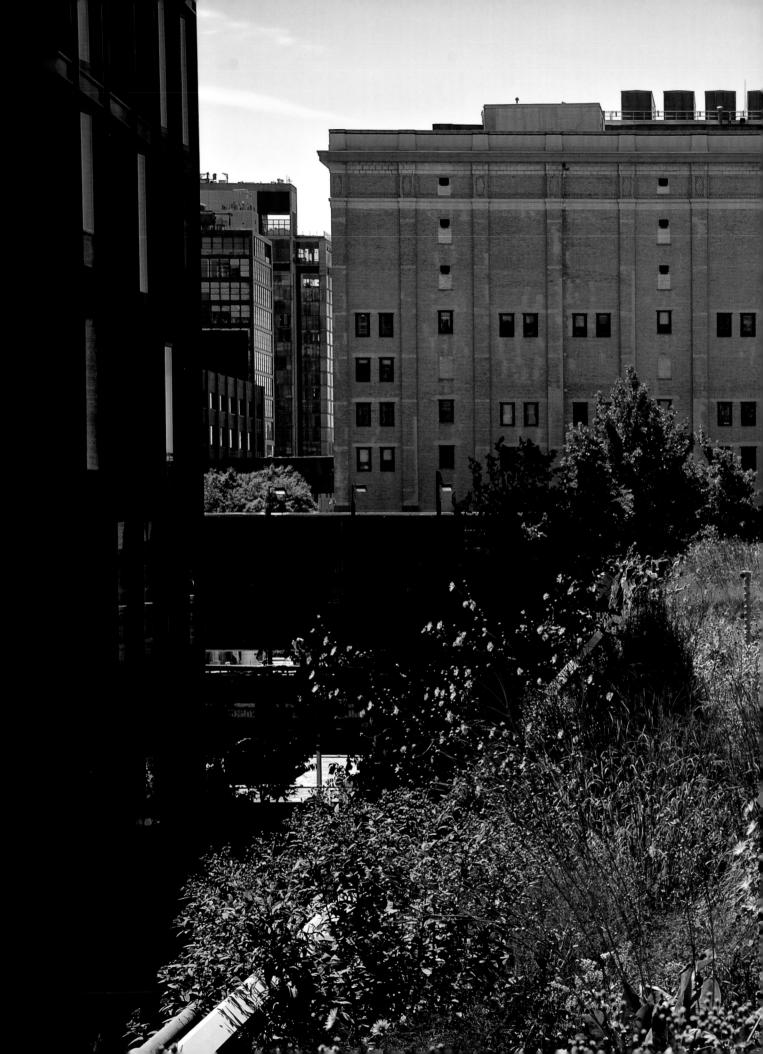

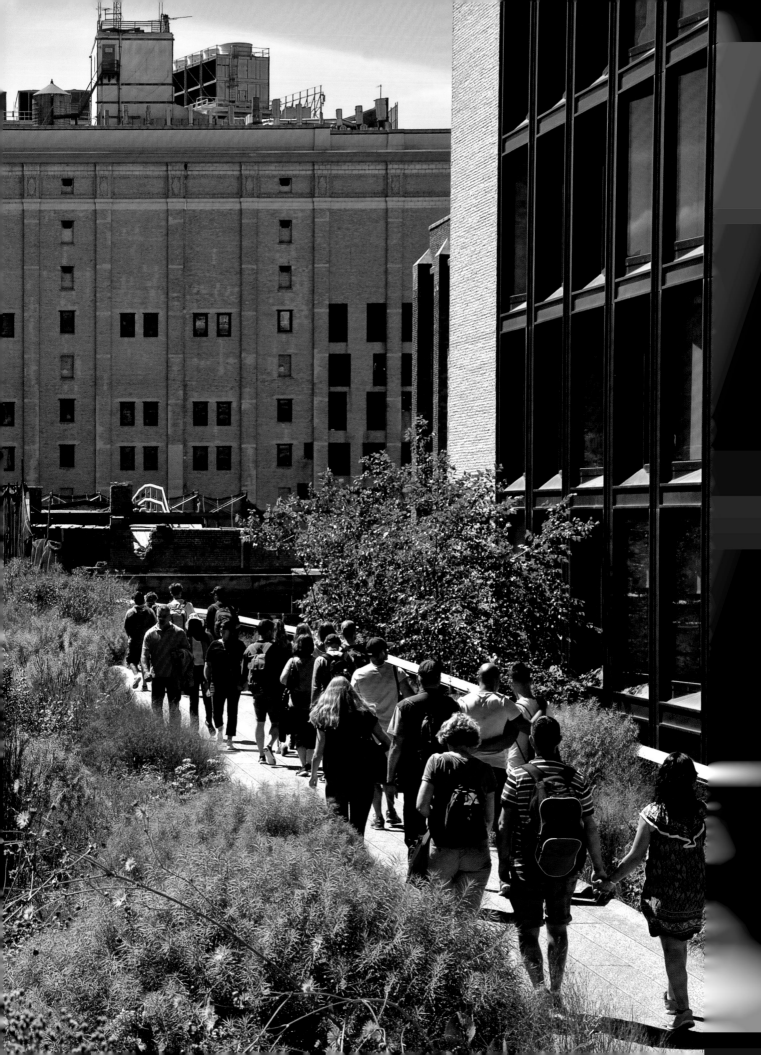

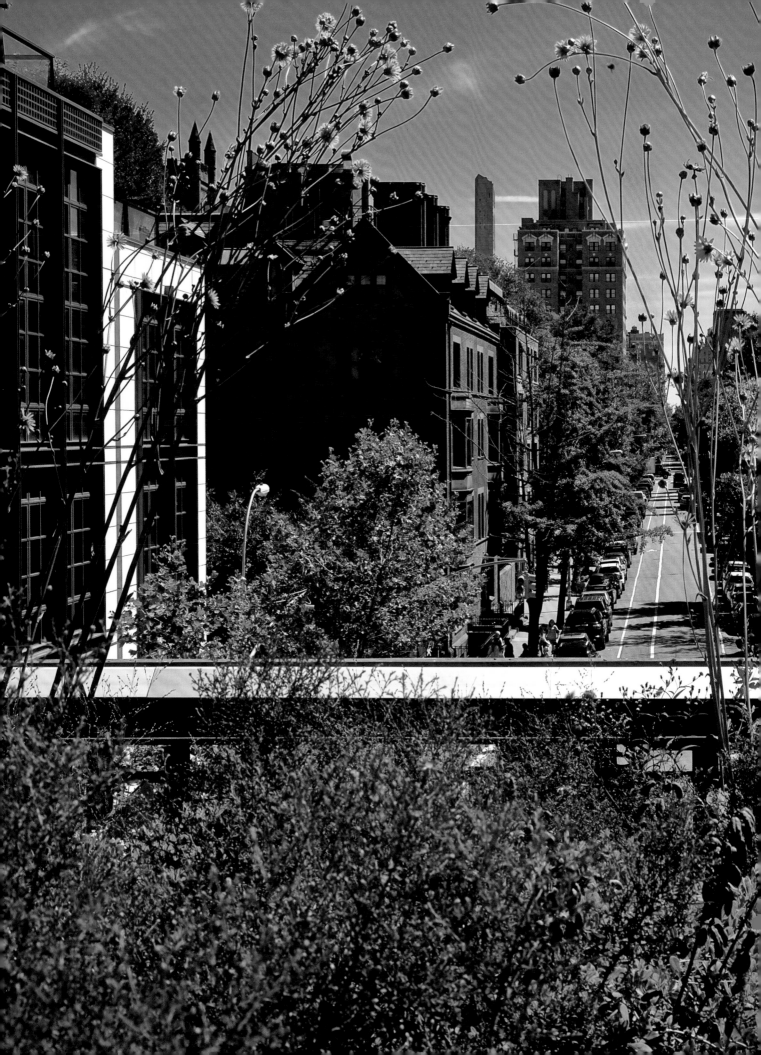

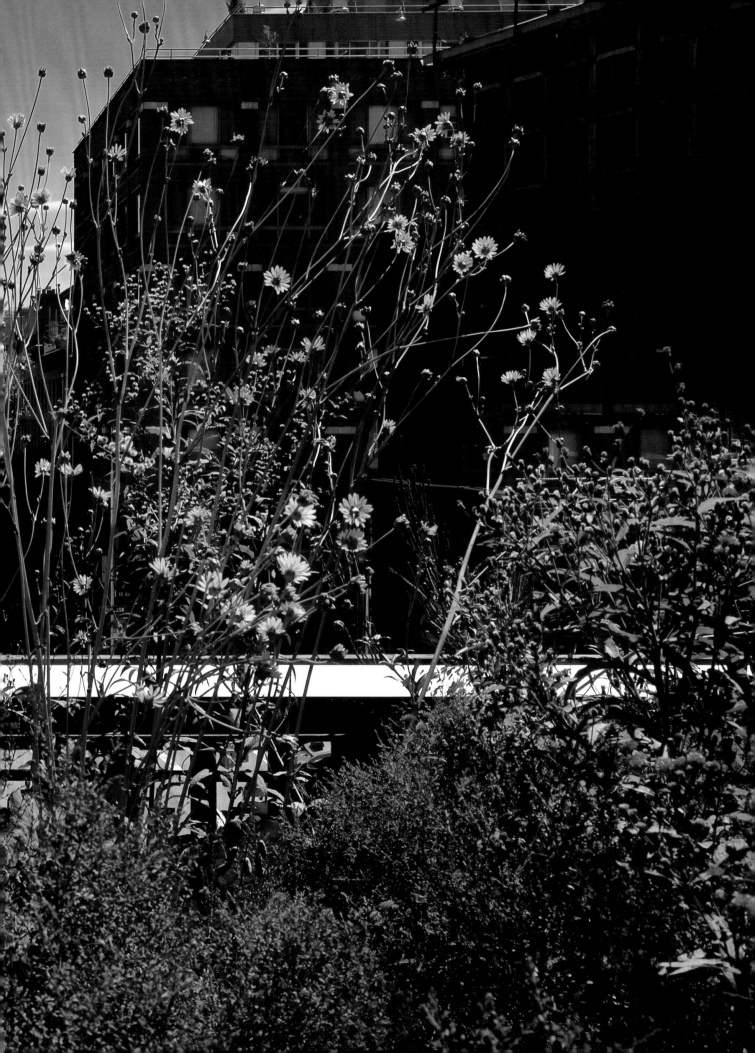

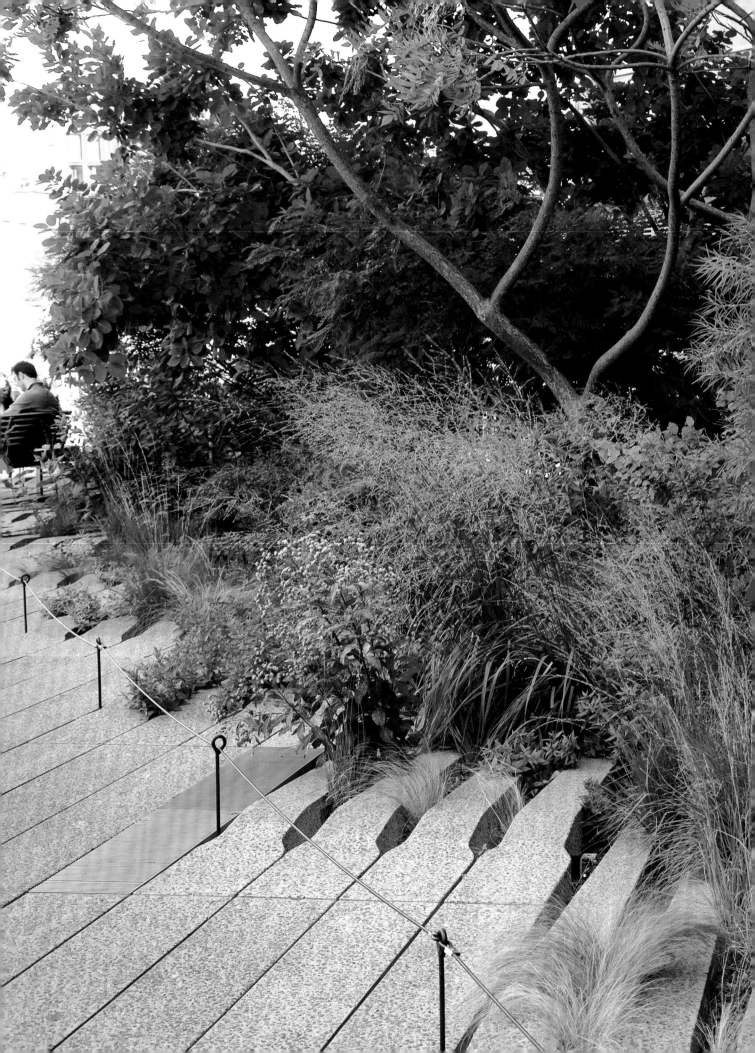

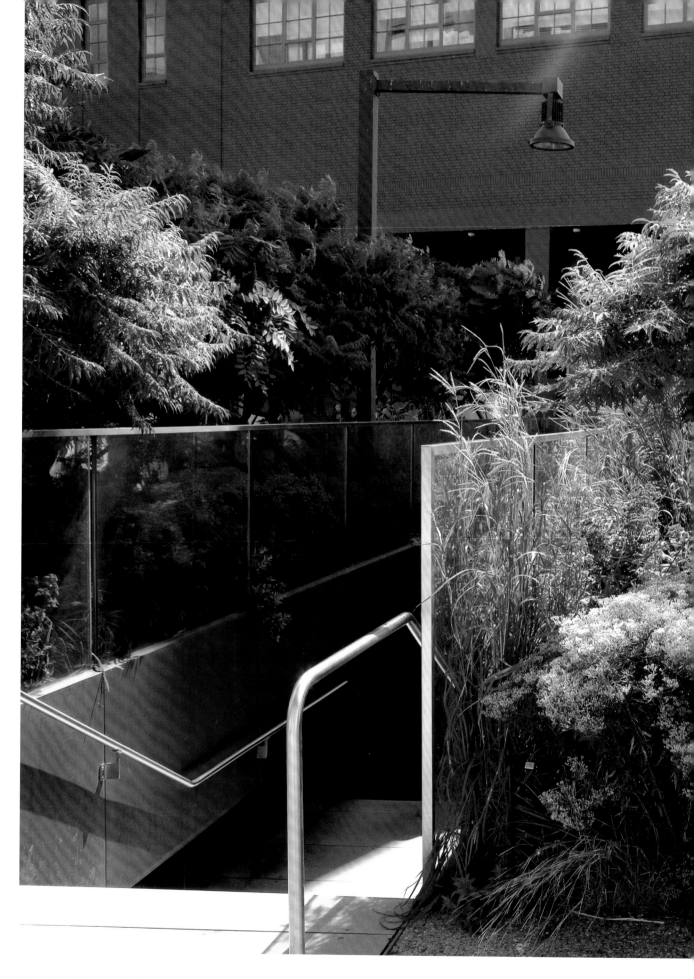

The garden design was inspired by
the tallgrass prairies of the American
Midwest, which hosts more plant species
per fifty square feet than the rainforest.

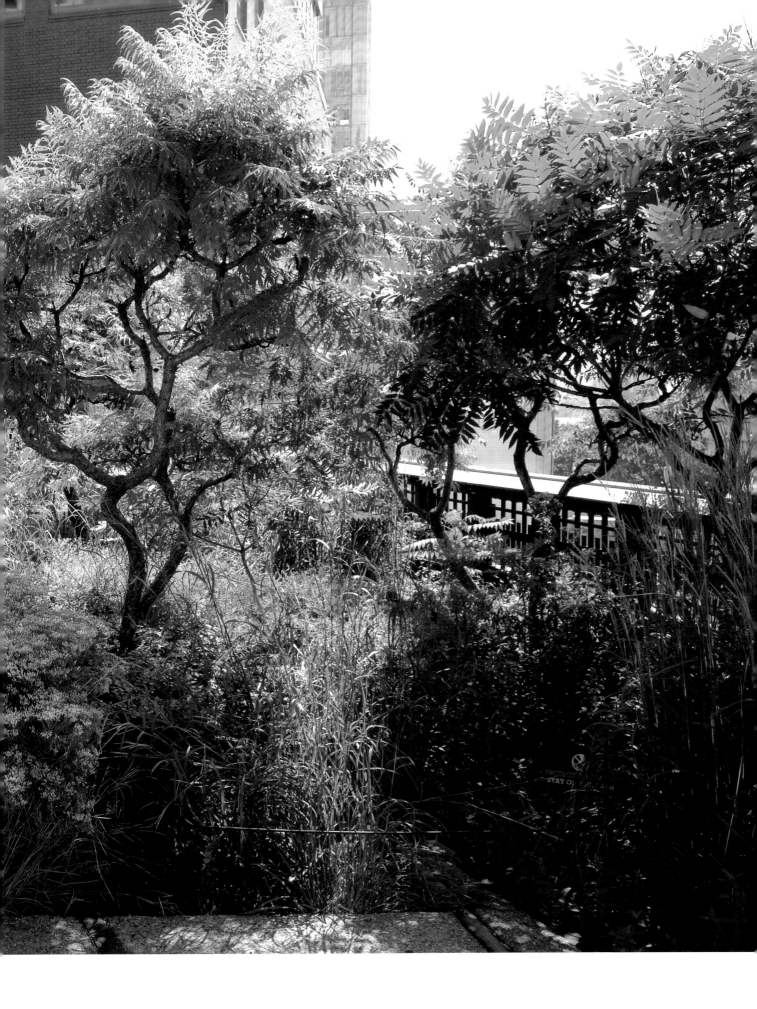

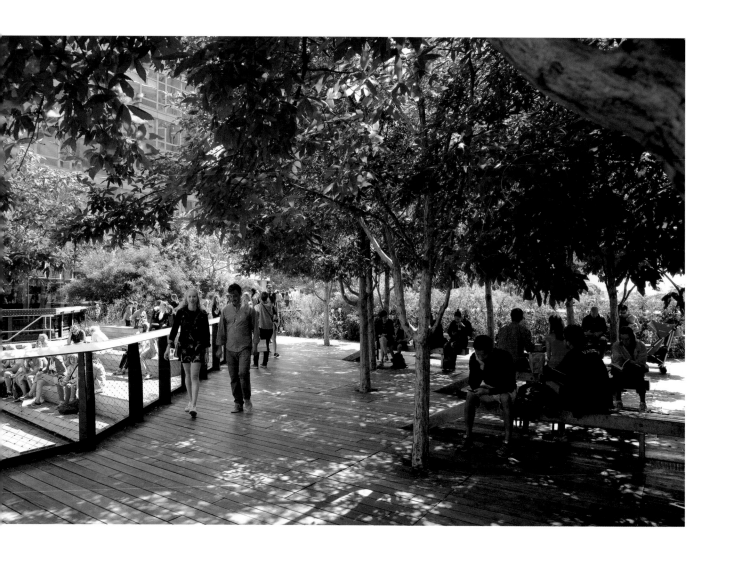

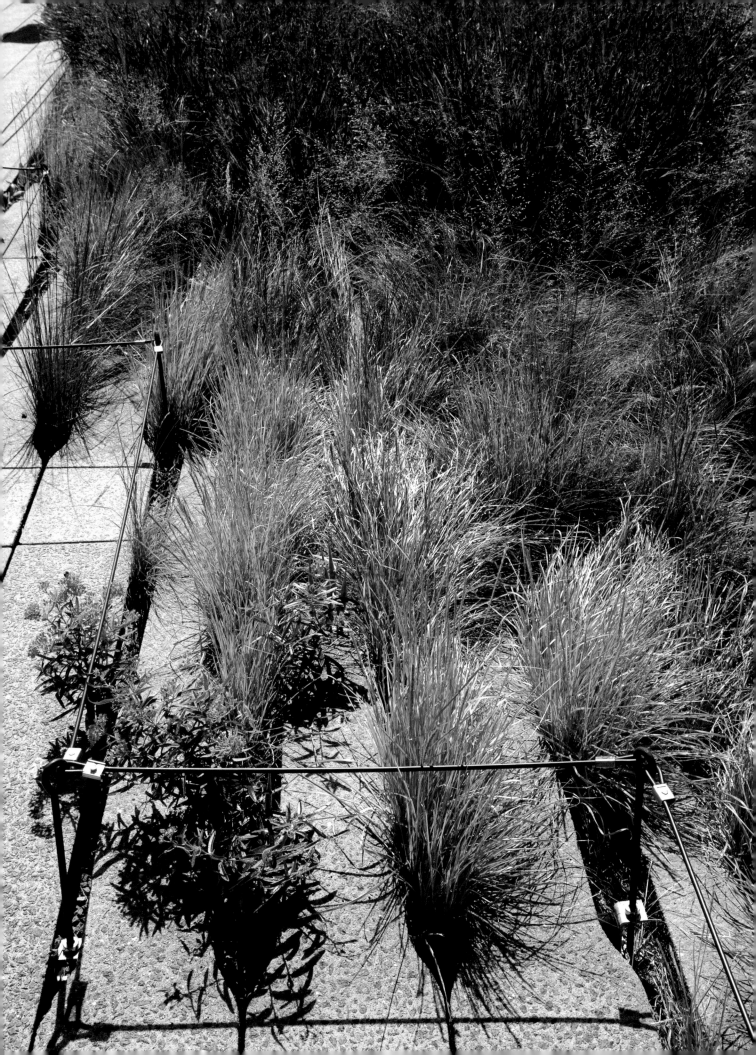

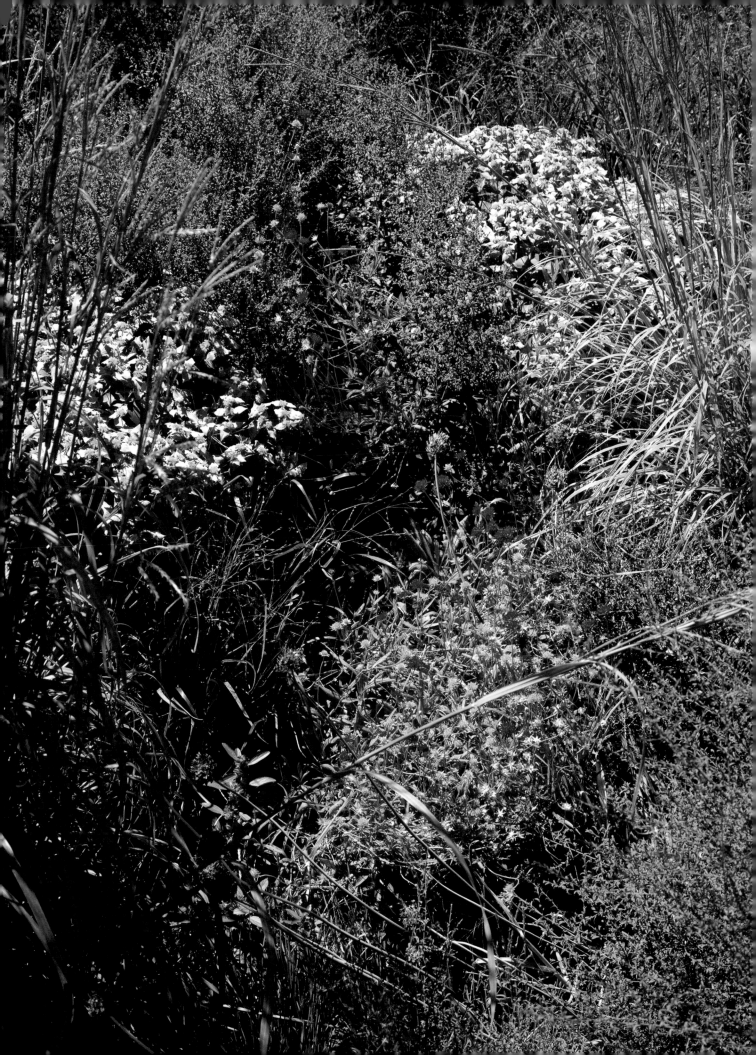

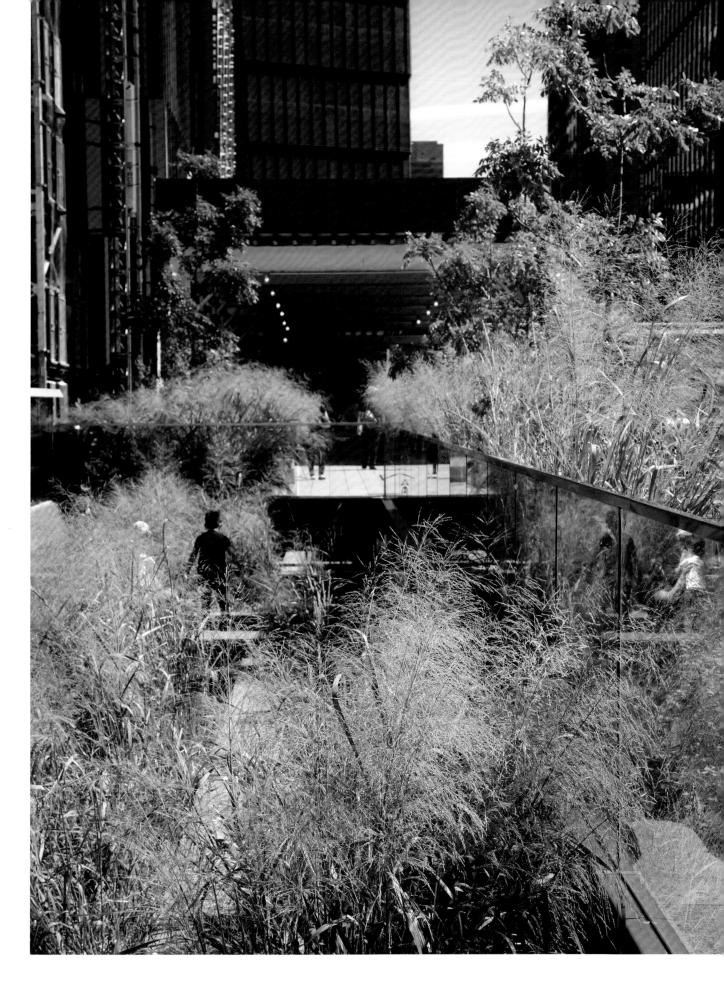

The High Line's planting design was also inspired by the self-seeded landscape that grew up between the rail tracks after the trains stopped running in the 1980s. Some of those species are reflected in the park landscape today.

Acknowledgments

ANDRE BARANOWSKI

Since arriving in New York in 1981 as an immigrant from Poland with a big dream of being a photographer, I have lived a huge continuous adventure for the last thirty-seven years.

One thing I have learned working in the New York publishing world is that most projects, as much as we want them to be our own, are a group effort. Being a photographer and working with great editors, designers, writers, art directors, and others is so important to the work and its development.

The quality of associations very often decides our progress. I am deeply grateful to so many individuals, starting with Dorothy Kalins, who hired me to work almost from the beginning, when her magazines *Garden Design* and *Saveur* were new. This creative relationship has lasted for many years, and has taken me to many amazing places around the world.

At Rizzoli, I thank publisher Charles Miers and editor Martynka Wawrzyniak for loving my work and putting an amazing team together to work on this book. Su Barber crafted a fantastic design, John Son wrote beautiful stories about each garden, and James Brayton Hall, Pamela Governale, and the Garden Conservancy made me aware of some fantastic gardens.

Garden owners and garden designers are a special people, with Mother Earth's well-being in their hearts. I am so deeply grateful for the contributions of Janet Mavec, Friends of the High Line, Annacharia Danieli, Peter P. Blanchard III, Stephen Morrell, Laura Mumaw Palmer, Kathy Moreau, Jack Lenor Larsen, Matko Tomicic, Maria Nation, Alex and Carol Rosenberg, Marc and Sheree Holliday, Eric Groft, Michael Boodro, Darrel Morrison, and Rea and Judd Tully.